OLD IRELAND IN COLOUR

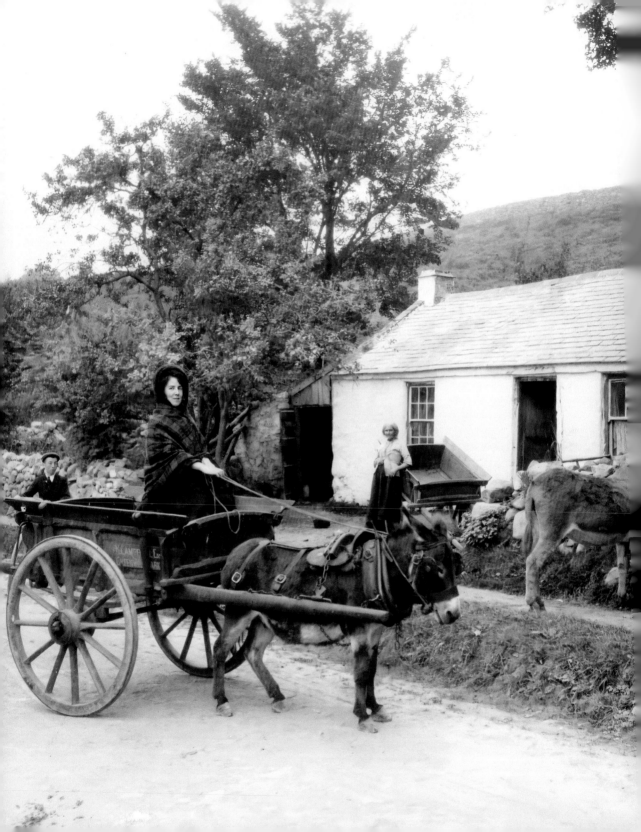

OLD IRELAND IN COLOUR

John Breslin & Sarah-Anne Buckley

MERRION
PRESS

First published in hardback in 2020 by
Merrion Press
10 George's Street
Newbridge
Co. Kildare
Ireland
www.merrionpress.ie

This edition first published in 2023

9781785374319 (Paper)
9781785373718 (Kindle)
9781785373725 (Epub)

A CIP catalogue record for this book is available from the British Library.

Typeset in Adobe Caslon Pro, Garamond and Avenir.

Cover design and typeset by: RIVERDESIGNBOOKS.COM

Printed in Dubai

Front cover image: **HAPPY DAYS**; *c.*1946, Feothanach, Co. Kerry; Members of the O'Sullivan, Griffin and Kavanagh families; Photographer: Caoimhín Ó Danachair; Source: National Folklore Collection Ref.: E003.18.00012.

Back cover image: **FAIR DAY**; 4 May 1910, Ballybricken, Waterford City; M.J. (Michael J.) Phelan's Hotel is seen in the background at no. 14. Poole Photographic Studio scratched out some of the sign behind the van, which reads 'Lipton's Tea 1s/4d'. Poole also adjusted the top of the van, so the sign was not obscured. Ballybricken became the centre of the pig and bacon industry in Waterford in the nineteenth and early twentieth centuries when fairs were a critical part of the agricultural economy and social life; Photographer: Poole Studio; Source: National Library of Ireland Ref.: POOLEWP 2103.

Opening credits:

YOUNG WOMAN IN A PONY TRAP DRAWN BY A DONKEY; *c.*1907; Photographer: Unknown; Source: Library of Congress Ref.: 93504400.

SPINNING; *c.*1930s, Carna, Co. Galway; Photographer: Caoimhín Ó Danachair; Source: National Folklore Collection Ref.: B063.01.00012.

WOMAN BAKING; *c.*1910, Galgorm Castle, Ballymena, Co. Antrim; A photograph by Mary Alice Young, inspired by Flemish art. Young was the eldest daughter of the Rt Hon. Sir F.E.W. Macnaghten, and in 1893 she married W.R. Young, the eldest son of the Rt Hon. John Young and the owner of Galgorm Castle near Ballymena. Between 1890 and 1915, she took over a thousand photographs and is therefore one of the period's most prolific female photographers; Photographer: Mary Alice Young; Source: Deputy Keeper of the Records, Public Record Office of Northern Ireland Ref.: D3027/8/E.

GRUBBING POTATOES; 1962, Carnanransy, Co. Tyrone; Prior to mechanisation, a horse and mechanical plough would be used to dig or grub for potatoes to harvest them. Potatoes were introduced to Ireland in the sixteenth century and are still a staple food source; Photographer: Michael J. Murphy; Source: National Folklore Collection Ref.: B021.32.00001.

FOWL AT GALWAY MARKET; *c.*1910, Lombard Street, Galway City; This photograph was taken beside St Nicholas' Collegiate Church and depicts a market scene in provincial Ireland. Today, Galway market operates in this exact area. In 1911, the population in Co. Galway was declining, having fallen to 182,224 in the ten years after the 1901 census. The population of Galway City was also falling – from 13,426 in 1901 to 13,255 in 1911; Photographer: Unknown; Source: National Library of Ireland Ref.: EAS_4051.

Merrion Press is a member of Publishing Ireland

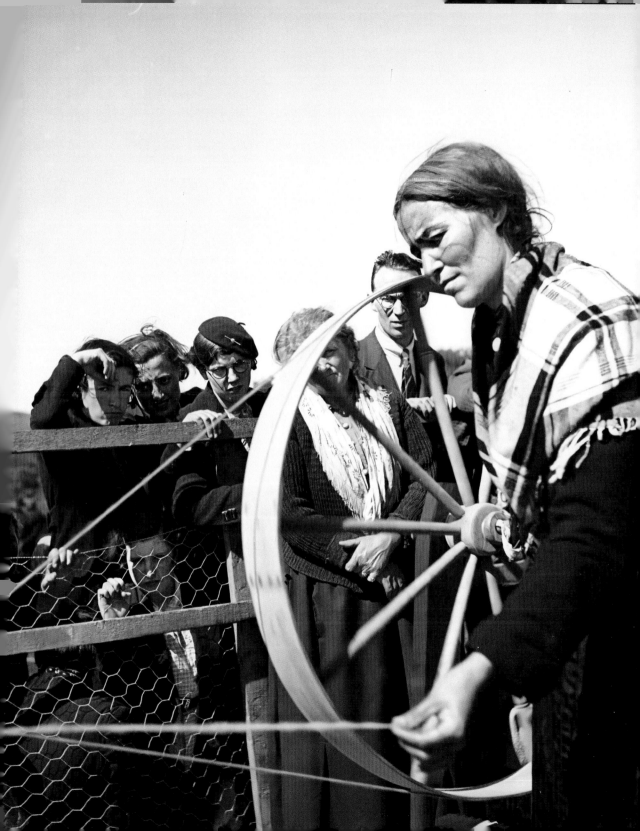

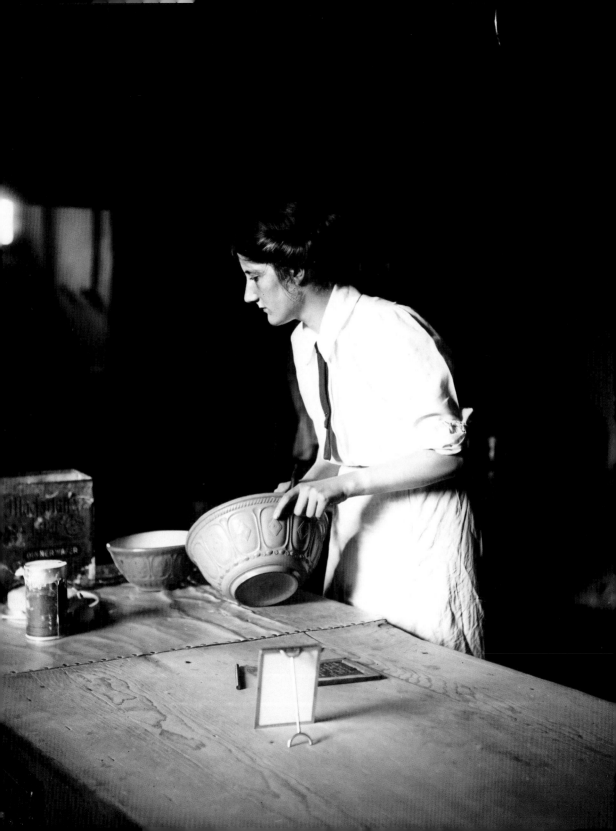

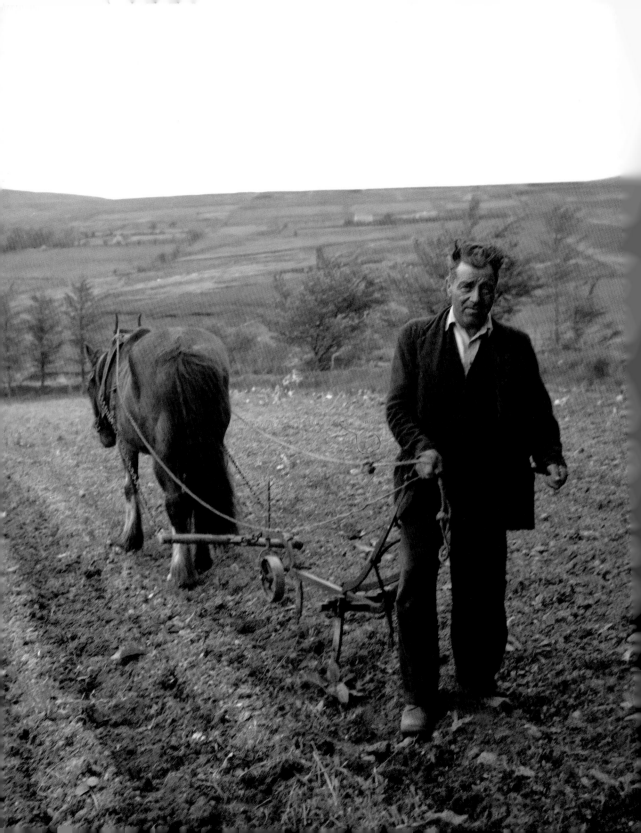

ACKNOWLEDGEMENTS

Sincere thanks to Jason Antic and Dana Kelley of DeOldify, without whom this project would not have occurred in the first place. Thank you also to Saileóg O'Halloran and Taff Gillingham for their assistance regarding Irish and British uniform colours, to Mike Darcy, Matt Loughrey, Johnny Sirlande and ColorizeImages.com for their continued support, and to Alexandr Borisovich and Laurent Perrie for their advice. Thanks also to NUI Galway and to Science Foundation Ireland, who, through the Insight, Confirm and VistaMilk SFI Research Centres (grant numbers 12/RC/2289_P2, 16/RC/3918 and 16/RC/3835), have supported John's ongoing research into the area of artificial intelligence applications.

On the captions, thank you to Úna Kavanagh for her assistance on the Dillon/Clonbrock photographs, Gerry White for his uniform advice, John Cunningham on all things Galway and Deirdre Ní Chonghaile on all things Aran. John Borgonovo and the *Atlas of the Irish Revolution* were of great assistance on the revolutionary period, as was Liz Gillis on Elizabeth O'Farrell and the infamous surrender photograph. Thank you also to Owen Ward.

Both John and Sarah-Anne would also like to thank their families for all their support throughout.

ABOUT THE AUTHORS

John Breslin is a Professor at NUI Galway, where he has taught engineering, computer science and entrepreneurship over a twenty-year period. He is a researcher with three SFI Research Centres: Insight (Data Analytics), Confirm (Smart Manufacturing), and VistaMilk (AgTech). He has written over 200 publications and co-authored two books. He is co-founder of boards.ie, adverts.ie, and the PorterShed. From the Burren, he lives in Connemara.

Dr Sarah-Anne Buckley is a lecturer in History at NUI Galway, President of the Women's History Association of Ireland and Chair of the Irish History Students Association. She has published two monographs and four edited volumes. She is co-founder of the Irish Centre for the Histories of Labour and Class and Senior Research Fellow in the UNESCO Child and Family Research Centre.

Old Ireland in Colour is online at www.oldirelandincolour.com. You can follow the project on Twitter @irelandincolour, on Facebook and Instagram @oldirelandincolour, and also on YouTube.

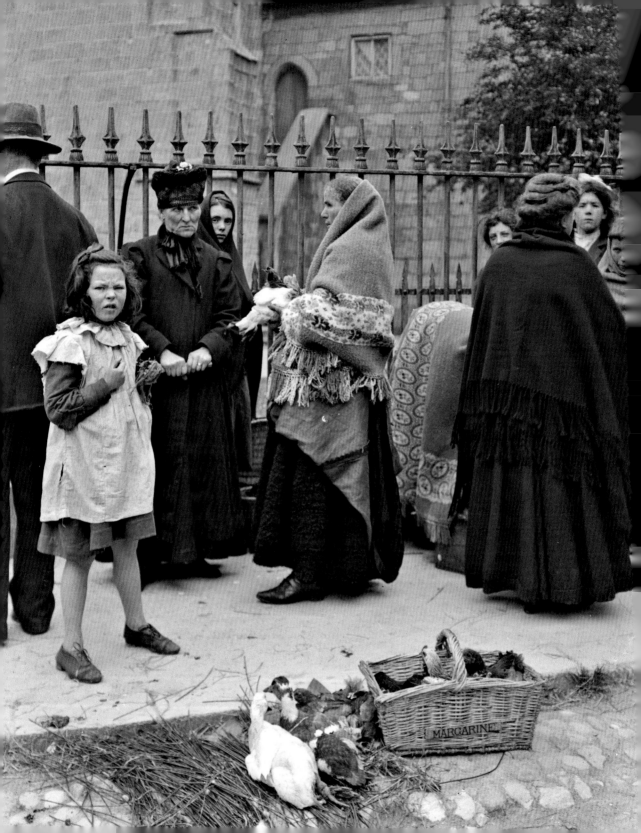

INTRODUCTION

In 1839, Louis Daguerre announced his discovery of the process of photography. In 1841, professional photography was introduced to Ireland, and by 1881 most counties had at least one photographer, many of them being women. For over a century, photographers – both professional and amateur – captured and collected moments in our history in black and white, the technology of the time. These are incredibly important historical sources, but just as we do today, people from this period lived their lives in colour, and we believe it is important to try to view their lives in this way.

This book, and the Old Ireland in Colour project, aims to bring Ireland's modern history to life through the colourisation of black and white photographs. The first hundred years of photography, during which most of the images in this book were taken, was one of dramatic demographic, social, economic, political, cultural and technological change in Ireland and internationally. This change and transformation is a key tenet of this book and the photographs it contains. Each was chosen with several considerations in mind: a reflection of Ireland's different social classes, the need for a diverse geographical spread, permissions and availability, and the importance of gender, religion and ethnicity. Although Ireland was predominantly agricultural at the turn of the twentieth century, urban life and streetscapes are an important feature. Yet the dominance of the West of Ireland cannot be denied – due in part to the wealth and focus of the Folklore Collection from the 1930s, and the initial work and interest of John's Old Ireland in Colour project.

As Marina Amaral and Dan Jones state in their hugely successful book *The Colour of Time*, there 'are many more omissions than inclusions' in this book. This collection is not a comprehensive history of Ireland, nor is it a history of photography in Ireland. This has been explored, and explored well, by other scholars – Seán Sexton and Christine Kinealy's *The Irish: A Photohistory: 1840–1940*, Ciara Breathnach's *Framing the West* and Erika Hanna's more recent *Snapshot Stories: Visuality, Photography, and the Social History of Ireland, 1922–2000* being prime examples. It is, however, a cross section of Ireland's remarkable photographic collections colourised through consultation with available historical sources. We have chosen to group these photographs thematically, and within these sections, we have largely adhered to a chronological order. In some cases, we have provided long captions, in others we feel the photograph speaks for itself and we have acknowledged who and where it came from. Our categorisation has also been driven by public interest in the history of Ireland and the Irish – particularly the history of the Irish revolution, social and cultural history, gender history, the history of the Irish abroad, and images of Ireland's beautiful landscapes and streetscapes.

Debates on the colourisation of black and white films and photographs have been ongoing since the 1980s. We do not wish to engage in these debates in this book; the purpose of the book for us is to reveal the capacity of modern technologies to provide realistic images with a wide palette of historical colours. While we are very aware of issues of consent when looking at the history of photography and individuals, we believe this is also an issue when using photographs from these collections in other academic and non-academic works. In this book, we believe we are drawing attention to existing collections as opposed to replacing them in any way.

The 173 photographs in this book address the period from just before the Great Famine (1845–52) to the outbreak of 'The Troubles' in Northern Ireland. During this time, the population of the island of Ireland went from over 8 million to a low of 4 million in the 1950s. Throughout the nineteenth century, we can see the importance of religion and the Irish language, the effects of the Great Famine and the Land War, and the growth in cultural nationalism. Work, play, technology and deviance are mingled between images of Irish landscapes and revolution. The public and the private are intertwined. There are familiar personalities and events, images that have been mass-produced and those that we have rarely seen. Social change is explored in many forms – through images of evictions and depictions of poverty, alongside earth-shattering events like the sinkings of the *Titanic* and the *Lusitania*. There is a focus on folklore, music, rural life and tradition, the Irish pub, and Ireland's islands. Work, and changes to work, as well as glimpses of the gentry or Anglo-Irish class emerge. Changes in clothing and play bring with them nostalgia and thoughts of our own childhoods. With that in mind, we have chosen to include a section on women and children, both of whose lives changed enormously during these years. Some of these changes include suffrage, the introduction of compulsory schooling, the opening up of spaces for women to work and study, advances like running water and electrification, changes to medicine and maternity care. Women and children are also prominent in the first section of the book, which begins with the iconic image of Edward Carson signing the Ulster Solemn League and Covenant. Another section deals with the Irish abroad, and it covers everyone from the Catalpa Six and Violet Gibson (also known as the woman who shot Mussolini) to cultural figures like Oscar Wilde and James Joyce, as well as artists, writers, actresses, politicians and performers who travelled from Ireland to countries around the globe for a variety of reasons. Some would be celebrated, others vilified. We end the book with images of Ireland that we feel represent its variety, its essence, and its beauty.

Old Ireland in Colour: The Project

Old Ireland in Colour started in 2019 when John developed an interest in historic photo colourisation, enhancement and restoration through personal genealogical research. He began to colourise old family photos – photos of his grandparents from Fanore in Co. Clare and Glenties in Co. Donegal. After discovering DeOldify, an application used for colourising images, he moved from family photographs to photographs of Galway and Connemara, and then on to others taken across the island of Ireland in the nineteenth and twentieth centuries. After a few months, the Old Ireland in Colour project was born, and since then thousands of photographs have been colourised and the project now has tens of thousands of followers online. In early 2020, Sarah-Anne joined John to advise on the historical content for this book.

The technology is a key part of the process. DeOldify was originally developed by American programmer Jason Antic in 2018 and later by programmer Dana Kelley. While at a meeting in San Diego in 2019, John met Jason and Dana and they discussed colourisation, their entrepreneurial plans, and ancestral links to Ireland. DeOldify works by learning what colours should be applied to different textures, shapes and objects in black and white photos, using models that are trained

on a large bank of millions of colour images. The accuracy of the colours is as good as what can normally be expected for a certain type of texture or shape encountered in the image bank. Grass, trees and the sea usually come out very well. Roofs sometimes (but not always) emerge with the wrong colour tiles. Quite often clothes are colourised with an averaged blue or purple colour, whereas you may know that they should be a particular hue. In those cases, all you can do is carry out some post-processing where you touch up or manually adjust that colour in an image-editing package e.g. Photoshop. There are many incidents where there is either a historical record or some human intuition or knowledge that the colour is just not right. For example, we have manually changed Constance Markievicz's uniform from navy/purple to bottle green, the shawls of Claddagh women to red and Tom Crean's woollen jumpers to any colour but lilac! The most common change is where we have had to manually touch up an ear, arm or leg that was not automatically colourised for some reason (e.g., if it was partially obscured so not recognised as such). Sometimes these colourisations are controversial – for example, in the case of Elizabeth O'Farrell and the surrender in 1916, we colourised what we saw as being her hood in blue and the hem of her dress in red/brown, with a green greatcoat for Pearse in the foreground, whereas others have interpreted more of O'Farrell's dress being visible and no greatcoat worn by Pearse (see p. 34). They are also influenced by the availability of primary sources. We know, for example, that Violet Gibson had blueish eyes and white hair from her police ID report; similarly, Ellis Island records pointed to Muriel Murphy MacSwiney's blue/grey eyes. Prison records also lead us to physical details of the Catalpa Six, while Peig Sayers' eye colour is told to us by the folklore collector Kenneth Jackson. It is always the case that new information can come to light post-colourisation, and over the past year we have updated various photos as this has occurred. In the aforementioned Ellis Island records, we later found a passenger record for Markievich instead of Markievicz, and updated her eye colour to blue in her return from prison photograph (see p. 47). Irish and British uniforms and vehicles are colourised according to advice from experts and various photos of period items (helmets, chevrons, badges and buttons, armoured cars, etc.). While it is often easier to find the eye colour for more famous historical figures, family members of others in these photographs have often come forward with details, e.g. the Murphy family gave us a correct eye colour for Theobald Wolfe Tone Fitzgerald.

We acknowledge fully the ethical concerns that arise from altering these primary documents and hope that the book leads the reader to the original source, as opposed to offering a replacement for these records. As a scientist and a historian, we skirt two different worlds, but we believe that together these images and captions offer an illuminating look at Irish life, Irish people and the dramatic transformation and change that has occurred over the 125 years covered in this collection.

<div align="right">

John Breslin and Sarah-Anne Buckley

</div>

THE IRISH REVOLUTION

CUMANN NA MBAN

*c.*1920–1921

Cumann na mBan ('The Irishwomen's Council') is an Irish republican women's paramilitary organisation formed in Dublin on 2 April 1914, with the stated objective to 'advance the cause of Irish liberty' and 'to organise Irishwomen in furtherance of this object'. In this image, we see an unidentified member wearing the golden badge associated with the organisation.

ULSTER'S SOLEMN LEAGUE AND COVENANT

28 September 1912, City Hall, Belfast

Edward Carson signing Ulster's Solemn League and Covenant. The preamble sets out five reasons for the rejection of Home Rule. The covenant was signed by over 218,000 men; there was a parallel declaration of support that was signed by a slightly larger number of women. Also seen in the photograph is James Craig (on Carson's left), the Belfast Mayor and councillors. The table Carson is leaning on is still in Belfast City Hall.

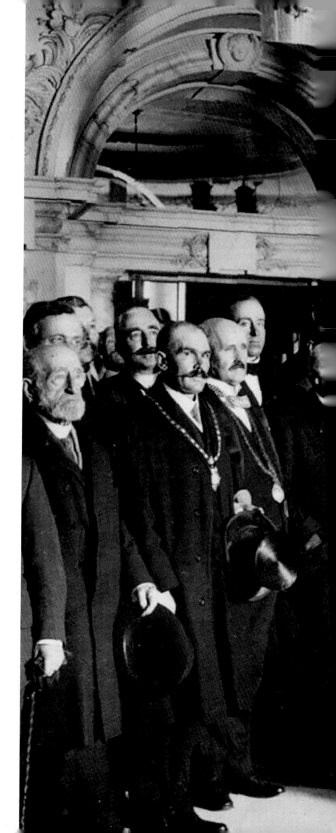

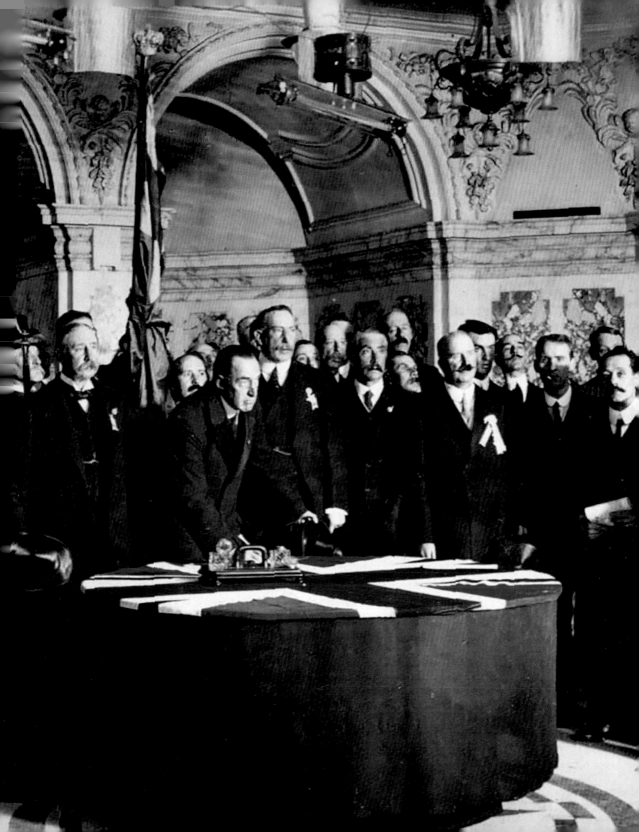

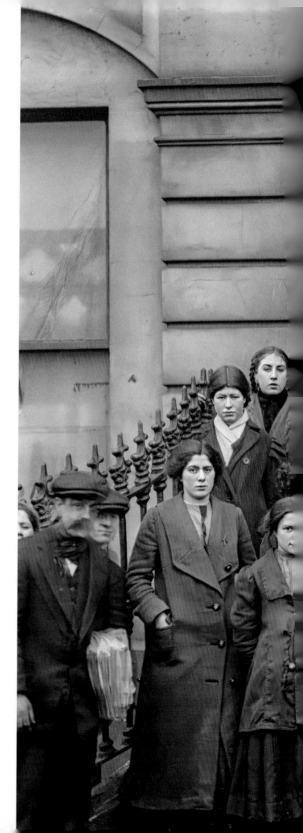

SUFFRAGE AND SOCIALISM

*c.*1914, Liberty Hall, Dublin City

This photograph depicts members of the
Irish Women Workers' Union (IWWU)
outside Liberty Hall in early 1914. The
union had been formed in September
1911 as a women's section of the Irish
Transport and General Workers' Union
(ITGWU). Delia Larkin, sister of James
Larkin, is pictured front and centre. While
James (Jim) Larkin was the nominal
president, Delia played the leading role
until a falling out with the ITGWU in
1915. In 1918, the IWWU was registered
as an independent trade union.

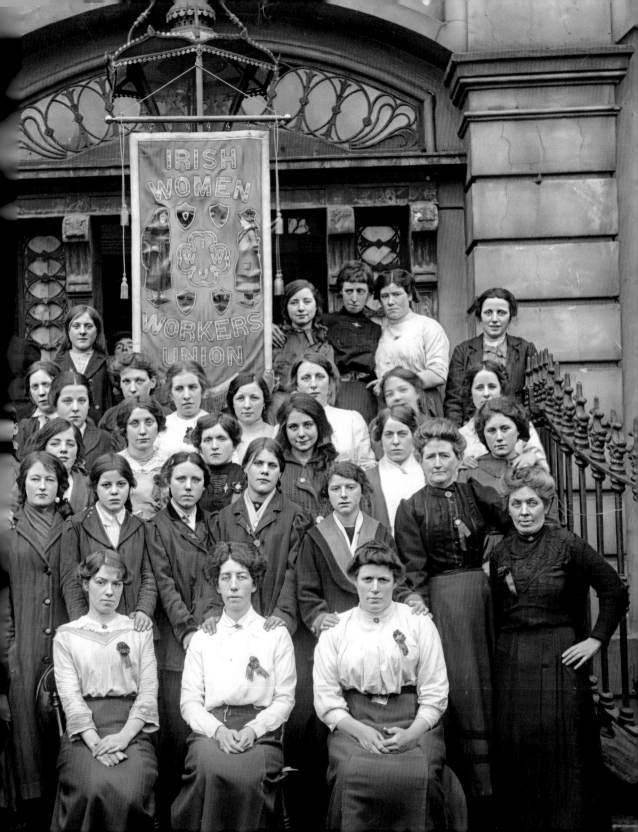

THE 1916 PROCLAMATION AND THE SEVEN SIGNATORIES

The key author of the 1916 Proclamation is believed to be Patrick Pearse, with James Connolly putting emphasis on social-equality and gender issues. It was an assertion of sovereignty – a proclamation of the Irish Republic – and seen to be a critical document for the future independent state. The document is less than 500 words in length and invokes the past as well as the future, referring to armed rebellions over the previous 300 years. There are three mentions of women, including a reference to universal suffrage two years before suffrage was granted to those over 30 years of age. 'Cherishing all the children of the nation equally' has been attributed to James Connolly and is a reference to all people, unionists and Protestants included, as opposed to children alone. While there are guarantees of citizens' rights and references to equality, it was a document that evoked the Irish Republican Brotherhood (IRB) and the Fenian past. Printed in Jennie Wyse Power's *Irish Farm and Produce Company*, the Proclamation was read outside the General Post Office (GPO) by Pearse.

Thomas Clarke (1858–1916)

*c.*1910, Dublin

Thomas Clarke was born in Hurst Castle in Hampshire, England; he was the son of James Clarke from Carrigallen, Co. Leitrim. In 1865, the family moved to Dungannon, Co. Tyrone, where Clarke attended national school. He was sworn into the Dungannon circle of the IRB in 1878, and after participating in an IRB attack on a Royal Irish Constabulary (RIC) barracks in 1880, left to go to New York. He joined Clann na nGael, and in 1883, after participating in a dynamite campaign in Britain, he was sentenced to penal servitude for life. He was released in 1898, and in 1899 he travelled to the US. He returned to Ireland in 1907, and alongside IRB militants like Seán Mac Diarmada in particular, was central to the organisation of the Rising. He was executed in the stone-breaker's yard in Kilmainham Gaol on 3 May 1916.

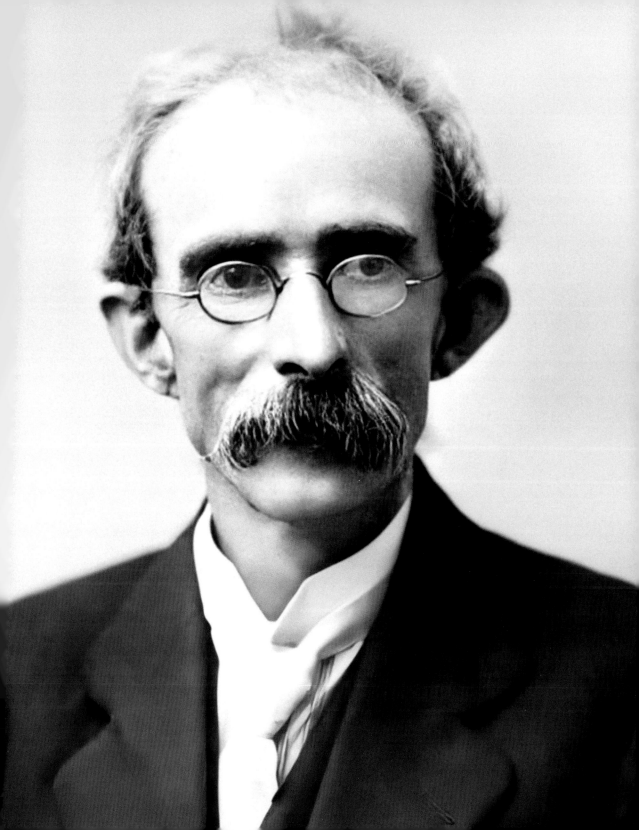

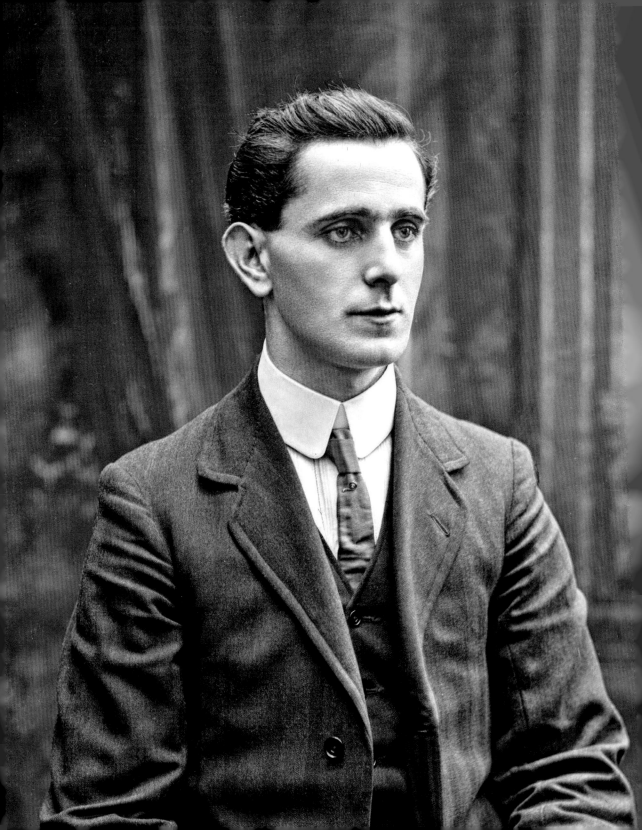

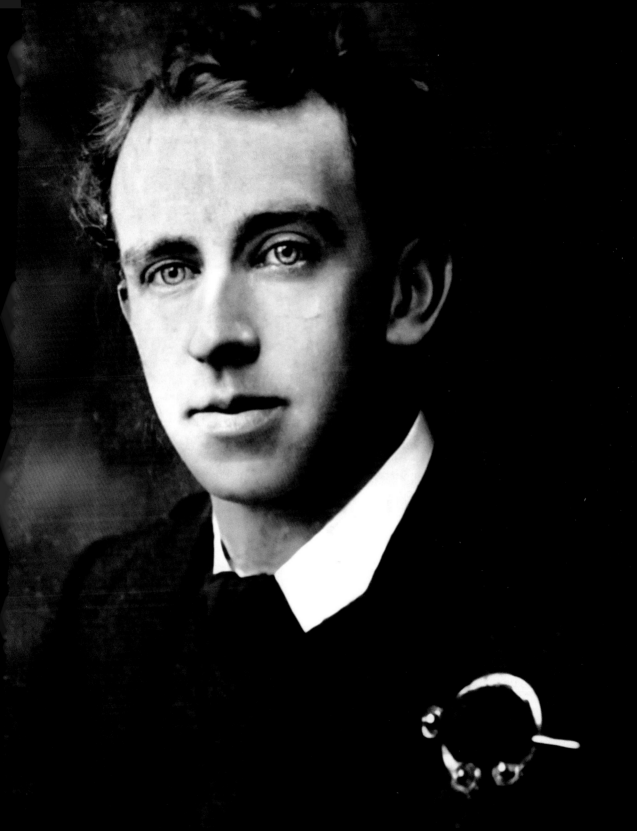

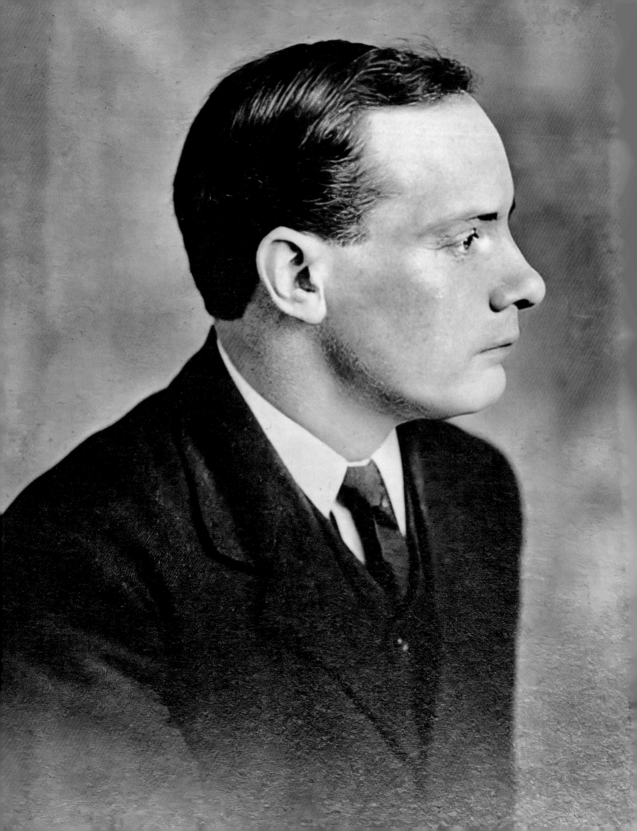

Patrick Pearse (1879–1916)

*c.*1916

Patrick Pearse is one of the most notable signatories of the 1916 Proclamation and leaders of the Easter Rising. Born in 1879, the son of an English stonemason living in Dublin, Pearse gravitated towards the Gaelic League in his teens and became an editor of its weekly newspaper, *An Claidheamh Soluis*. In 1901, he graduated with a degree in Arts and Law, and his literary output was prolific – publishing in both English and Irish. In 1908, he set up St Enda's, which was a radical and experimental school where nationalism was inspired in many of his pupils. One of the founding members of the Irish Volunteers, and the principal author of the Proclamation of Independence, Pearse was present in the GPO during the Rising and was commander-in-chief of the Irish forces. He was executed on 3 May 1916.

Seán Mac Diarmada (1883–1916) *(left)*

*c.*1914–1916, Dublin

Seán Mac Diarmada, a key figure in the orchestration of the Rising, was from a small farming family in Co. Leitrim. His nationalist politics were quite moderate in his earlier years, or until his move to Belfast in 1905 in search of work. There he joined the republican Dungannon Club and met Bulmer Hobson. In 1906, he was sworn into the IRB. In 1911, he was struck by polio, which would ensure he walked with a stick for the rest of his life. He was a key instigator of the Rising and was stationed in the GPO during the fighting.

Thomas MacDonagh (1878–1916) *(right)*

*c.*1909, Dublin

Thomas MacDonagh was a poet, playwright, literary critic, lecturer and founder of the Irish Theatre Company and the *Irish Review*. Born in Cloughjordan, Co. Tipperary in 1878, his parents were national schoolteachers. After the death of his father, he went to Rockwell College, Cashel in 1894, initially to train as a priest, but he found he did not have a vocation and became a teacher. He taught in St Kieran's College, Kilkenny (1901–1903) and in St Colman's College in Fermoy, Co. Cork (1903–1908) before joining the staff at St Enda's School in Dublin in 1908. While teaching in Dublin, he studied part time in UCD and graduated with a BA in 1910 and an MA in 1911, after which he was appointed as a lecturer in English. As well as being involved in the Gaelic League, he was active in the Irish Women's Franchise League and a member of the Dublin Industrial Peace Committee during the 1913 Lockout. He was executed on 3 May 1916 alongside Patrick Pearse and Thomas Clarke.

Éamonn Ceannt (1881–1916)

*c.*1914–1916, Dublin

Éamonn Ceannt was born Edward Thomas Kent on 21 September 1881 in Ballymoe, Glenamaddy, Co. Galway. He was raised in Co. Louth and later took a job as a clerk in the finance department, Dublin Corporation. In 1899, he joined the Gaelic League. A devout Catholic, he was extremely committed to the Irish language and traditional Irish music, and was among the country's leading uilleann pipers. He was sworn into the IRB in 1911, and in 1915 he joined the Supreme Council and was later appointed to the IRB's Military Committee. During the Rising, he commanded 120 men of the 4th Battalion of the Irish Volunteers in the South Dublin Union. Ceannt was executed at Kilmainham Gaol on 8 May 1916, along with Con Colbert, Seán Heuston and Michael Mallin.

James Connolly (1868–1916) *(left)*

*c.*1911

James Connolly was born in Edinburgh, Scotland, in June 1868. After school he joined the British Army. In 1890, he married Wicklow woman Lillie Reynolds, and they would go on to have seven children together, six daughters and a boy. He worked as a carter and became involved in the trade union movement. He moved to Dublin in 1896, later forming the Irish Socialist Republican Party (ISRP) and *The Workers' Republic* newspaper. He moved to the US in 1903, returning to Ireland in 1910 and working as a union organiser for the ITGWU. From 1907, in the US, he had been an organiser for the Industrial Workers of the World, embracing syndicalist politics. Connolly led members of the Irish Citizen Army during the Rising and directed military operations from the GPO alongside Patrick Pearse. He remained in charge even after suffering a serious injury to his ankle and stayed in the GPO until surrendering on 29 April. On 12 May 1916, he was executed while seated on a wooden box in Kilmainham Jail.

Joseph Mary Plunkett (1887–1916) *(right)*

*c.*1910

Joseph Mary Plunkett was a poet, playwright and journalist, and the youngest signatory of the 1916 Proclamation. From a wealthy family, he had a broad education in a range of private schools. In 1913, he became the editor of the *Irish Review*, and in 1914 he became a co-founder of the Irish Theatre Company alongside Thomas MacDonagh and Edward Martyn. He was involved in the formation and early activities of the Irish Volunteers, and in 1915 was involved in securing arms from Germany. He suffered from ill-health for most of his life. He was stationed in the GPO during the Rising and married his fiancée, the artist Grace Gifford, in a prison chapel in Kilmainham on 3 May 1916. He was executed the next day.

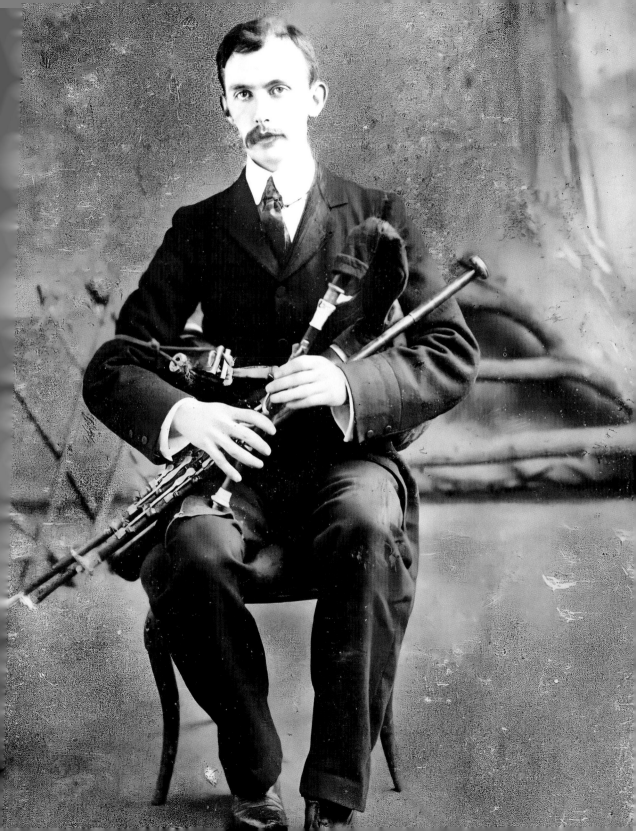

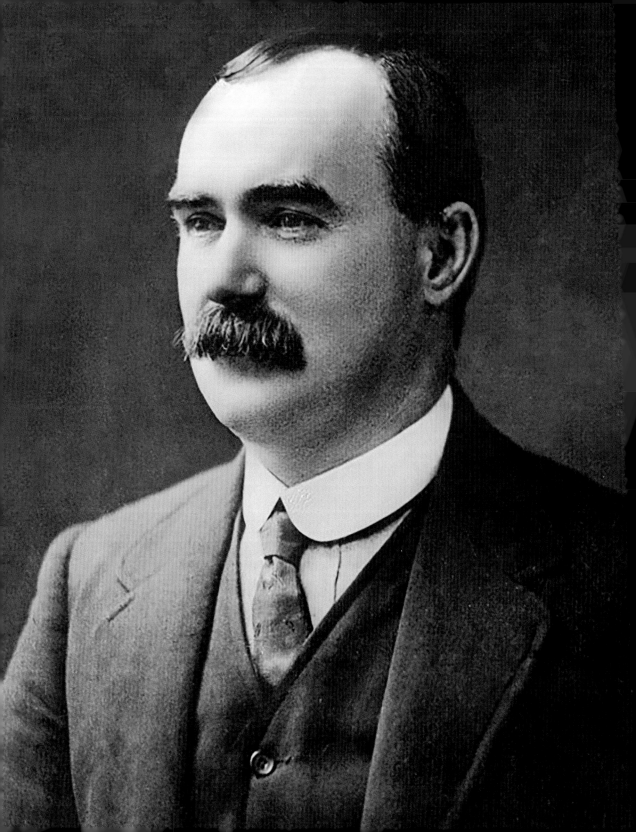

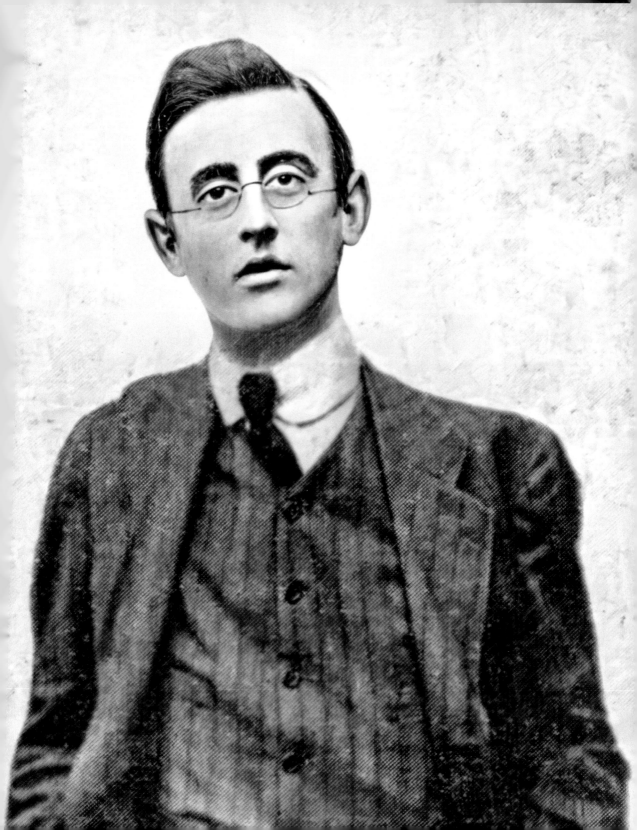

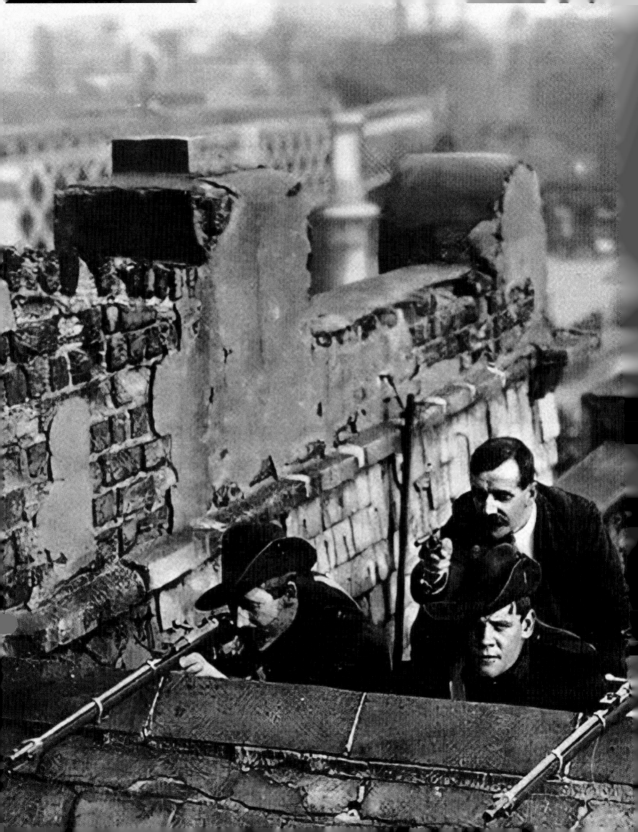

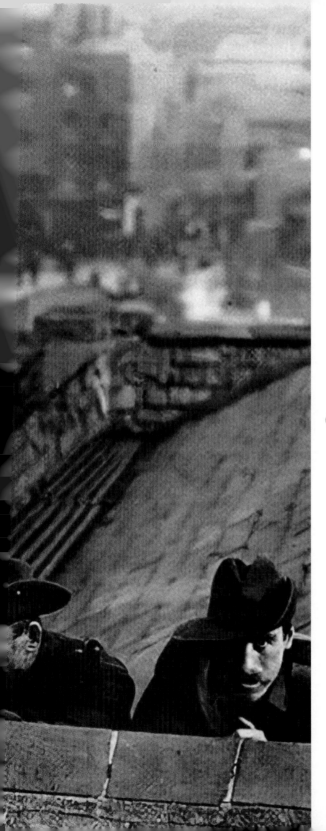

TAKE AIM

*c.*1916, Dublin City

A photo of Irish Citizen Army (ICA)
members, including Christopher 'Kit'
Poole (second from right), atop a
building in 1916. Poole is aiming his rifle
alongside other Citizen Army members.
They are apparently on the roof of
Liberty Hall, with the Loopline Bridge in
the background. It was not taken during
the Rising but was most likely a publicity
photograph.

ICA AND IRISH VOLUNTEERS

25 April 1916, GPO, Dublin City

Group of Volunteers and Irish Citizen
Army (ICA) members inside the GPO.
From left to right: Des O'Reilly, Tony
Swan, Tom Nolan, Paddy Byrne, Jack
Doyle, Tom McGrath, Hugh Thornton
and Paddy Twamly; names taken
from the *Atlas of the Irish Revolution*.
Alternative lists of names for those in this
photograph are available from the Bureau
of Military History and the National
Library of Ireland, however there is some
conflict between all three sets in terms
of the order of names and their affiliated
military organisations.

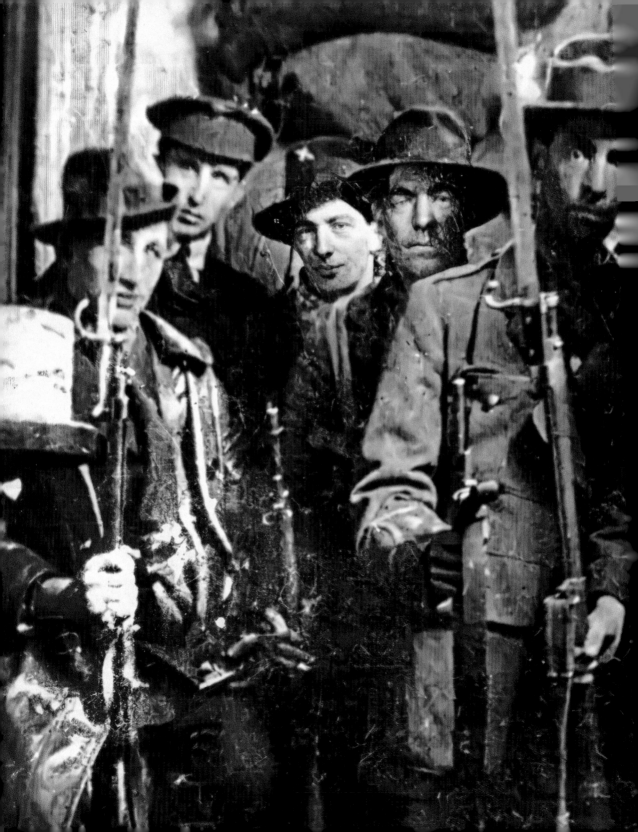

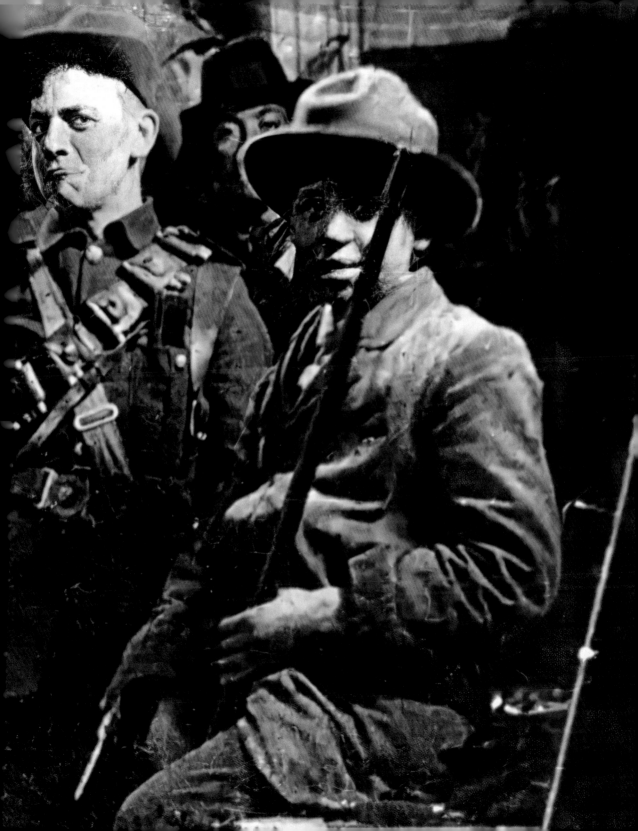

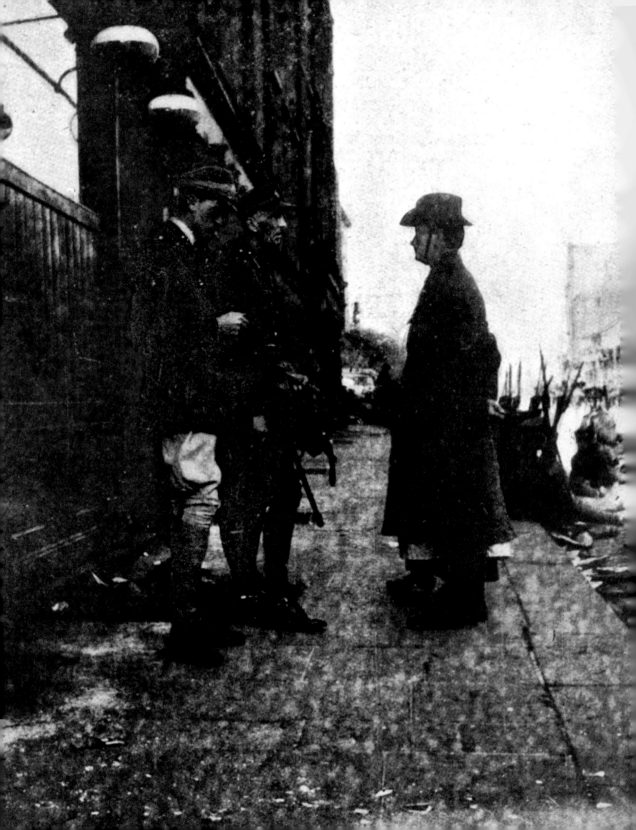

PEARSE'S SURRENDER

29 April 1916, Parnell Street, Dublin City

Patrick Pearse is pictured on the front right and the hem of Elizabeth O'Farrell's dress is visible behind him. The photograph was taken at the scene by an unknown British Army officer who was an amateur photographer. The question as to whether O'Farrell was 'airbrushed' from this historic moment has been addressed by several scholars with both Michael Barry and Seán J. Murphy arguing that she was not. In her memoir O'Farrell stated that she stepped out of the picture.

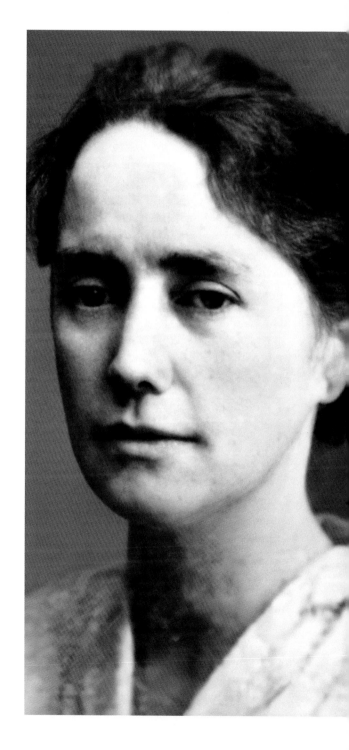

ELIZABETH O'FARRELL

Elizabeth O'Farrell was born 5 November 1883 at 42 City Quay, Dublin, and baptised in St Andrew's church, Westland Row. She was a member of Cumann na mBan in 1916 and would train to be a midwife after the Rising.

RUINS

May 1916, Abbey Street and Sackville (O'Connell) Street, Dublin City

The shelled ruins of Dublin City Centre in the aftermath of the Rising. This photograph depicts landmarks such as Nelson's Pillar in the background and a statue of Sir John Gray in the foreground. The tram passing by is number 244; the advertisements on the tram are for Donnelly's Bacon, Hudson's Super Soap and the Metropolitan Laundry. An advertisement for Bovril can just be made out on another tram. In the background is William Laird Chemist. It is at least 17 May, as building demolition was still ongoing on 16 May, according to the Westropp photographs in Trinity College Dublin.

❯ REMAINS

May 1916, Sackville (O'Connell) Street, Dublin City

What is left of the GPO on Sackville Street in the aftermath of the Rising. The crooked flagpole on top of the GPO may be the one from which the 'Irish Republic' flag flew during the insurrection (painted by Theo Fitzgerald, who is pictured on p. 45 with Markievicz). The trams are heading to Clonskeagh (18) and Dartry Road (148). There are advertisements for Bovril, Hudson's Super Soap, McBirney & Co. Ltd Boots and Shoes on the trams.

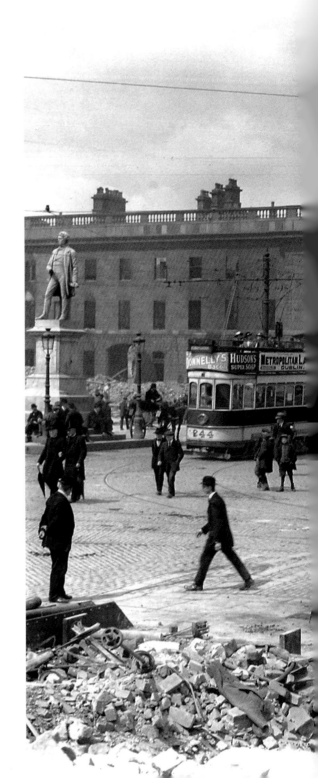

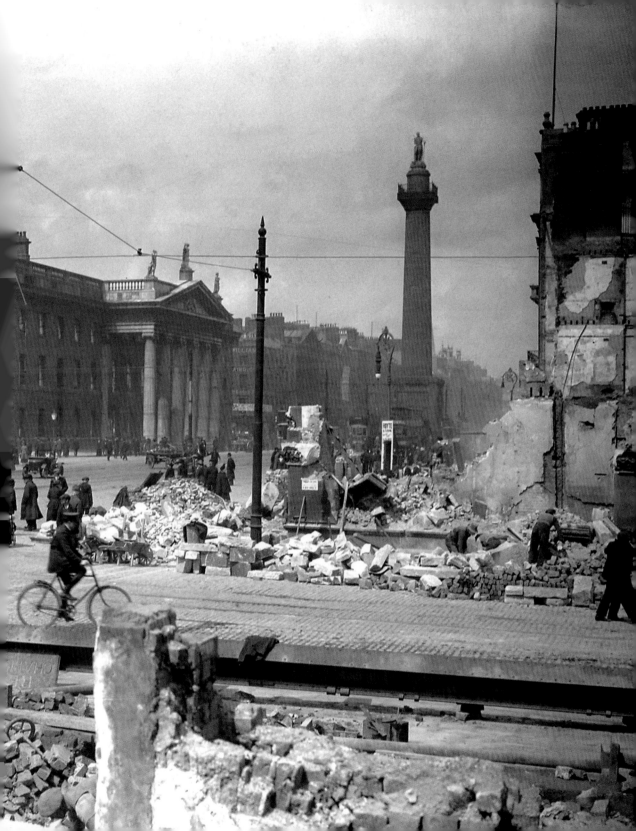

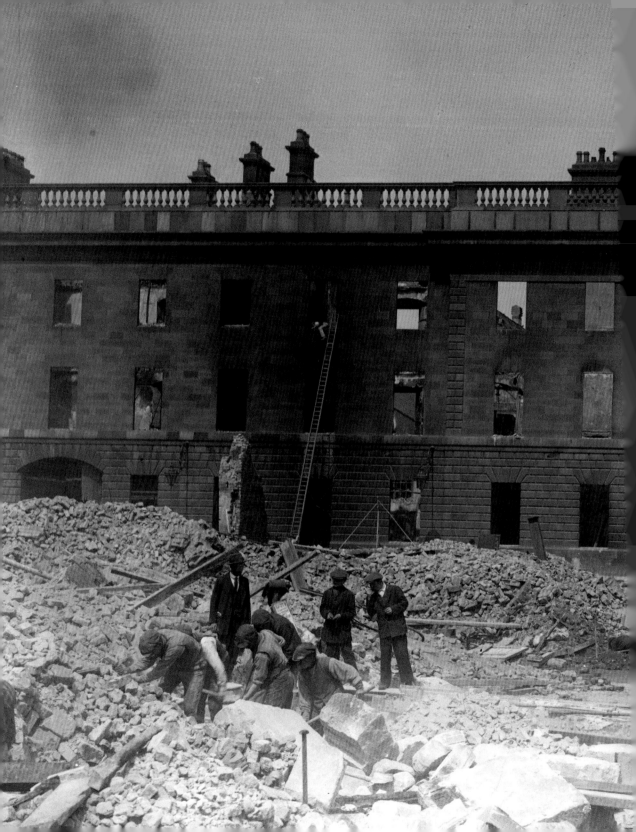

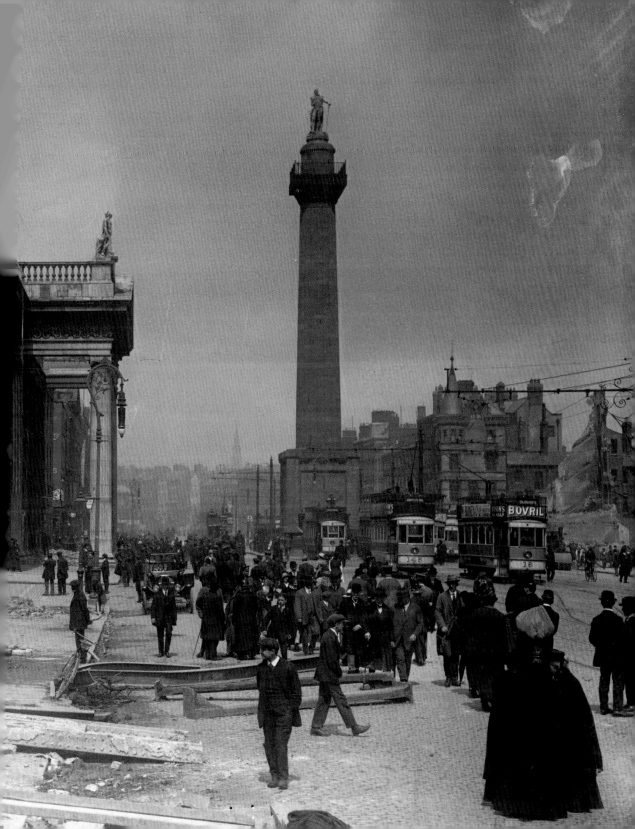

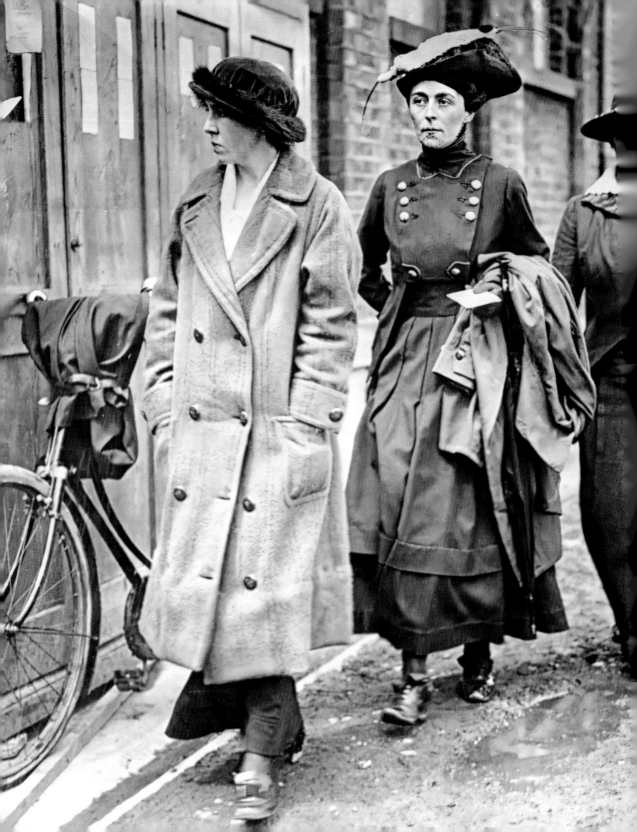

COURT MARTIAL

6–7 June 1916, Richmond Barracks, Dublin

Furthest to the right is Hanna Sheehy-Skeffington as she arrives at Richmond Barracks for the court martial of Captain John Bowen-Colthurst, who murdered her husband Francis Sheehy-Skeffington in April 1916. Also in the picture (left to right) are Meg Connery, with Sheehy-Skeffington's sisters Mary Sheehy Kettle and Kathleen Cruise O'Brien.

ORATION IN CLARE

11 July 1917, Ennis, Co. Clare

Éamon de Valera addressing Sinn Féin supporters from the front of Ennis Courthouse during the East Clare by-election in July 1917. During this campaign the Volunteers emerged as a significant force, politically. The man with his hand on a walking stick, closer to the photographer, is William Considine, a hurler for the Clare team that won the 1914 All-Ireland Senior Hurling Championship.

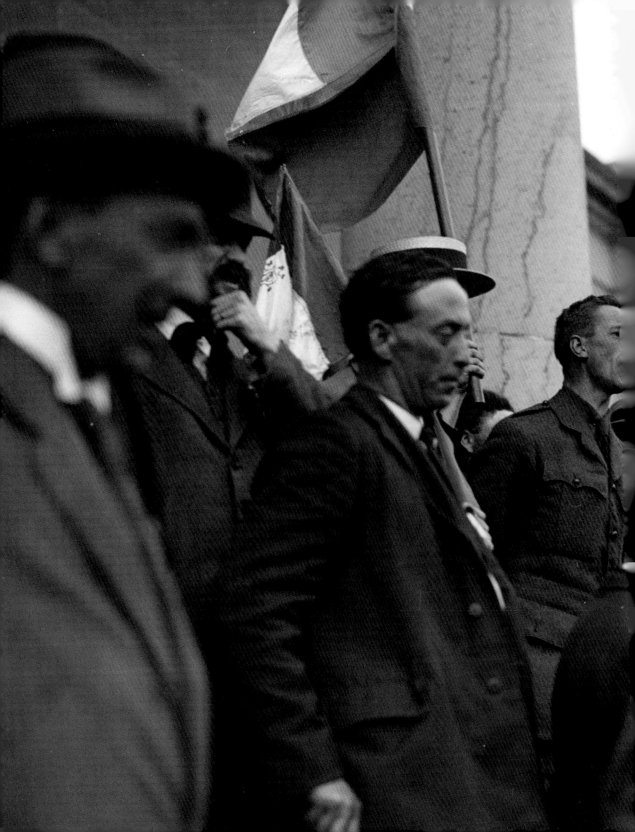

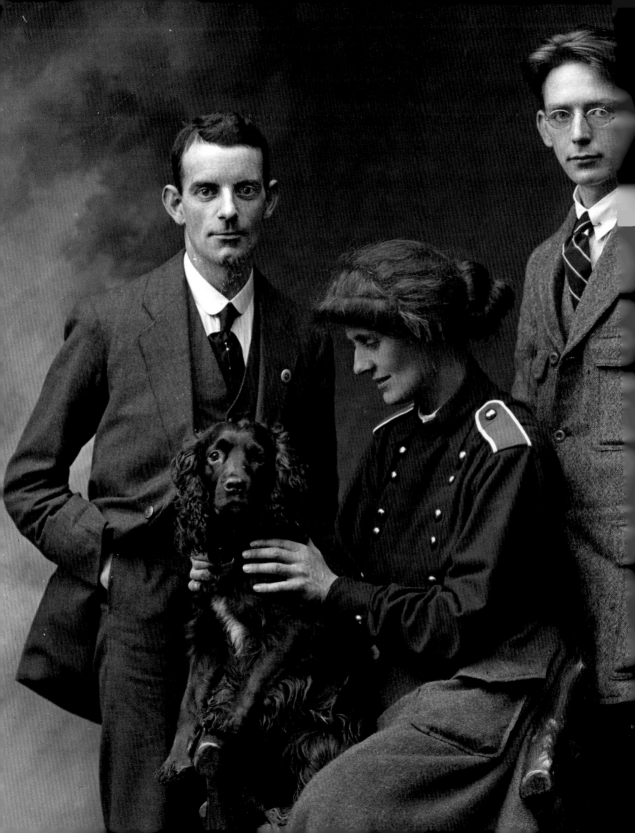

THE COUNTESS

1917, Co. Waterford

Countess Markievicz, born Constance
Georgine Gore-Booth, was a nationalist,
suffragist and socialist republican who
took part in the Rising and would go on
to become the first female MP. Pictured
here with her dog Poppet and Fianna
Éireann officers Thomas McDonald
(left) and Theo Fitzgerald (right).
Thanks to the Murphy family – the
grandchildren and great-grandchildren
of Theo Fitzgerald – for their help with
Theo's eye colour.

THE COUNTESS'S RELEASE

15 March 1919, Liberty Hall, Dublin City

A photograph taken of Constance Markievicz after her release from Holloway Prison, England, and her subsequent return to Dublin. She had been imprisoned for her role in anti-conscription protests in 1918. While in prison, in December 1918, she became the first female MP elected to the British Parliament. Pictured with her are key figures in the republican movement, including Madeleine ffrench-Mullen, Kathleen Lynn, Nora Connolly and Agnes Mallin. Markievicz was greeted by huge crowds in Dublin, which was widely reported in the press.

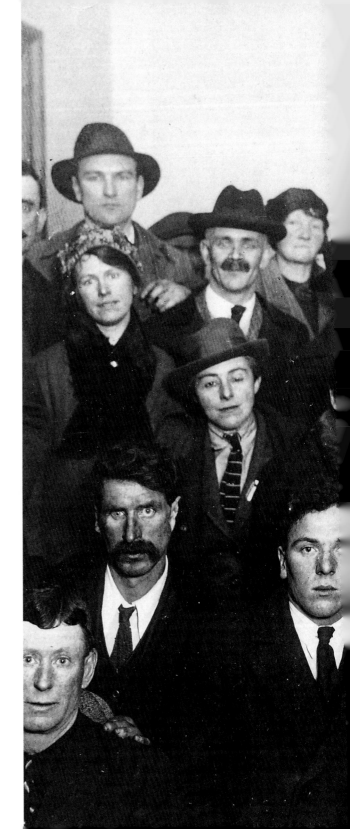

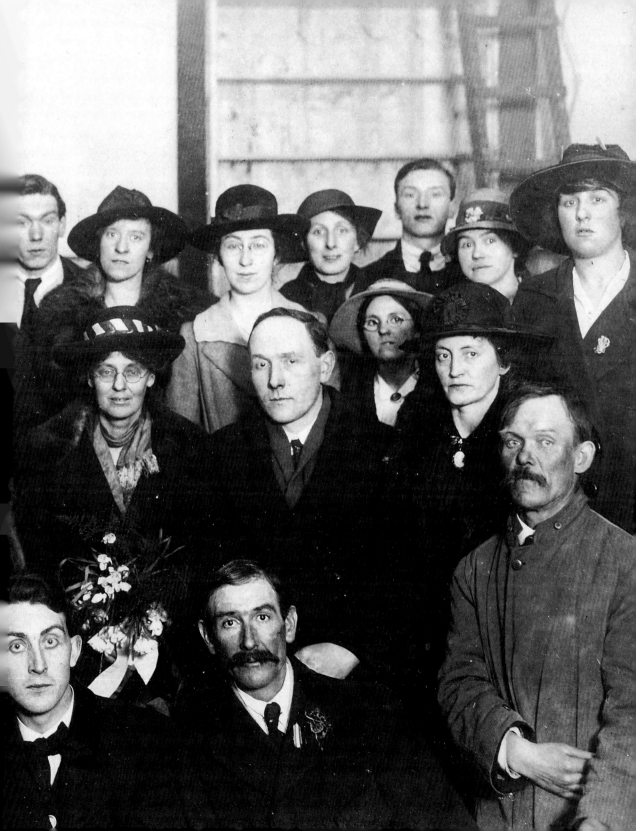

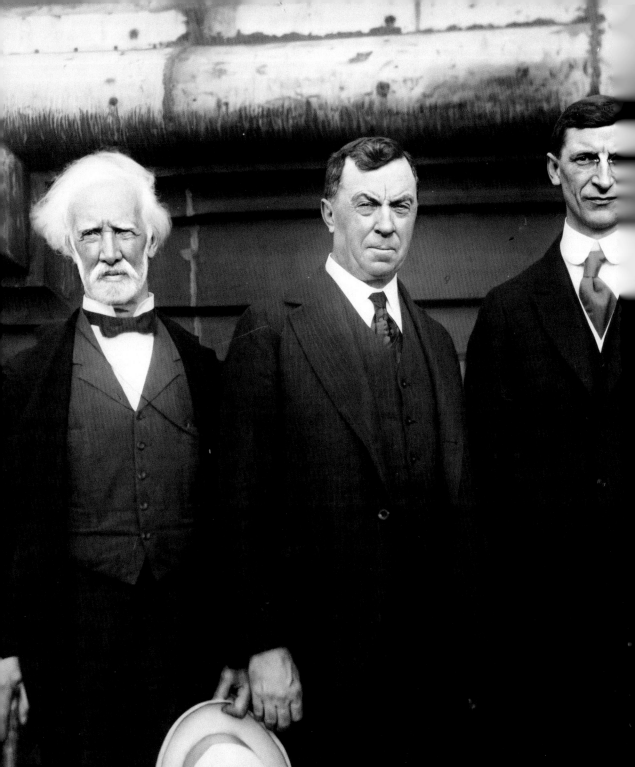

GOFF COHALAN DE VALE

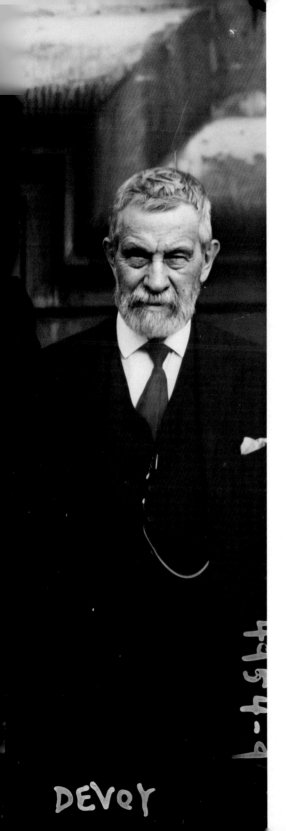

DEVOY

DE VALERA TOURS AMERICA

June 1919, Waldorf Astoria, New York City, USA

John W. Goff (1846–1924), Judge Daniel Florence Cohalan (1867–1946), Éamon de Valera (1882–1975) and John Devoy (1842–1928) pose together at the Waldorf Astoria, New York City in March 1919. Taken in the early stages of de Valera's American tour, as he sought to raise funds and gain political recognition for the nascent Irish Republic. He would later fall out with Cohalan and Devoy, who dominated Irish-American politics. De Valera remained at the centre of Irish politics and statescraft throughout his long career, which only ended in 1972. He was born in New York in 1882, and his mother, Catherine (Kate) Coll, was the daughter of a farm labourer from Co. Limerick. His father left the family when de Valera was 2 years old, and de Valera was sent to be raised by his grandmother in Bruree, Co. Limerick. A teacher and lecturer, in 1908 he joined the Gaelic League, and in 1910 he married his Irish-language teacher, Sinéad Flanagan. During the Rising, he was based at Boland's Mill; he was sentenced to death for his role in the fighting, but the sentence was commuted. He was elected Sinn Féin MP for East Clare in 1917 and re-elected as parliamentary representative for Clare at subsequent general elections until his election as President in 1959. He founded the Fianna Fáil party in 1926; from 1932 to 1937, he was President of the Executive Council of the Irish Free State, and from 1932 to 1948 he was Minister for External Affairs. He was Taoiseach three times, and on 25 June 1959 he was inaugurated as President of Ireland. He died on 29 August 1975.

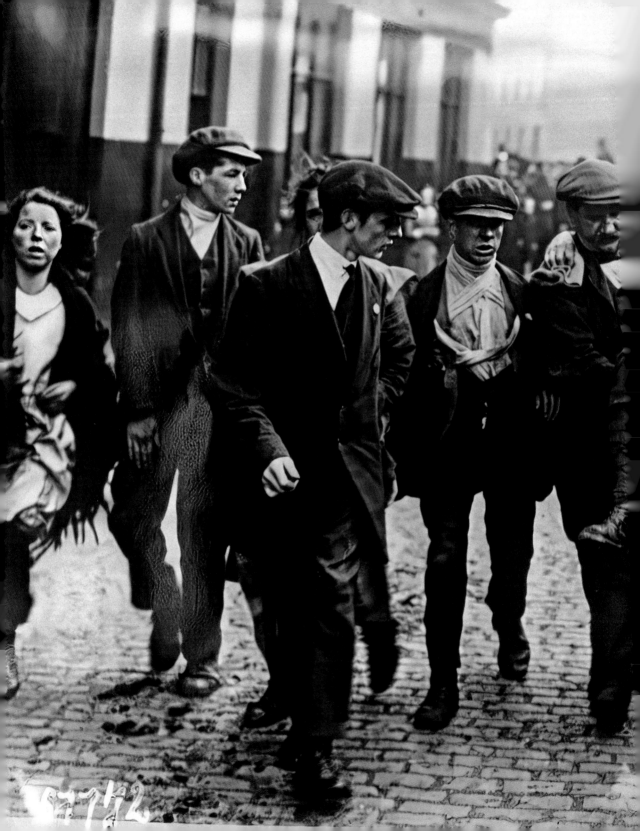

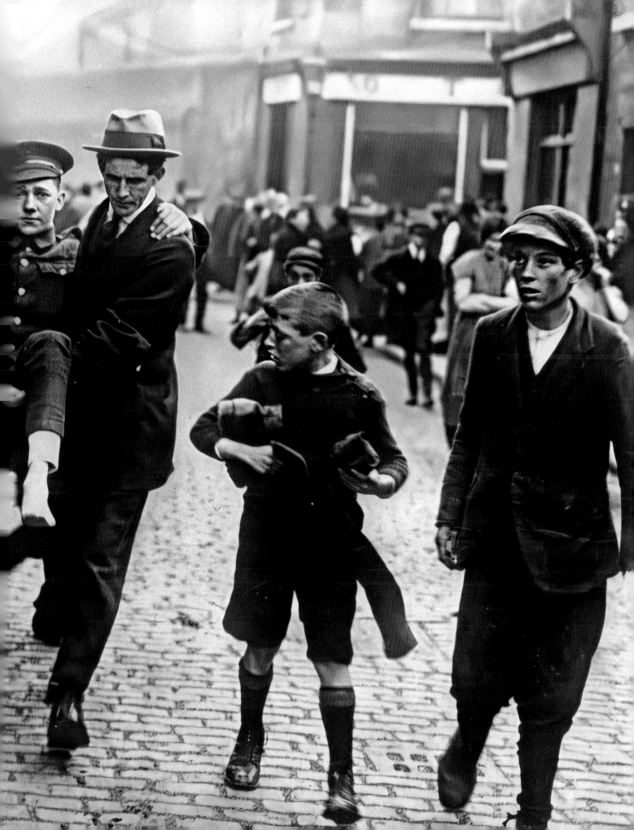

AFTERMATH OF A RAID

October 1920, Brunswick Street North, near Smithfield, Dublin City

This photograph depicts a wounded British soldier who is being carried along East Essex Street after a raid on a ration party. The boy to the soldier's left carries the soldier's legwear (puttees). It depicts, in many ways, a scene of solidarity during a time of war.

LILLIAN METGE (1871–1954)

*c.*1920

Lillian Metge was born in Lisburn, Co. Antrim, and was the co-founder of the Lisburn Suffrage Society. In 1914, she joined the Women's Social and Political Union (WSPU), an umbrella body for militant suffragettes, and she was arrested in August 1914 for her alleged role in the Lisburn Cathedral attack. While on trial, she went on hunger strike and was awarded a medal in recognition of this.

MAUD GONNE (1866–1953)

*c.*1901, Boston, USA

Maud Gonne MacBride was a noted political activist who was instrumental in the advancement of republican feminism in the early twentieth century. While often known for being the subject of much of the love poetry of W.B. Yeats, her influence on Irish nationalism went far beyond this association. She was actively involved in social justice and humanitarian campaigns in Dublin City throughout the revolutionary period, highlighting the effects of poverty on women and children particularly. She was deeply immersed in dramatic and literary circles in Dublin, and in 1900 she was a co-founder of Inghinidhe na hÉireann, who would be instrumental in placing republican feminism into the revolutionary movement. After her divorce from John McBride in 1906, she moved to France, returning just after the Rising. She continued her protest work and was imprisoned in 1918 for her supposed role in the 'German plot'. During the Civil War she took the anti-Treaty side and was involved in the republican movement for the remainder of her life.

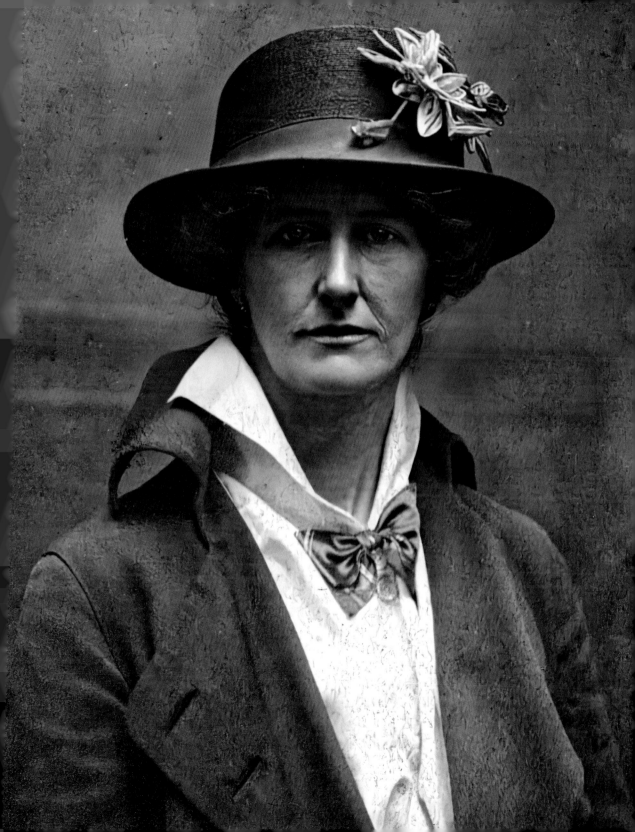

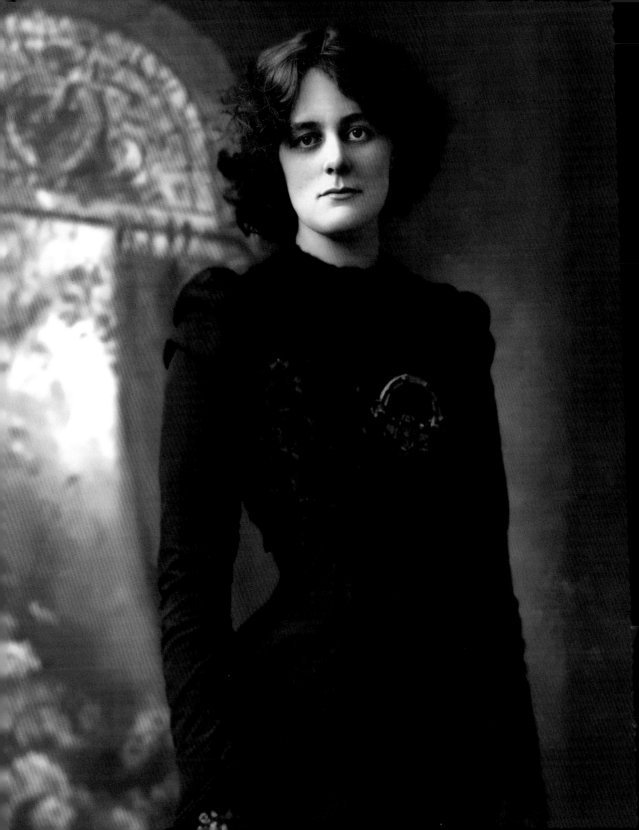

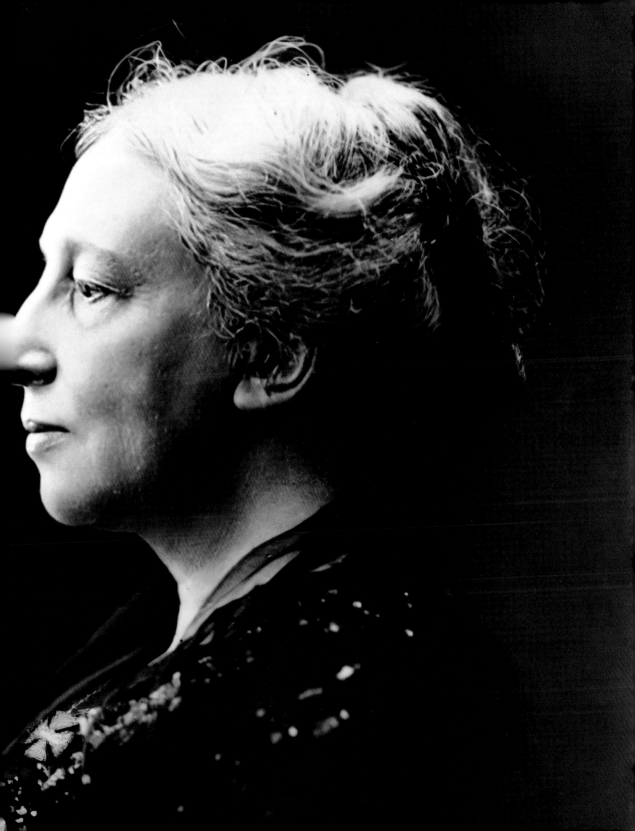

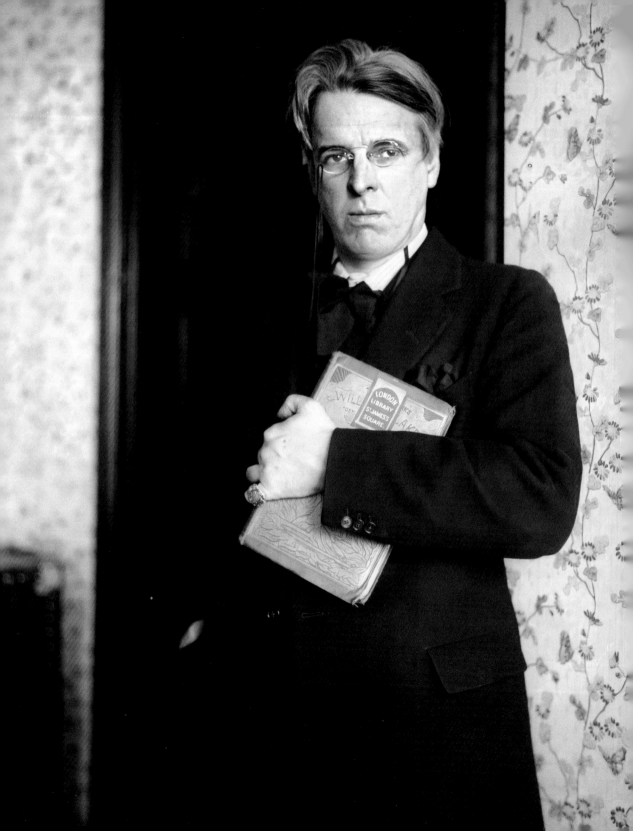

LADY GREGORY
(1852-1932)

1900–1910, USA

Isabella Augusta, Lady Gregory (née Persse) was an Irish dramatist, folklorist, theatre manager and one of the most prolific figures in Ireland's cultural revival. In 1880, she married Sir William Gregory of Coole. In the proceeding years, she would develop an interest in politics, journalism and language. From 1895, she became particularly engaged in Irish nationalism, learning the Irish language, and becoming active in the Gaelic League at a local level. These activities laid the basis for the intense friendship which she formed from 1896 with W. B. Yeats. Over the years, Gregory engaged in numerous literary collaborations with Yeats; her contributions were not always recognised at the time. She privately expressed resentment that *Cathleen Ní Houlihan* was not publicly acknowledged as their joint work, for example. With W.B. Yeats and Edward Martyn, she co-founded the Irish Literary Theatre and the Abbey Theatre and between 1904 and 1912 the Abbey staged nineteen original plays and seven translations by Gregory, and she was the company's most widely performed and popular author. During the 1902 reorganisation of the national theatre, Gregory became one of the three governing directors. She died on 22 May 1932 at Coole and was buried at Bohermore cemetery in Galway city.

WILLIAM BUTLER YEATS
(1865-1939)

1920, New York, USA

W.B. Yeats was an Irish poet and a key figure in the literary, cultural, and political scenes in nineteenth and twentieth century Ireland. He published his first works in the mid-1880s while a student at Dublin's Metropolitan School of Art. His works include *The Wanderings of Oisin and Other Poems* (1889) and *Words for Music Perhaps and Other Poems* (1932) and the plays *The Countess Cathleen* (1892) and *Deirdre* (1907). In 1923, he was awarded the Nobel Prize for Literature. This photograph shows Yeats in New York, possibly at the beginning of his lecture tour of the US and Canada. He holds a volume of the work of the English poet William Blake, with a label from the London Library on St James Square, and is wearing his butterfly ring on the little finger of his left hand.

LEINSTER HURLING FINAL

11 September 1921, Croke Park, Co. Dublin

The Dublin hurling team look on as a very happy Harry Boland smiles directly at the camera, while Michael Collins shakes hands with former GAA president Alderman James Nowlan. This photograph was taken on the day of the final. Dublin beat Kilkenny that day, on a scoreline of 4–4 to 1–5. The picture was taken during the time known as 'the Truce', between the War of Independence and the Irish Civil War.

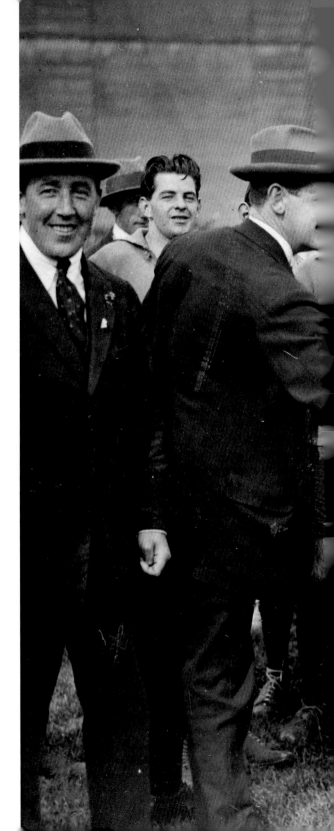

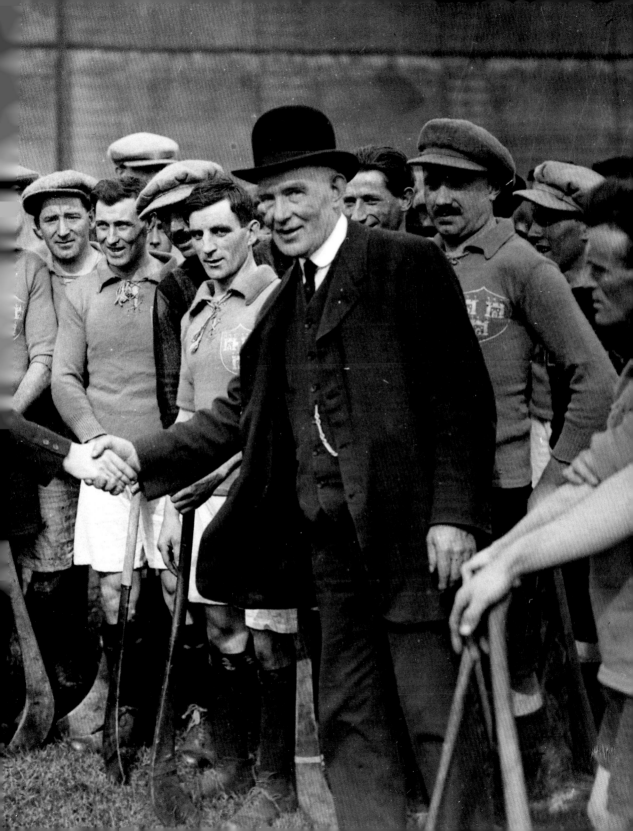

MICHAEL COLLINS
(1890–1922)

1922, Co. Dublin

Michael Collins was born in the townland
of Woodfield, near Clonakilty, Co. Cork
in 1890. The youngest of eight, he moved
to London when he was 16 to become
a clerk in the Post Office Savings Bank.
He became radicalised through his
involvement with the GAA and the Gaelic
League, and was sworn into the IRB.
Collins left London for Dublin
in 1916 and participated in the Rising.
Following his release from Frongoch
Camp, Collins served on the executive
councils of the IRB, Sinn Féin and the
Irish Volunteers. He was elected to the
First Dáil as Minister of Finance. Within
the IRA he was a key leader of the
General Headquarters in Dublin, taking
on the Intelligence portfolio. After helping
negotiate the Anglo-Irish Treaty in
London, he became the Chairman of the
pro-Treaty Provisional Government. He
was commander-in-chief of the National
Army when killed in a roadside ambush at
Béal na Blá on 22 August 1922.

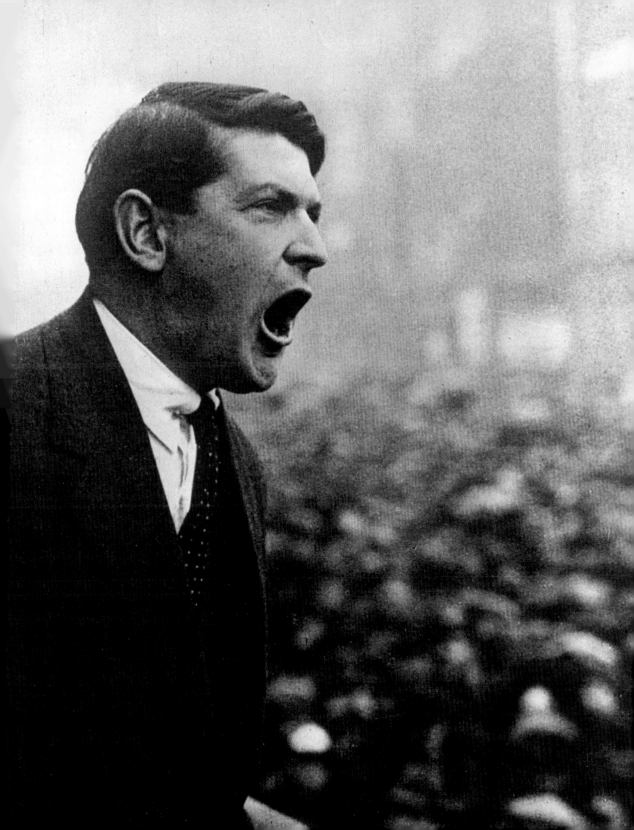

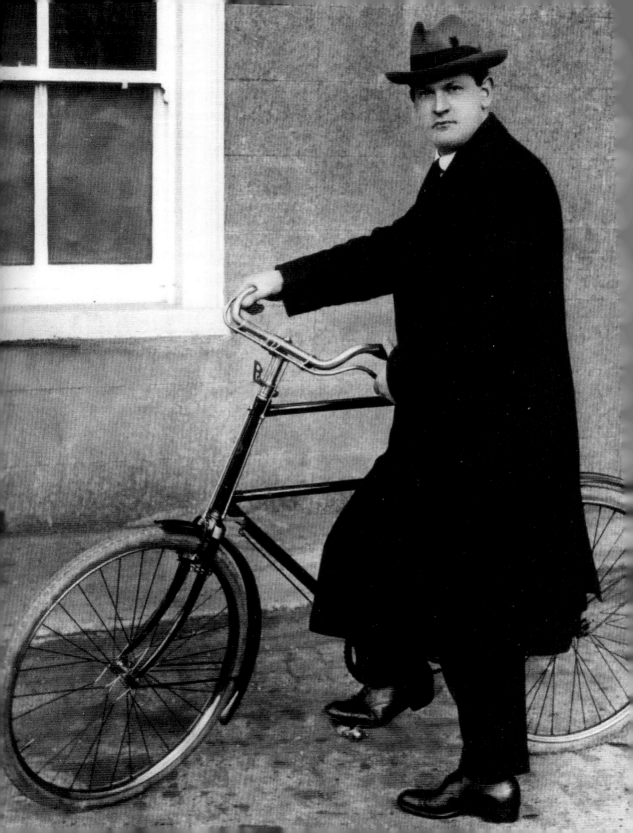

CYCLE COLLINS

Michael Collins was an Irish revolutionary, soldier, and politician, who also served as Joseph Plunkett's aide-de-camp at the GPO during the 1916 Easter Rising. He is pictured here with a Pierce high nelly bicycle, presented to him when he visited the Pierce & Co. factory in Wexford in April 1922. The bicycle had become a chosen form of transport for many from the nineteenth century and was important during the revolutionary period.

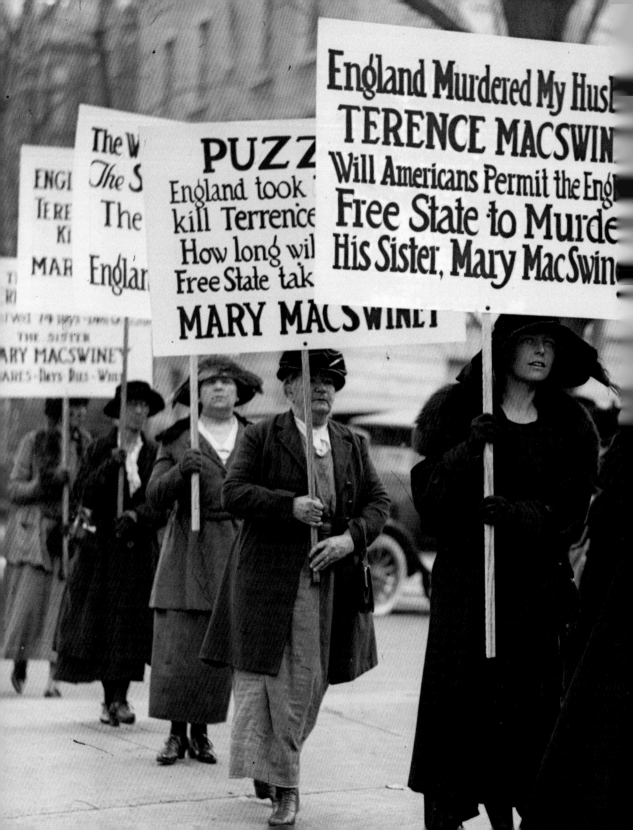

MURIEL MURPHY MacSWINEY (1892–1982)

14 November 1922, USA

Muriel Murphy was born in 1892 in Cork City to a wealthy Catholic family – the owners of Cork distilleries. The youngest in the family, she was educated in an English convent in Sussex, and in 1915 she met Terence MacSwiney, who would go on to be the Lord Mayor of Cork. The couple married in June 1917 and Muriel gave birth to a daughter, Máire, in June 1918. Much of their four years together was spent apart, Terence being arrested several times. On 25 October 1920, Muriel's husband Terence, the Lord Mayor of Cork, died after seventy-four days on hunger strike. The strike had been very traumatic for Muriel, with at one point herself and Terence's sisters being accused of feeding him. Afterwards, Muriel travelled to the United States to promote the republican cause and became the first woman to receive the Freedom of New York City. This photo was taken during the Irish Civil War in 1922, as she demonstrated in support of her sister-in-law Mary MacSwiney's hunger strike. She left Ireland for Europe with her daughter Máire in 1923, but they spent long periods apart. Máire returned to Cork City, and Muriel lost a subsequent court custody in 1934. She was later involved with French intellectual Pierre Kaan and had a daughter, Alix. Muriel died in 1982.

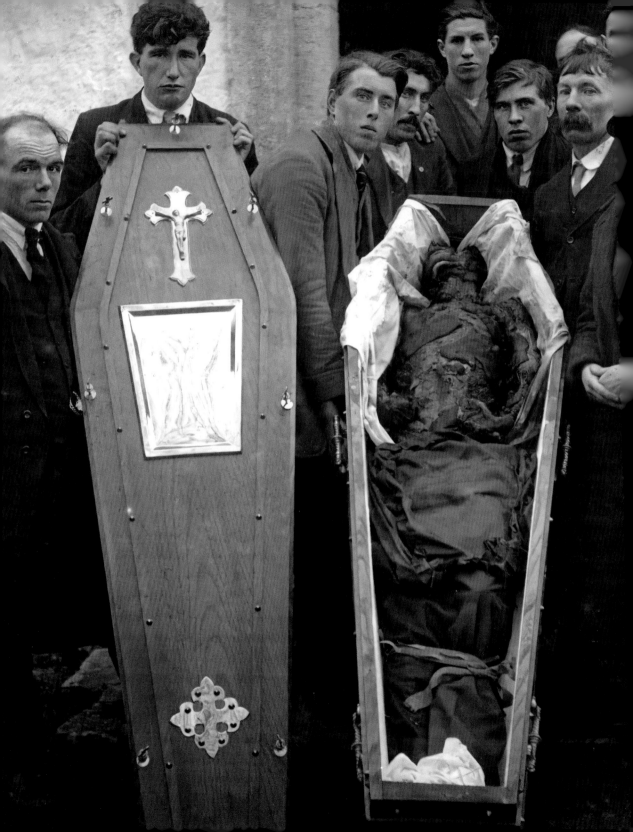

WAR OF INDEPENDENCE DEAD

December 1920, Shanaglish, Co. Galway

The burned remains of one of the Loughnane brothers. On 26 November 1920, brothers Pat and Harry Loughnane were taken from their family farm in Shanaglish by Auxiliaries. After being tortured and murdered, their bodies were burned. The brothers had been members of local Sinn Féin, Volunteer and GAA branches. The coffin, and lid, are being propped up towards the photographer by a group of men; the shroud has been pulled back from the upper half of the body and the legs are crudely tied together with a strap. Their bodies were found burnt and mutilated between Kinvara and Ardrahan early in December 1920.

FREE STATE GENERALS

*c.*July 1922, believed to be in Limerick City

Senior leaders of the National Army involved in the conventional fighting around Munster in July/August 1922. From left to right, Generals Eoin O'Duffy (future commissioner of an Garda Siochana), Dermot MacManus, Michael Brennan (future National Army Chief of Staff), Fionán Lynch (future Cumann na nGaedheal government minister), and W.R.E. Murphy (last commissioner of the Dublin Metropolitan Police).

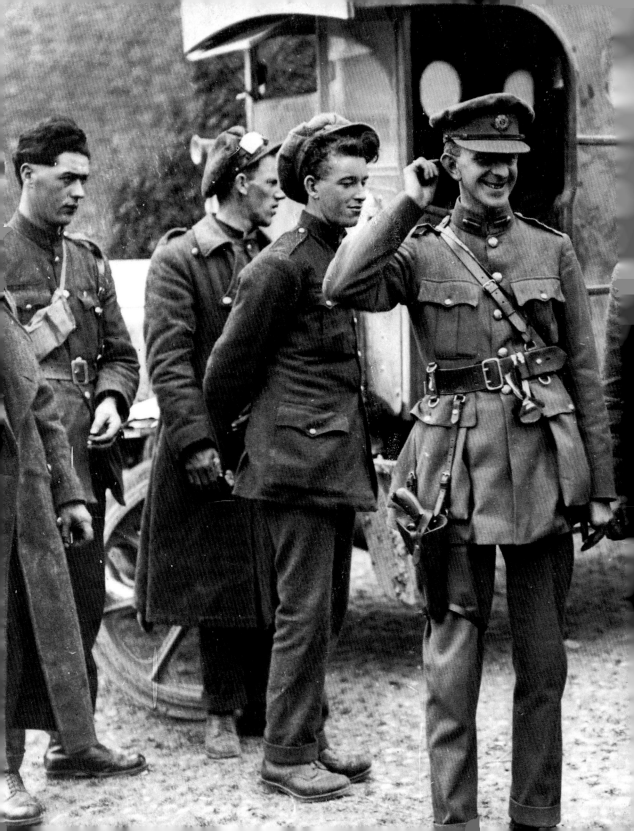

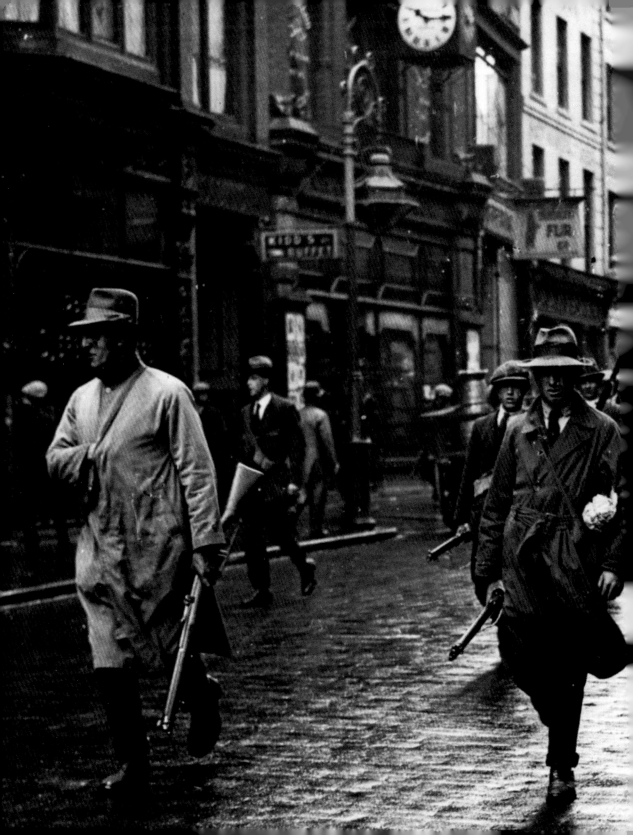

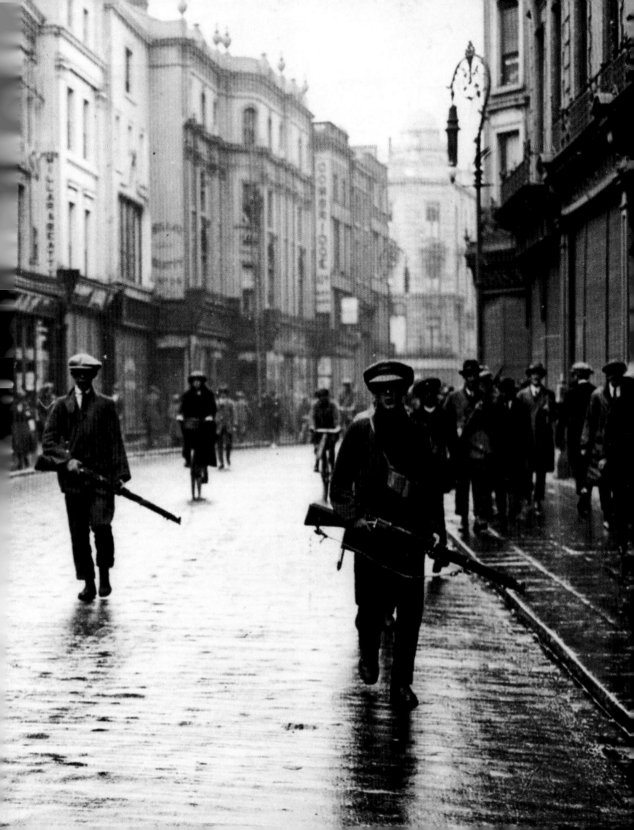

REPUBLICANS IN GRAFTON STREET

1922, Grafton Street, Dublin

A unit of anti-Treaty IRA men, referred to as 'Irregulars' by Irish Free State forces, is photographed patrolling Grafton Street in Dublin's city centre on the brink of the Irish Civil War. Likely from the Dublin Brigade, some of these republicans can be seen carrying Lee Enfield rifles.

AUXILIARIES

*c.*1920, Dublin City

A photographic print of two armoured cars of Black and Tans and Auxiliaries (six in the first vehicle, eight in the second) outside Amiens Street Station while several men look on. These were members of 'I' Company Auxiliaries, under Platoon Commander C.E. Vickers (beside driver of first vehicle). A handwritten caption on the mount reads 'Black and Tans leaving Amiens St Station, about to begin their work of destruction on the streets of Dublin'. Amiens Street Station was renamed Connolly Station in 1966. The print was exhibited as part of 'From Turmoil to Truce, photographs of the War of Independence', 19 November 2019–May 2020, at the National Photographic Archive.

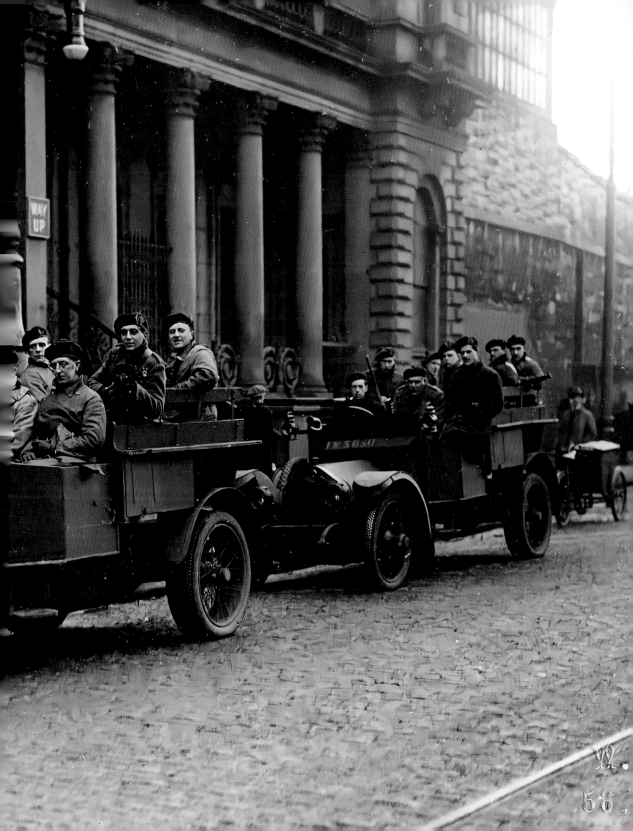

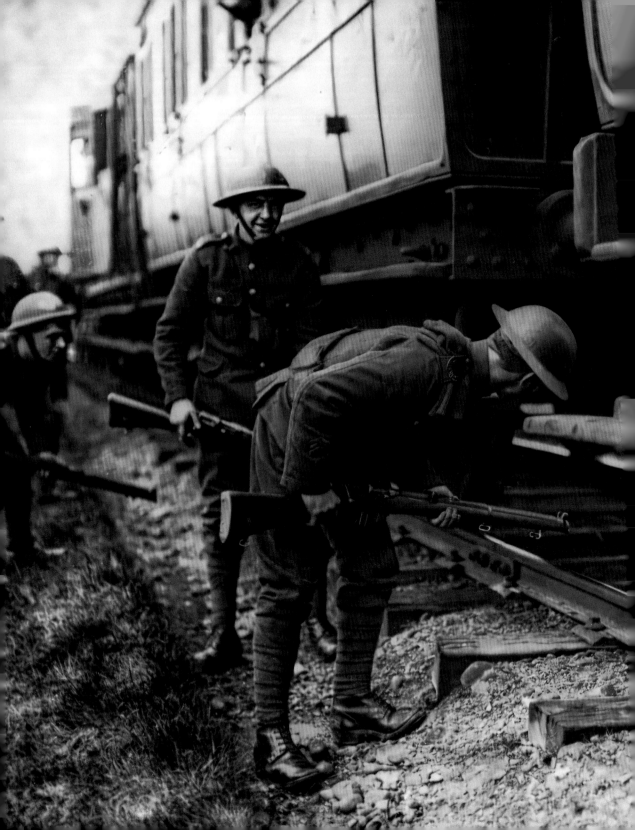

HIDE AND SEEK

*c.*1921, Co. Kerry

This image depicts British soldiers searching trains on the Kerry line for republicans. We chose khaki as per British uniforms worn around this time and in the First World War. The helmets are a greenish colour and regiment shoulder titles and buttons are gold as per photos of period items. We enhanced the sky to be more blue and fixed various blemishes on the photo using Photoshop.

UP SINN FÉIN

12 April 1920, Dublin City

This slogan can be seen chalked on the side of the Austin Peerless armoured car outside Mountjoy Prison during the 1920 Mountjoy Hunger Strike. On the wall in the background is a poster for the Labour Exchange. Scores of republican prisoners went on hunger strike in Mountjoy on 5 April 1920. Within days, their campaign attracted intense national interest and drew massive crowds of supporters to the prison (which can be seen in the background). The trade union movement and Sinn Féin organised a successful general strike across most of Ireland on 13 April. The concerned governor of Mountjoy offered the prisoners political status, but their spokesman Peadar Clancy insisted on a general release. The following day, sixty-six prisoners were released, handing the republicans a great symbolic victory.

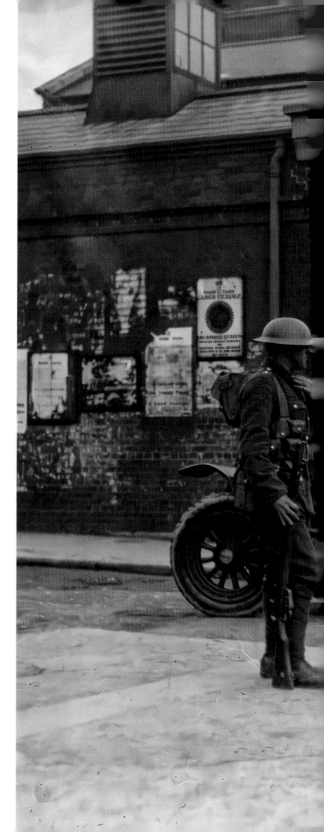

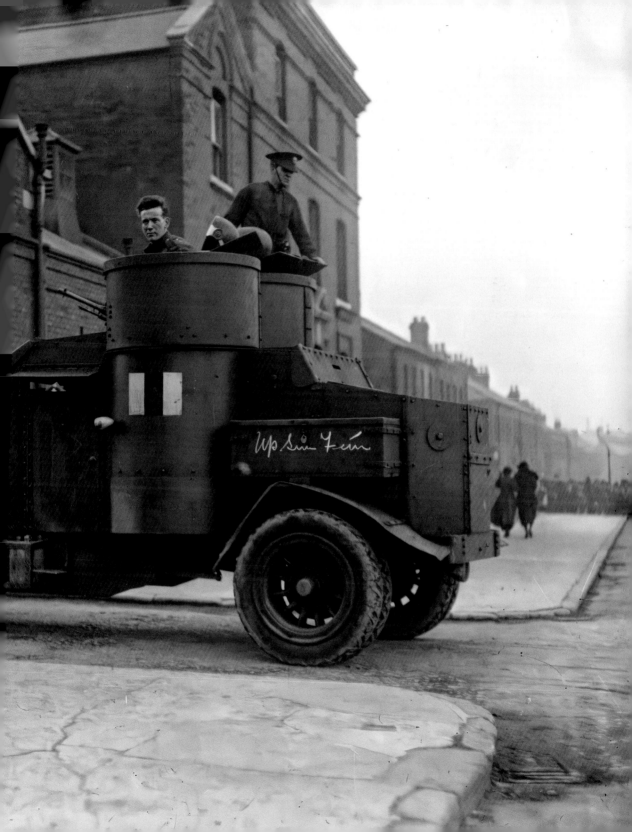

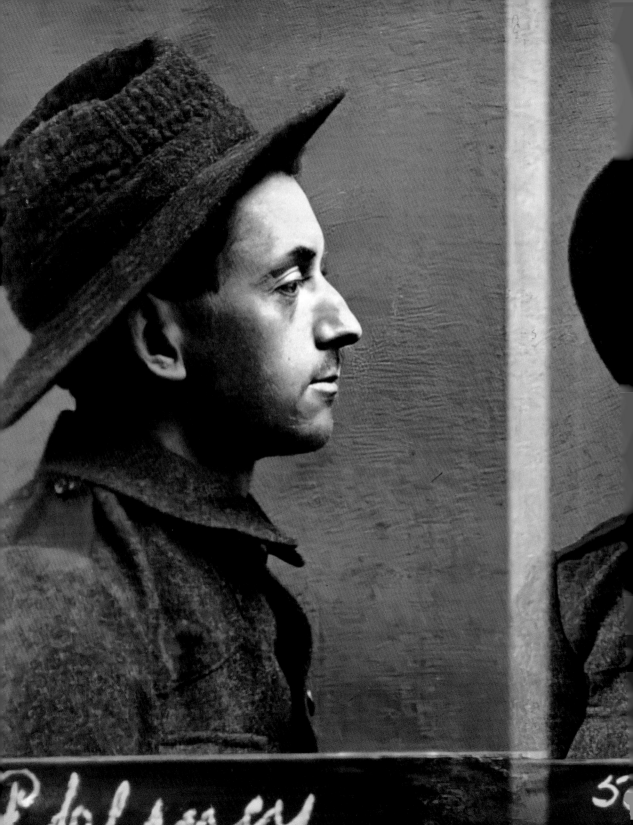

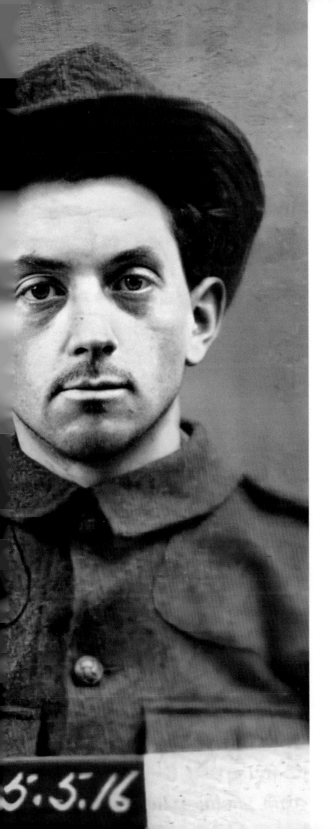

PEADAR CLANCY

5 May 1916, Dublin City

Peadar Clancy was a republican and member of the Irish Volunteers who served in the Four Courts garrison during the Rising. He was second-in-command of the Dublin Brigade of the IRA during the War of Independence and took part in the 1920 Mountjoy Hunger Strike. He was shot dead by British guards while under detention in Dublin Castle on the eve of 21 November 1920, also known as Bloody Sunday.

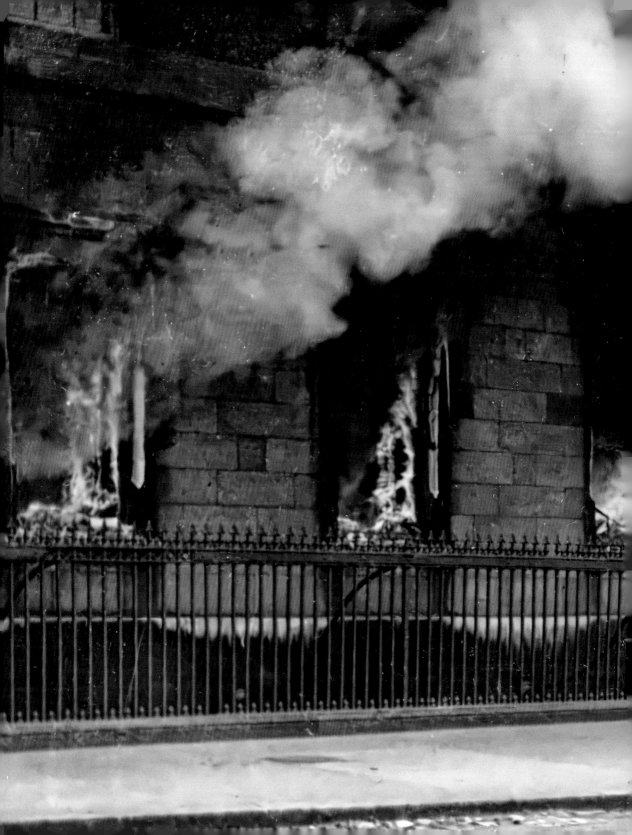

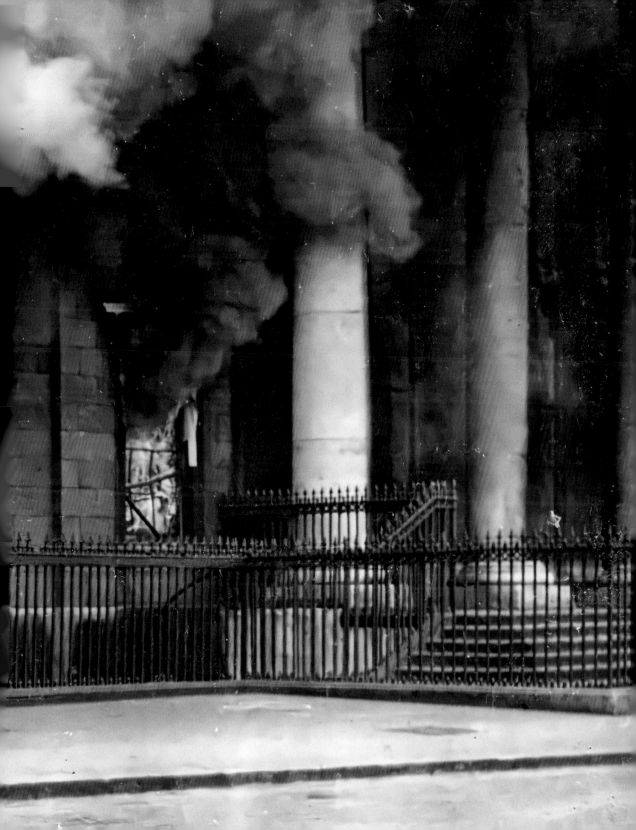

BURNING OF THE CUSTOM HOUSE

25 May 1921, Dublin City

The burning of the Custom House, the heart of the British administration in Ireland, by the Dublin Brigade of the IRA had significant short-term and long-term effects. A total of 111 people were arrested, nearly eighty being IRA members. The building burned for five days and was all but destroyed by the fire. With it, many centuries of local government records were also destroyed.

REMEMBRANCE

15 August 1923, Leinster House Lawn, Dublin City

Irish tenor singer John McCormack laying a wreath at the new cenotaph erected to the memory of Irish republican leaders Michael Collins and Arthur Griffith. The cenotaph was poorly constructed and was later replaced.

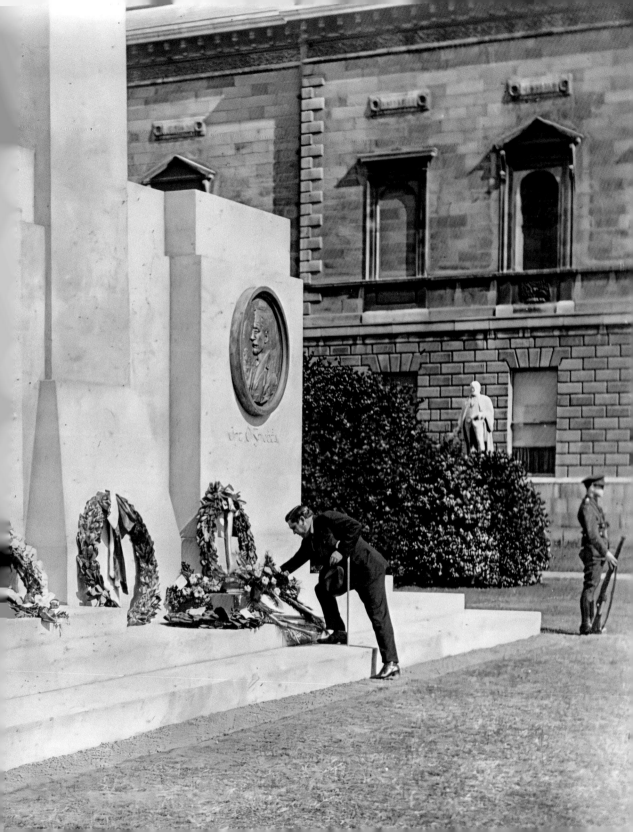

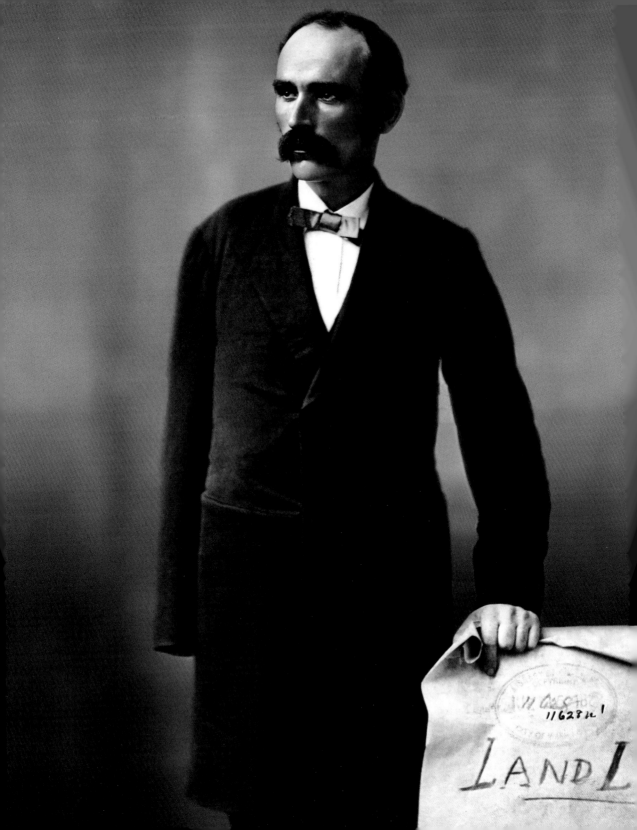

LAND L
11628u

SOCIETY AND CULTURE

THE LAND FOR THE PEOPLE

*c.*1882, New York City

Michael Davitt (1846–1906), was born in
Co. Mayo, the second of five children. At the
age of 4, Michael and his family were evicted
from their home and forced to migrate to
Lancashire, England. At the age of 11, while
working in a cotton mill, Davitt had his arm so
badly maimed in an accident that it had to be
amputated. Davitt was the founder of the Irish
Land League in 1879. The league organised
resistance to absentee landlordism and sought
to relieve the poverty of tenant farmers by
securing fixity of tenure, fair rent, and free sale
of the tenant's interest.

THE FIRE BRANDS

3 June 1887, Bodyke, Co. Clare

This photograph was taken at the Bodyke
evictions. Father Murphy, who wrote an
account of the evictions, is pictured on the
right. This image was taken one day after
Mrs MacNamara, a widow, was evicted from
her home, one of a number of evictions to
take place in the area. Commenting on the
background to the picture, the photographer
claimed the first sheriff, McMahon, had turned
up with a large force several days earlier but
had an epileptic fit and the police withdrew.
The tenants saw this as divine intervention and
made this effigy of him:

> PRAISE THE LORD
> FOR HERE
> THE TYRANT'S ARM WAS
> PARALYSED

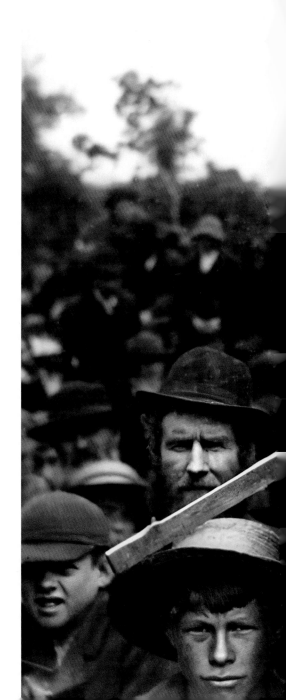

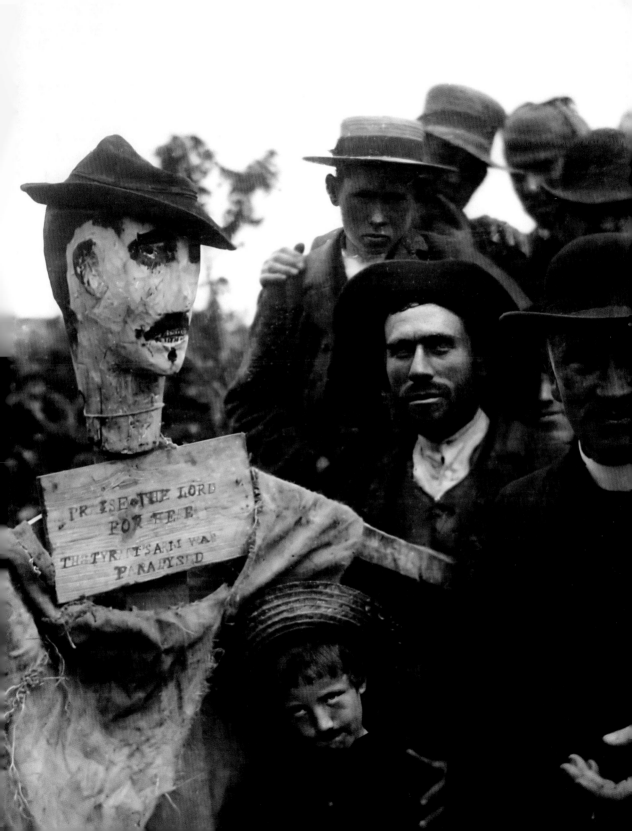

RESTING

12 February 1870, Clonbrock Estate, Ahascragh, Co. Galway

Two Clonbrock workmen – one with a billhook, a traditional cutting tool used widely in agriculture and forestry for cutting smaller woody material such as shrubs and branches. Lord Clonbrock was listed as a resident proprietor in Co. Galway in 1824, and in the 1870s the Clonbrock estate in Galway amounted to over 28,000 acres.

EVICTION

1 September 1888, Woodford, Co. Galway

An eviction on the land of the Marquis of Clanricarde. Pictured is Francis Tully, known locally as 'Dr Tully', an activist for the Plan of Campaign in Galway. The Plan of Campaign was an attempt to gain lower rents through collective bargaining after prices for agricultural exports had fallen dramatically in the 1880s. Maud Gonne agitated for change by projecting images like this one onto a building in Parnell Square, Dublin.

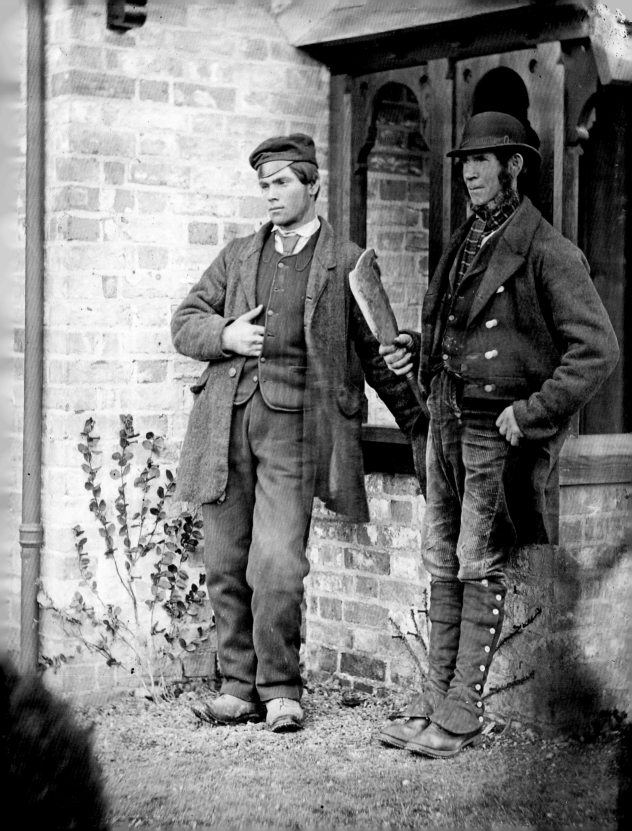

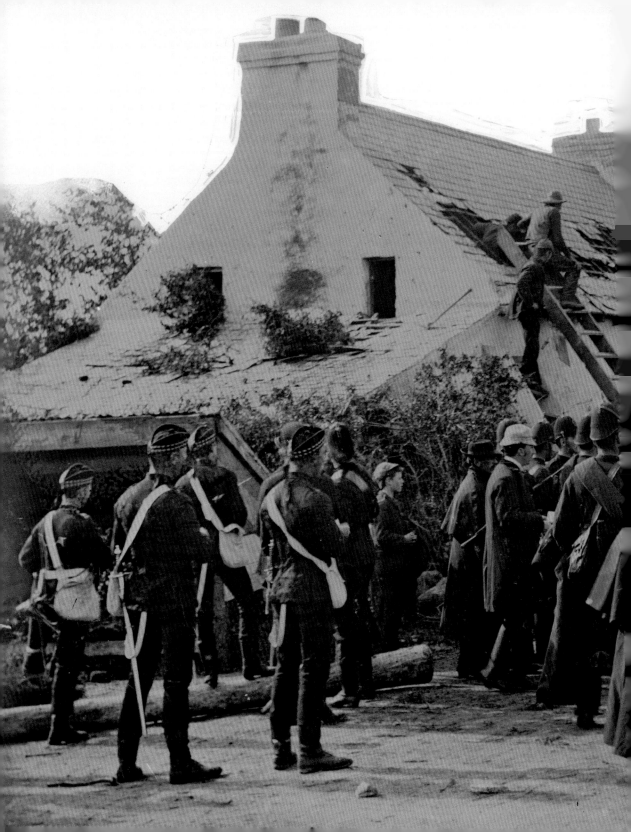

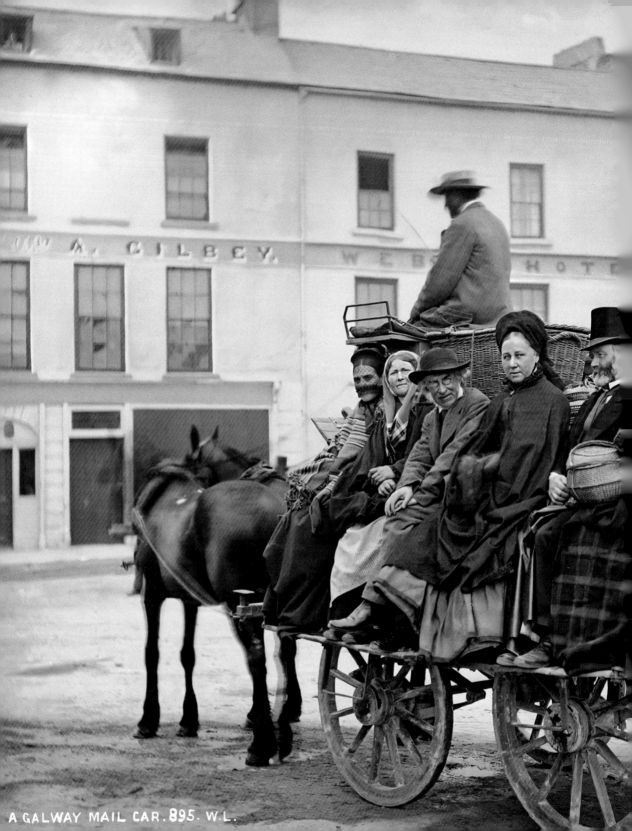

A GALWAY MAIL CAR. 895. W.L.

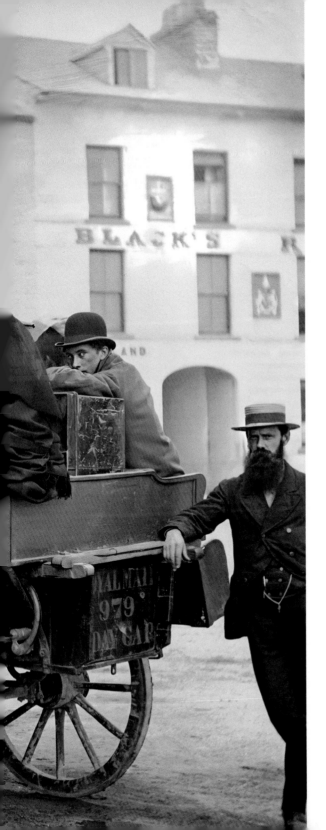

YOU'VE GOT MAIL

27 August 1886, Eyre Square, Galway City

A Royal Mail 979 Day Car, or a Bianconi mail car, near Webb's Hotel (now the Imperial Hotel) and Black's Royal Hotel in Eyre Square. Black's Royal Hotel was a noted Galway landmark. An advertisement published in 1879 announced that it was 'established 70 years', that it was 'patronised by nobility and gentry', and that it offered guests 'Free omnibuses to and from trains and steamers'. Tourism had received a boost with the opening of the railway from Dublin in 1851, but the city of Galway struggled economically, which is reflected in the decline of its population – from 23,744 in 1851 to 13,255 in 1911.

THE BALLAD SINGER

*c.*1890, Newtown Castle, Ballyvaughan,
Co. Clare

A ballad singer pictured here with
his mother. The paper the son is
holding is a printed verse with the
heading 'Lines on the Scenery round
St. Bridget's Well in County Clare'.
Newtown Castle is a sixteenth-
century fortified tower house, built
originally for a branch of the O'Briens
and passing thereafter into the
possession of the O'Loghlens.

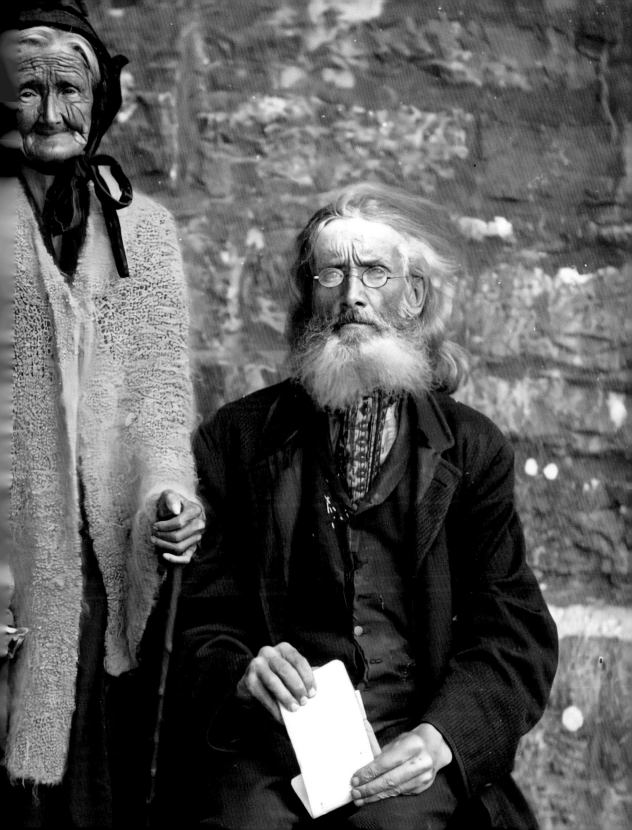

WEIGHED

*c.*1908, Clifden, Co. Galway

A weigh station, where the contents of
a woman's panniers are being calculated.
Foyle's Hotel is in the background, on
the right. Foyle's is Connemara's longest
established hotel, having been owned and
managed by the Foyle family for nearly
a century.

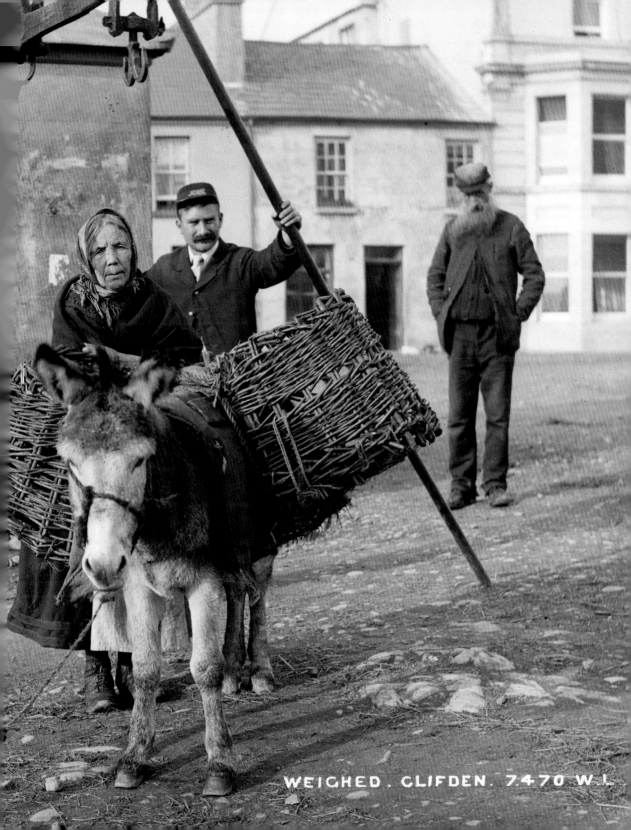

WEIGHED. CLIFDEN. 7470 W.L.

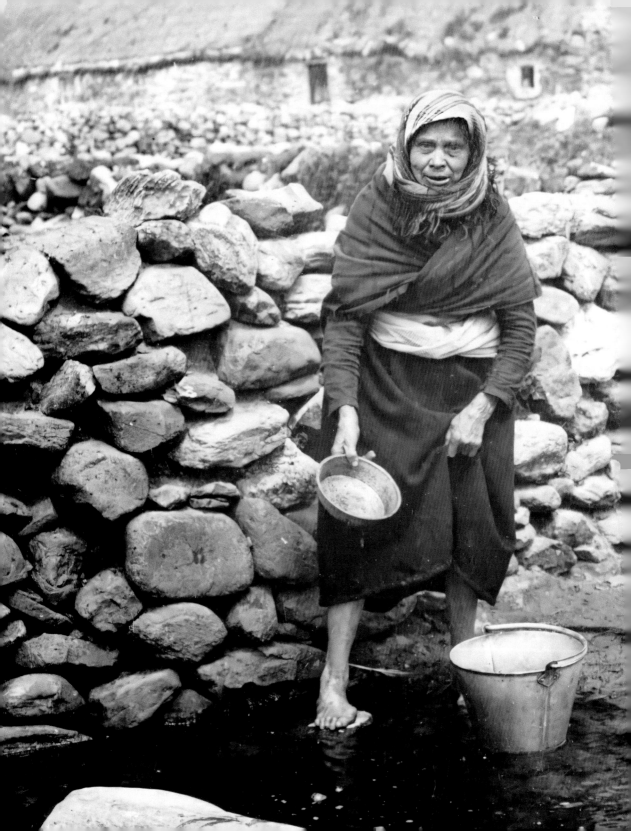

WOMAN FROM KEEL

*c.*1903, Achill Island, Co. Mayo

The woman is standing with a bucket in front of a stone wall. She is barefoot. Achill Island mostly survived on seasonal migrants in the nineteenth and early twentieth centuries. Conditions were harsh, particularly in the winter months. In the early twentieth century, Achill had a population of approximately 4,800 to 5,000 people.

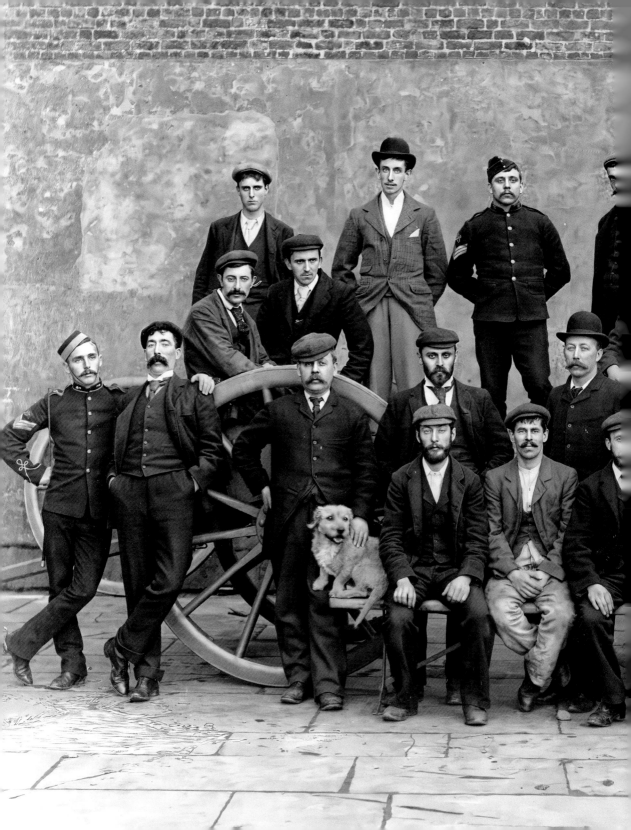

BRIGADE TRADESMEN

3 November 1899, Co. Waterford

This photograph includes three soldiers from the Royal Field Artillery and one from the Army Ordnance Corps, as well as tradesmen and possibly reservists. We consulted British military uniform experts and discovered that the soldiers would have worn dark blue uniforms with red collars and golden yellow on the badges, buttons, trefoil knots, shoulder straps and chevrons.

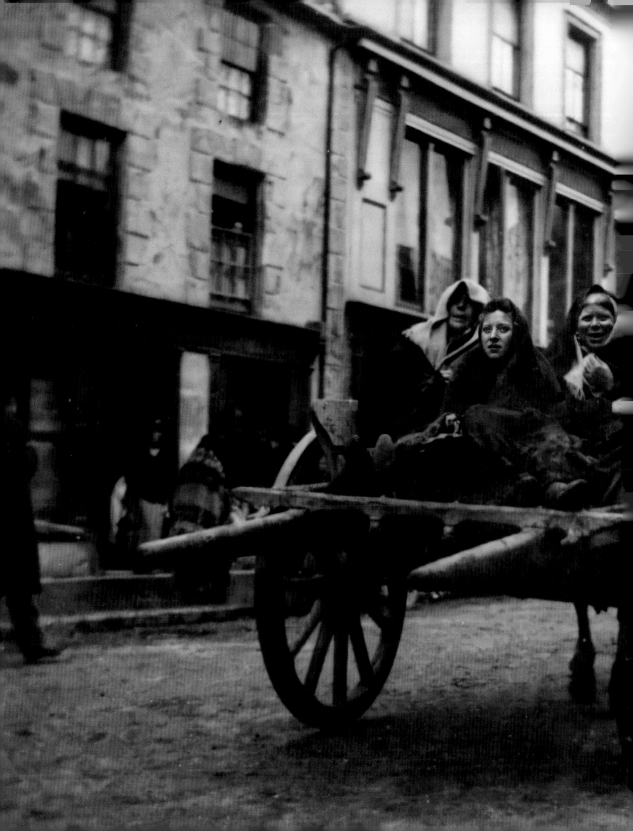

GOING TO A FUNERAL

*c.*1899, Killarney, Co. Kerry

This image is titled 'Irish women going to a funeral' in its original collection. The three women are in a horse-drawn cart, and while two are quite serious, one is smiling, possibly at the photographer. We believe that the photograph was taken on High Street, Killarney. The photographer was Frances Benjamin Johnston, an American photographer and photojournalist. She also photographed the signing of the peace protocol of the Spanish-American War, as well as various famous Americans including George Washington Carver, Booker T. Washington, and Theodore Roosevelt's family.

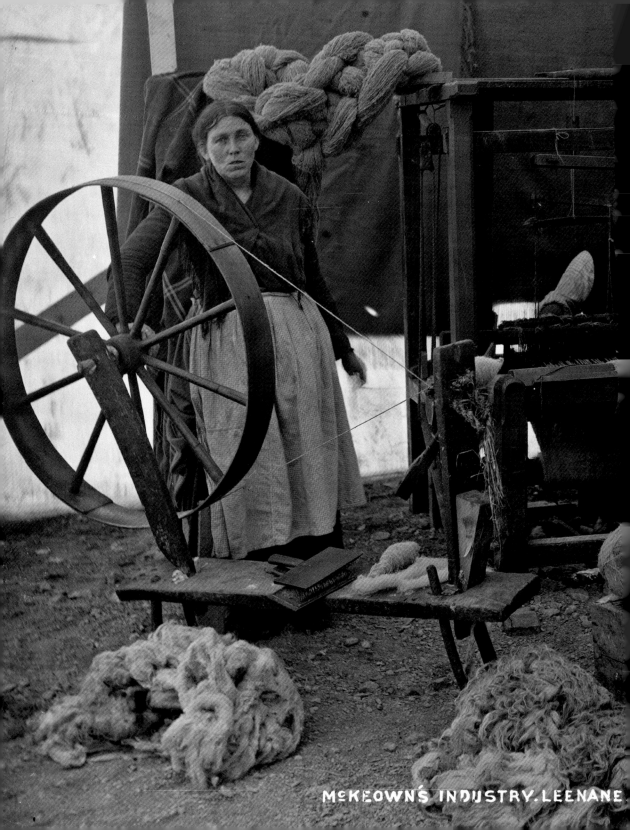

McKEOWN'S INDUSTRY. LEENANE

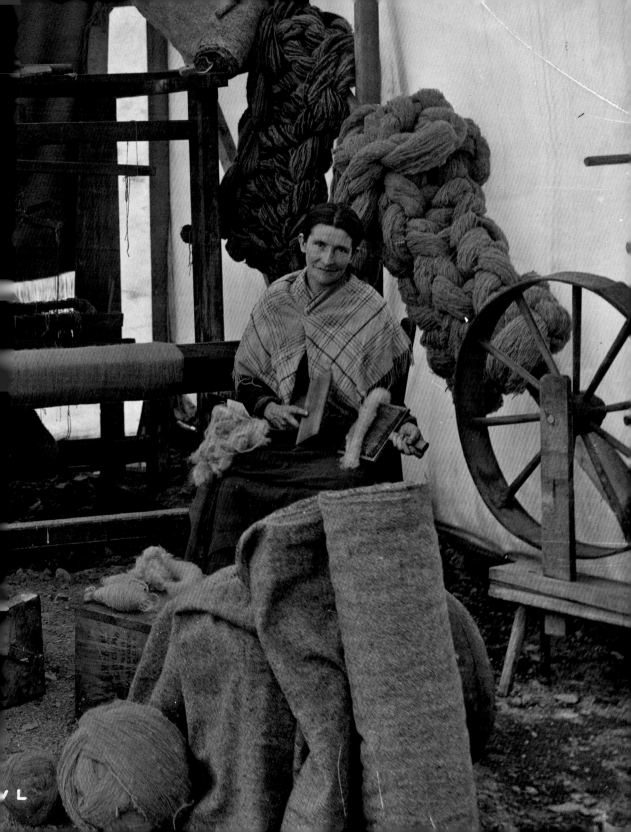

SPINNING, WEAVING AND CARDING

1902–1914, Leenane, Co. Galway

Taken in the early twentieth century, this photo depicts work in McKeown's Industry, which employed almost three hundred workers at the time, approximately half of them women. Finished woollen products as well as different stages of textile production are visible.

FOX HUNTING

1913–1914, Longueville House, Mallow, Co. Cork

This image depicts Mr J.P. Longfield, 'Master of Fox Hounds', on his horse, surrounded by hounds, about to go on a hunt. Fox hunting originated in the sixteenth century in the form that was practiced legally until 2005 in Great Britain. It is still legal in Ireland.

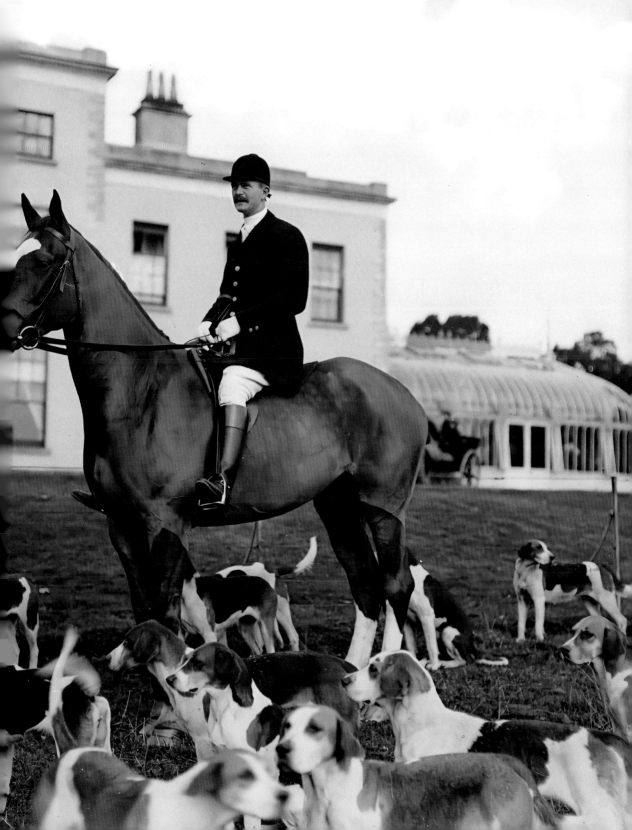

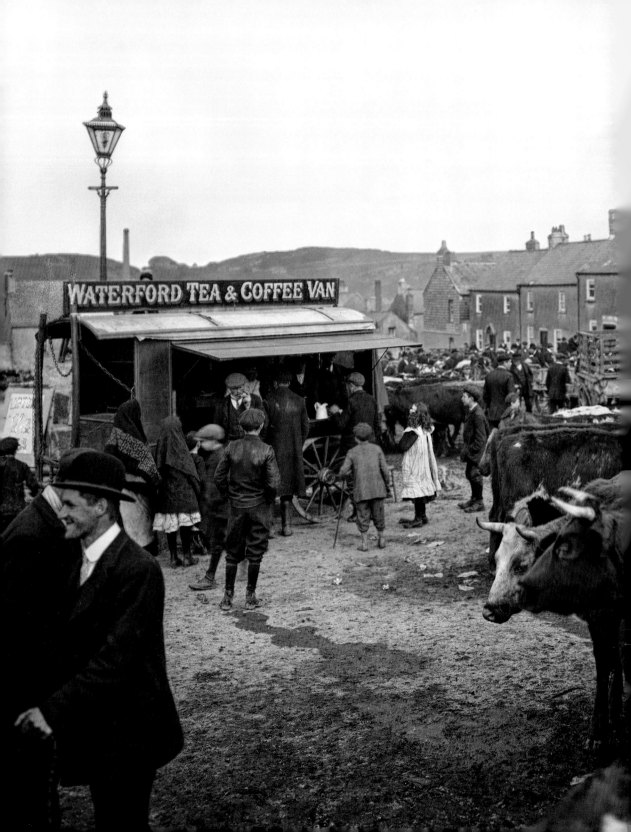

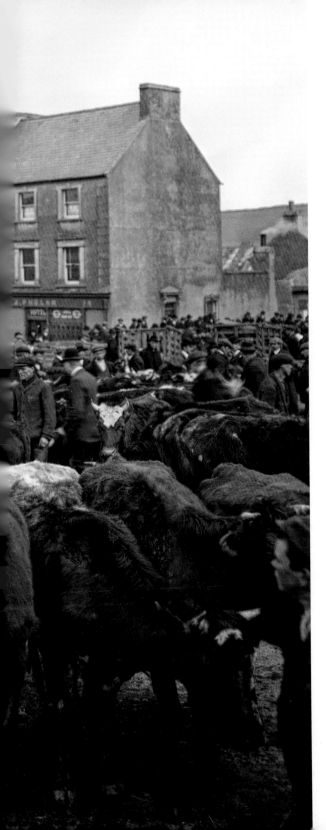

FAIR DAY

4 May 1910, Ballybricken, Waterford City

One of the earliest references to the existence of a market in Ballybricken was in 1680 when the Market House outside Saint Patrick's Gate was mentioned. Ballybricken became the centre of the pig and bacon industry in Waterford in the nineteenth and early twentieth centuries when fairs were a critical part of the agricultural economy and social life. M.J. (Michael J.) Phelan's Hotel is seen in the background at no. 14. Poole Photographic Studio scratched out some of the sign behind the van, which reads 'Lipton's Tea 1s/4d'. Poole also adjusted the top of the van, so the sign was not obscured.

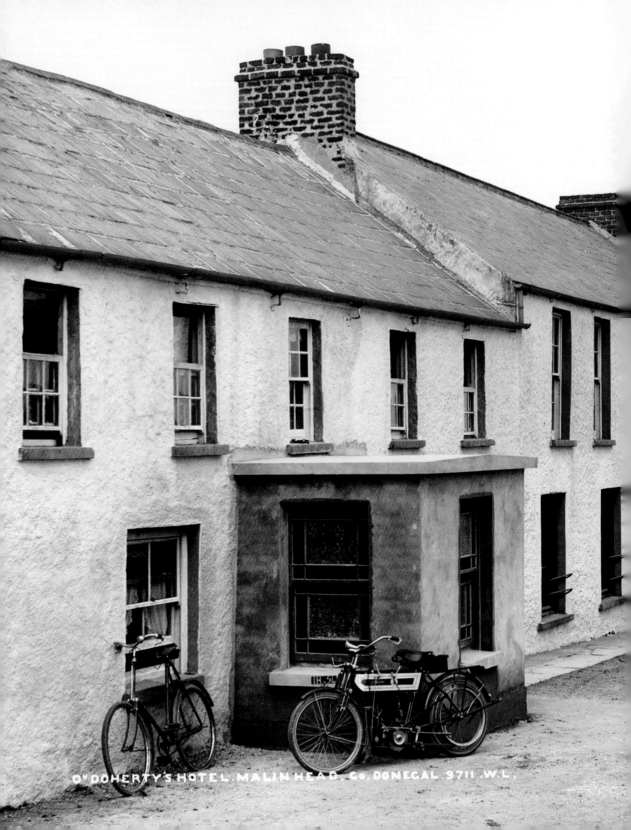

O'DOHERTY'S HOTEL MALIN HEAD. Co. DONEGAL 9711 .W.L.

AN EARLY AUTOCYCLE!

1907–1911, Malin Head, Co. Donegal

A Triumph 3.5 horsepower motorcycle/autocycle on view outside Margaret Doherty's Hotel. Malin Head is located on the Inishowen Peninsula and is the most northerly point of mainland Ireland.

WINNING OARSMEN

*c.*1885, Waterford Boat Club, Waterford City

Waterford Boat Club was established in 1878 and is the oldest sports club in the city. The Irish Amateur Rowing Union was established at a meeting in the Grosvenor Hotel, Westland Row, Dublin on 3 February 1899. It was an association of the clubs in Irish rowing and its aims were to put the organisation and control of the sport on a proper footing, both nationally and internationally.

FUNNY GEORGE CLOWNING AROUND

*c.*1911, Strabane, Co. Tyrone

The circus has its roots in eighteenth-century equestrian trick-riding feats, and its heyday was in the Victorian era. When this photograph was taken in 1911, John Duffy's Circus was being run by his wife Ann, who took over the business after John Snr died in 1909. In 1914 the brothers and sisters took charge and began touring as the Duffy Family Circus. They toured for three seasons before creative differences and family divisions caused them to split in 1917 into three separate companies. Today, Tom Duffy's Circus is currently being run by Tom's son David. The family tradition stretches back to David's great, great grandfather, Patrick James Duffy in the nineteenth century.

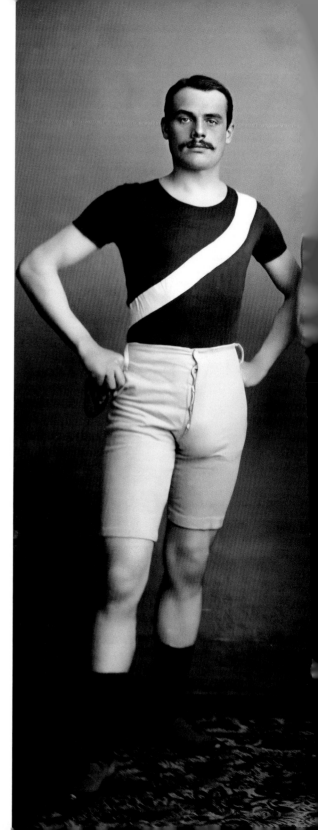

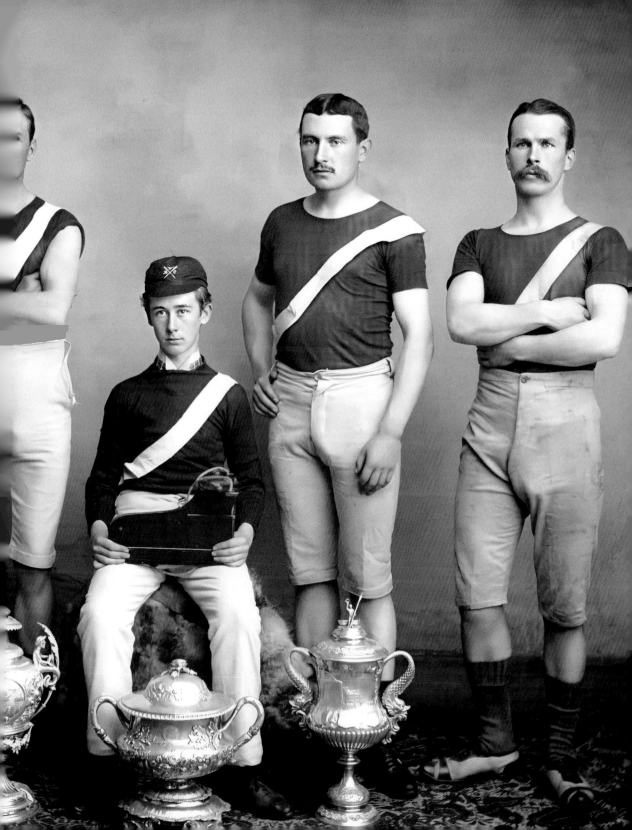

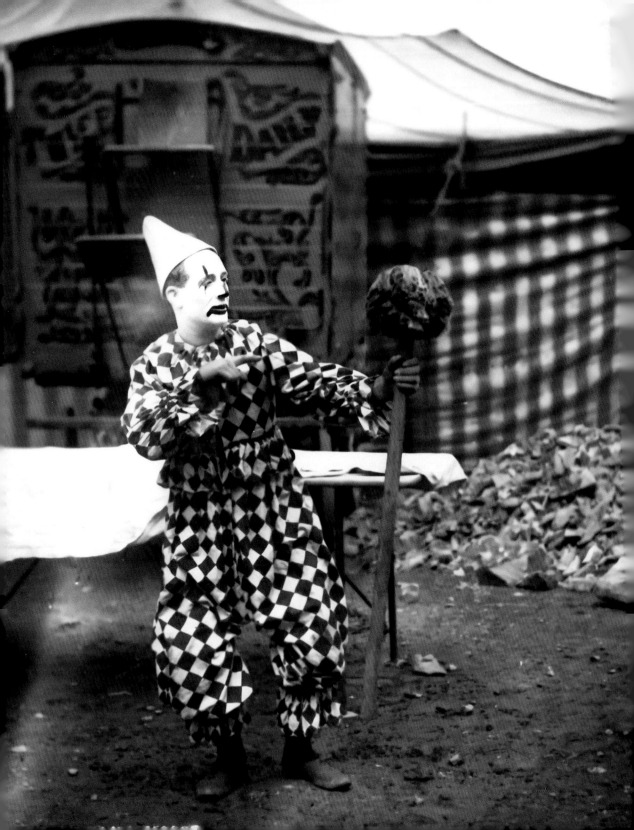

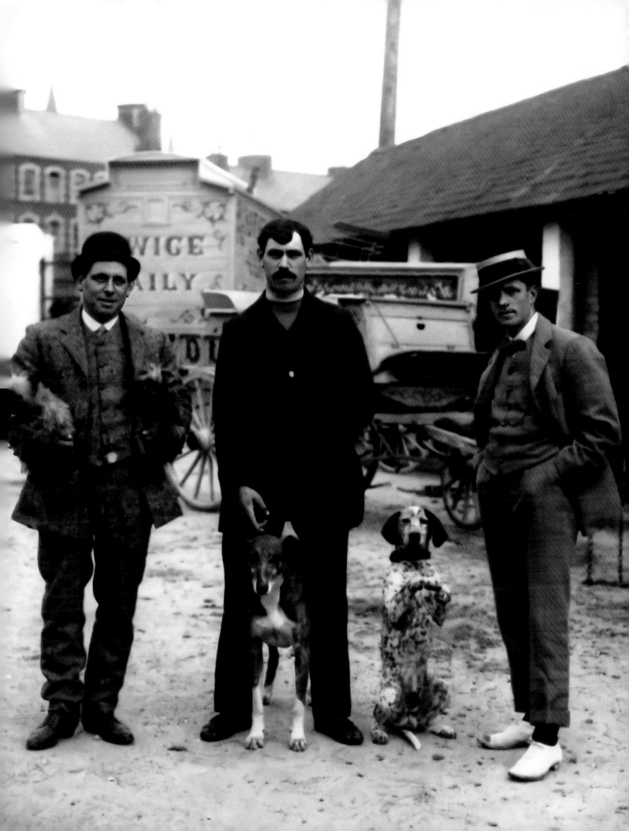

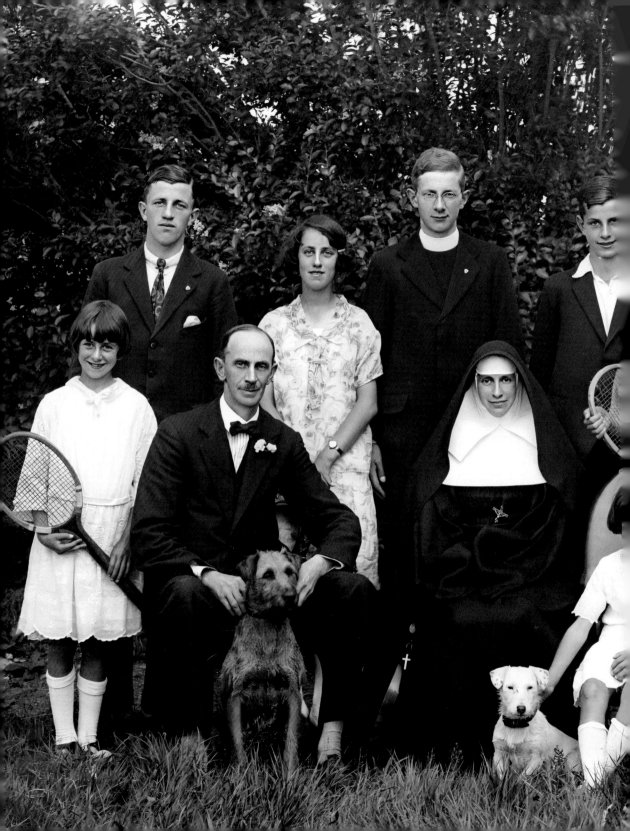

CIRCUS LIFE

*c.*1911, Strabane, Co. Tyrone

This image shows three men working for Duffy's Circus and four dogs, presumably with some role to play in the activities. While the role of animals today has been questioned regarding the circus, they have been a part of many acts since the eighteenth century.

'ERIN GO BRAGH!'

17 August 1927, Tramore, Co. Waterford

Peter O'Connor (1872–1957), who is pictured in front with his dog, held the long jump world record (7.61 metres) for twenty years, winning silver for the long jump and gold for the triple jump at the 1906 Intercalated Olympic Games. At the flag-raising ceremony, in protest at the flying of the Union Jack, O'Connor scaled a flagpole and waved an 'Erin go Bragh' flag.

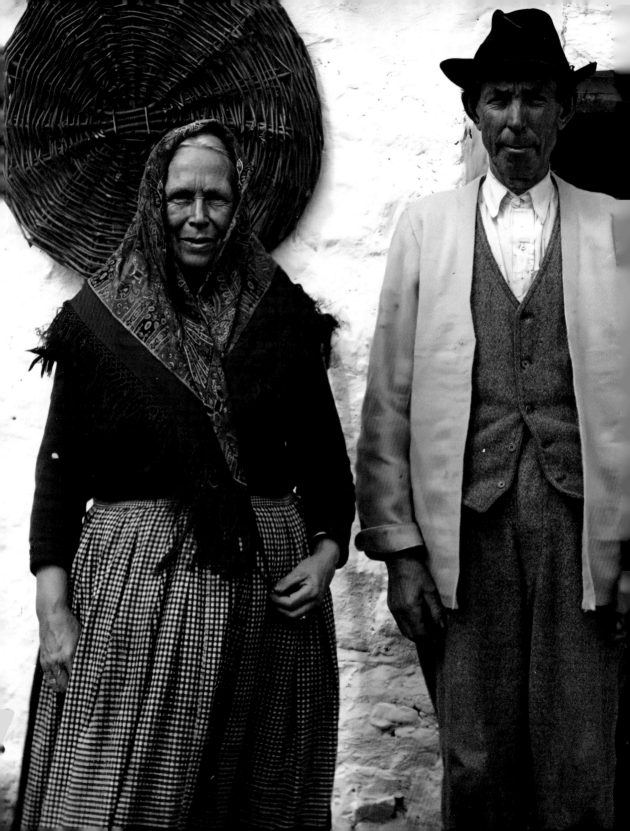

THE MARRIED COUPLE

1936, An Cheathrú Rua, Co. Galway

Máirtín Ó Conaire and his wife, Peige (Peige Liam Ní Fhátharta before she married). Thanks to great-grandson Micheál Ó Conaire for identifying the year.

GWEEDORE

1880–1900, Co. Donegal

An image of locals grouped and posing for the photographer. Traditional dress, thatched cottages, and children all barefoot. Very few smiling for the camera. Gweedore was the scene of several notable evictions in this period recorded in the House of Commons.

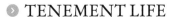 ## TENEMENT LIFE

c.1865–1914, tenements on Michael's Lane, Dublin City

This image shows the living conditions for many in Dublin City during this time. While the conditions could be harsh and dangerous, there also existed a strong sense of community solidarity.

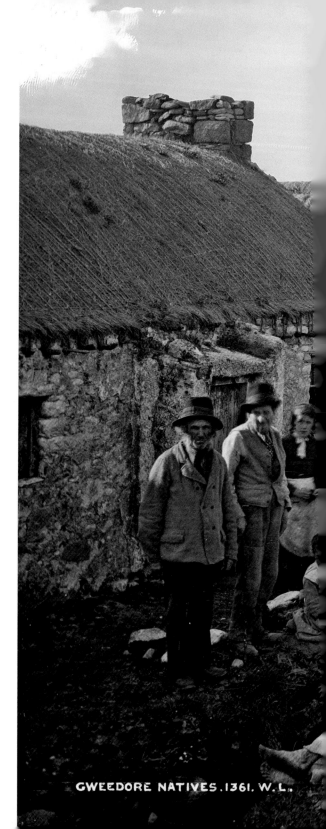

GWEEDORE NATIVES. 1361. W. L.

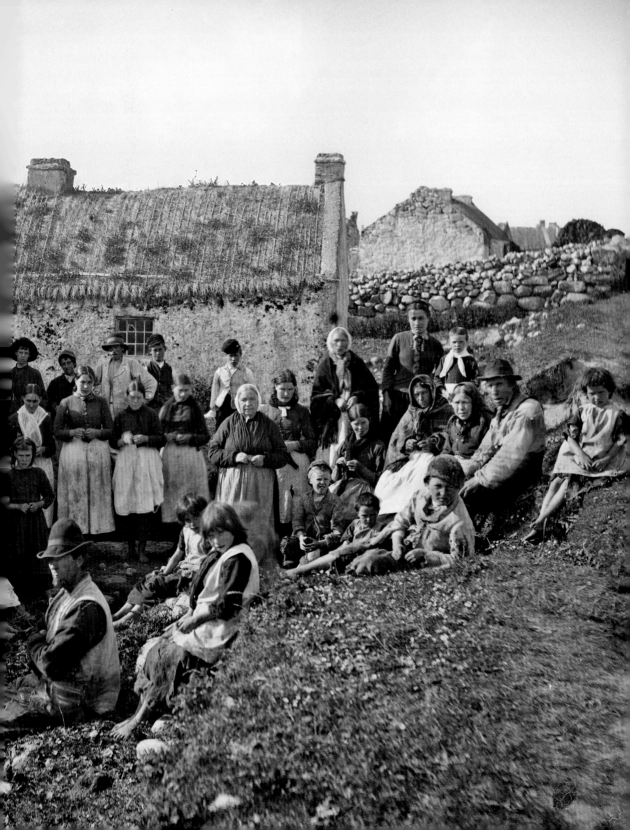

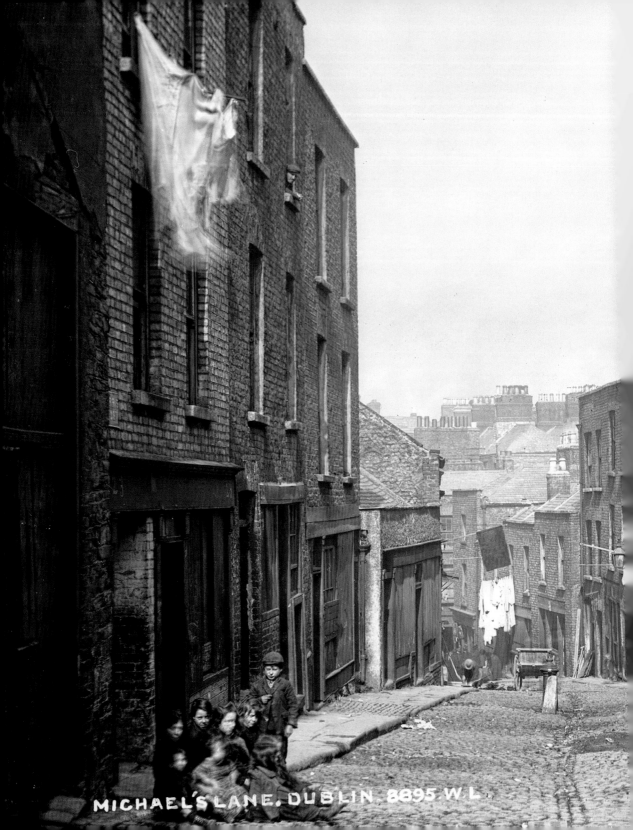

MICHAEL'S LANE. DUBLIN. 8895. W.L.

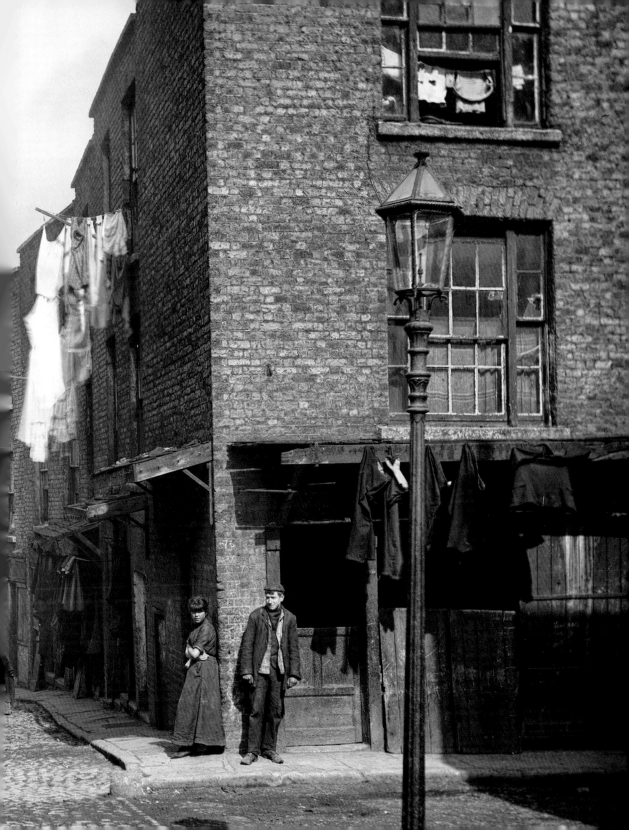

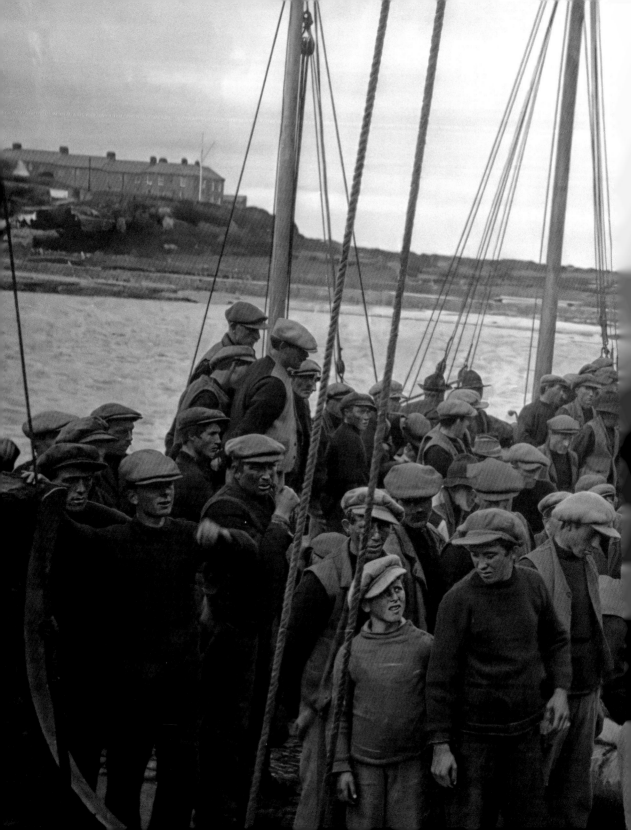

WAITING AT THE QUAY

1924, Kilronan Quay, Inis Mór, Aran Islands, Co. Galway

Kilronan became the primary port of the island only after its two piers were developed in the late nineteenth century along with the coastguard station, the long building on the hill in the distance. The photograph was taken from the deck of the steamer MV *Dun Aengus*, which entered service to the islands in 1912.

RMS *TITANIC* LEAVING BELFAST

2 April 1912, Belfast

Built by the Harland and Wolff shipyard in Belfast, the RMS *Titanic* left Belfast on 2 April and sank on 15 April 1912, with the loss of over 1,500 lives. About 110 victims and 54 survivors were from the island of Ireland. Robert Welch, who took this photo, was one of the official photographers for Harland and Wolff.

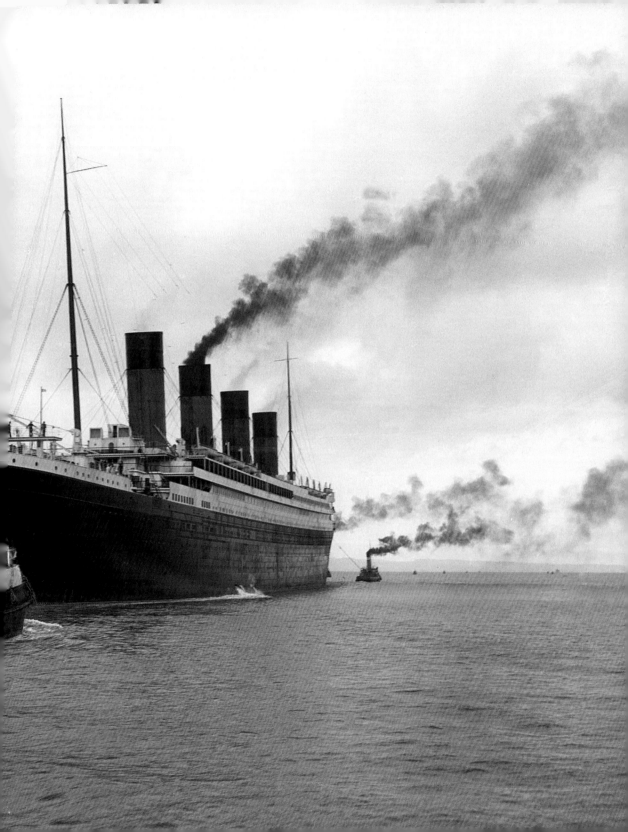

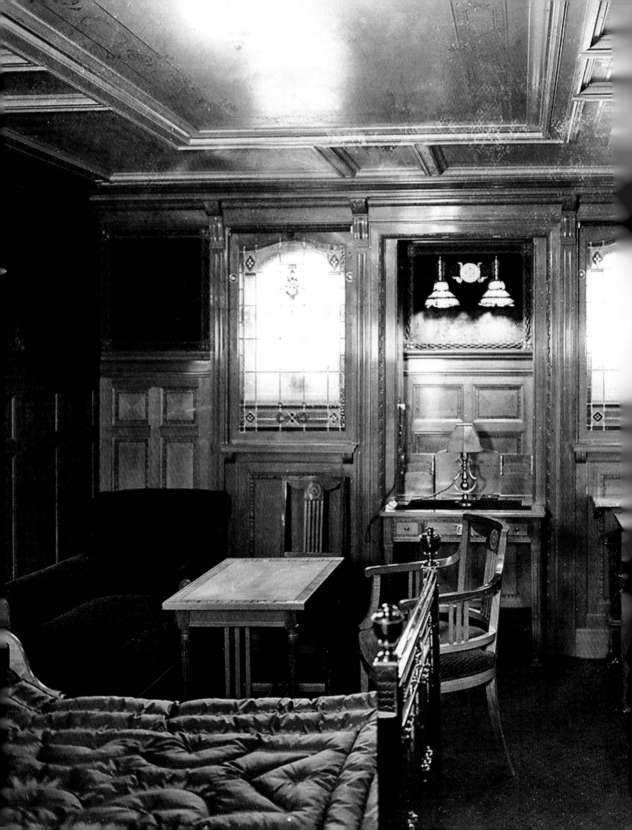

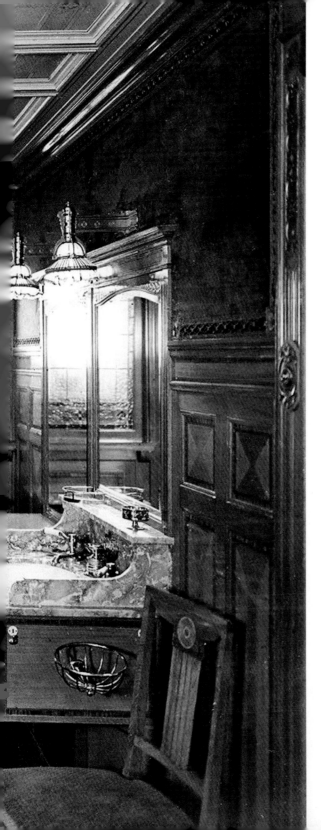

LIFE IN FIRST-CLASS

1912, Belfast

This image shows the accommodation in first-class aboard the RMS *Titanic*. First-class accommodation occupied almost the entirety of B and C Decks, but also large sections forward on A, D and E Decks; a handful of first-class cabins were located on the boat deck between the forward grand staircase and the officer's quarters. First-class accommodation aboard the *Titanic* included thirty-nine private suites: thirty on the Bridge Deck and nine on the Shelter Deck. The suites were comprised of bedrooms with private toilet facilities. All had up to five different rooms: two bedrooms, two wardrobe rooms and a bathroom.

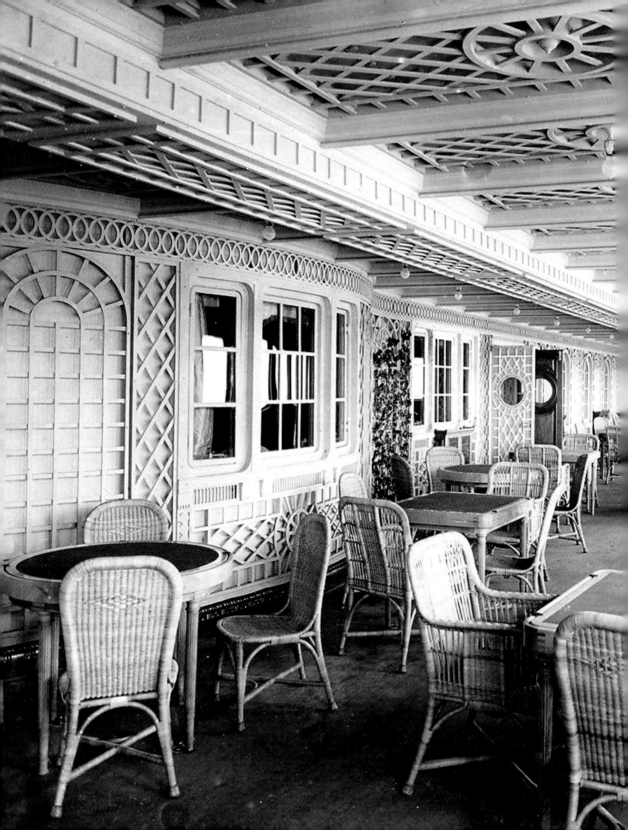

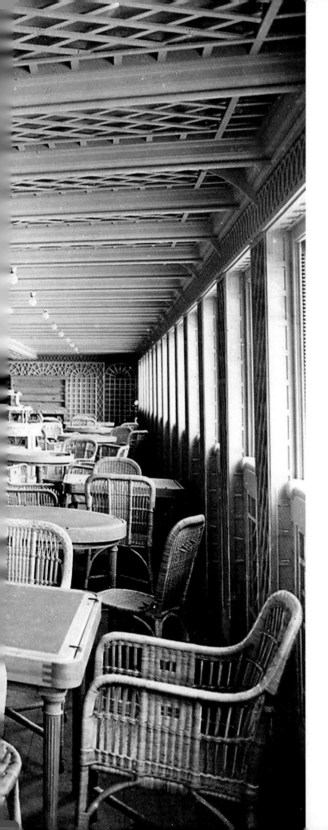

CAFÉ PARISIEN

1912, Belfast

The Café Parisien was a new feature on the *Titanic* designed to occupy a part of the space that served as a rarely used B Deck promenade on the *Olympic* (the largest ocean liner prior to the *Titanic*'s completion). Located on the starboard side, the café was connected to the à la carte restaurant. Passenger accommodation and public areas were located on the Promenade, Bridge, Shelter, Saloon and Upper, Middle and Lower Decks. The other three decks were reserved for the crew, cargo and machinery.

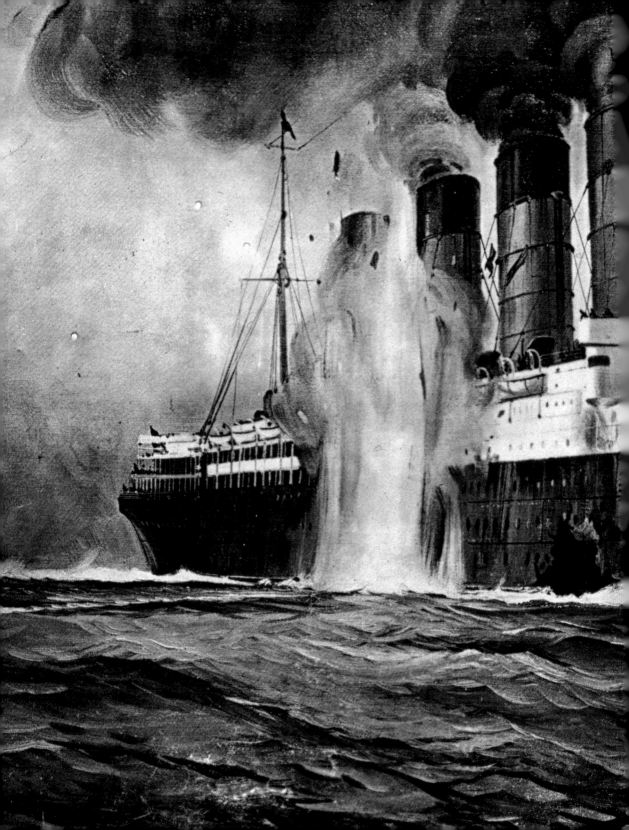

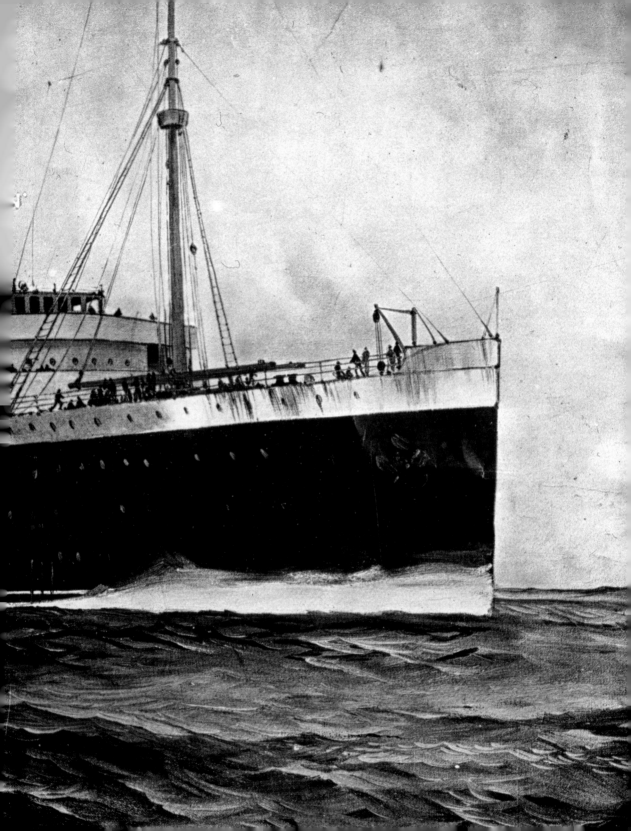

FINAL VOYAGE

7 May 1915, Off Kinsale Head, Ireland

The RMS *Lusitania* was an ocean liner that was sunk on 7 May 1915 by a German U-boat eighteen kilometres off Kinsale Head, killing 1,198 passengers and crew. There are no known photographs of the *Lusitania* sinking, so we have colourised this photograph of a black and white sketch made for the *New York Herald* and the *London Sphere* that shows the RMS *Lusitania* with a gaping hole in the hull.

SURVIVORS

8 May 1915, Cobh (formerly Queenstown), Co. Cork

The Riley family, from Bradford, England, were survivors of the *Lusitania* sinking. Photographed here are parents Annie and Edward Riley and their 4-year-old twins, Sutcliffe and Ethel. Of the almost 2,000 persons aboard the *Lusitania*, 764 were saved.

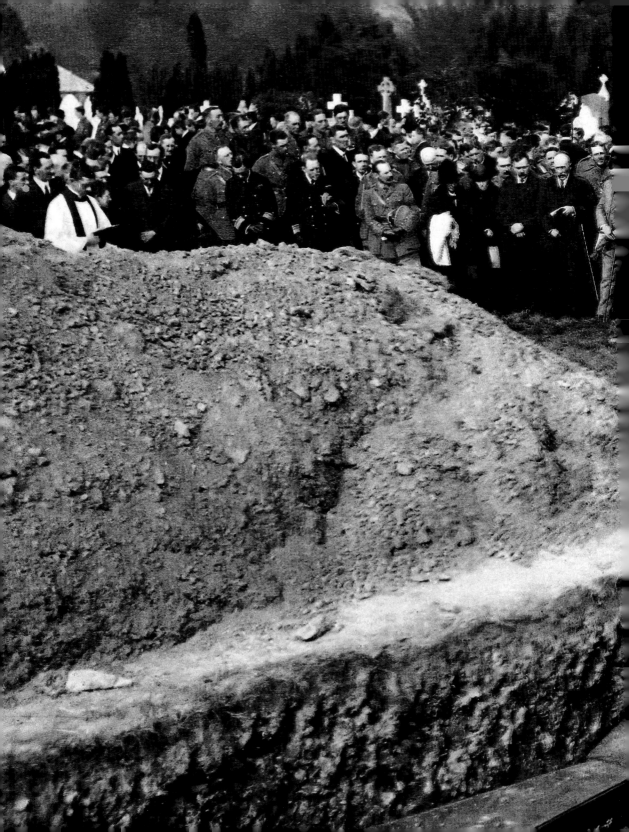

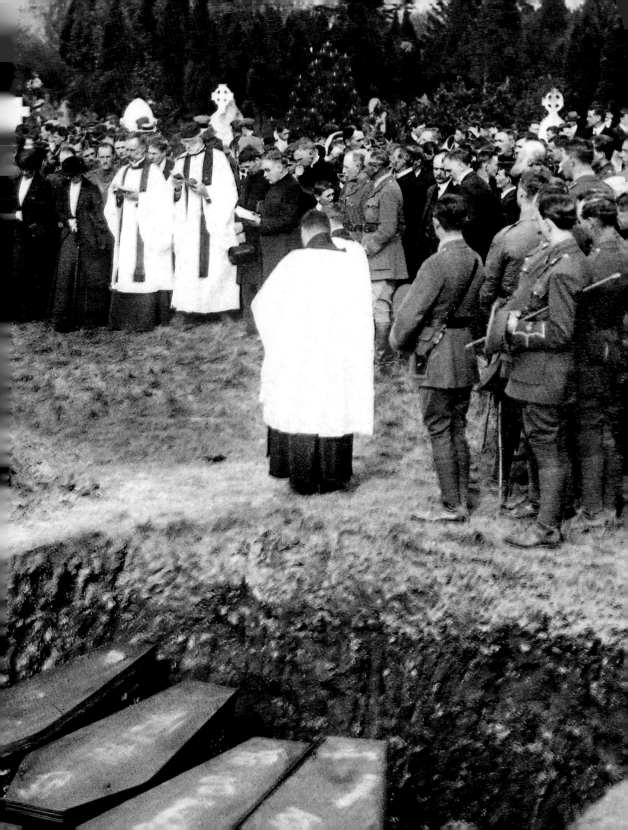

MASS BURIALS

10 May 1915, Cobh, Co. Cork

This image is of the mass burials after the *Lusitania*'s sinking. The Old Church Cemetery is an ancient cemetery on the outskirts of the town; the cemetery contains a significant number of important burials, including three mass graves and several individual graves containing the remains of 193 victims.

ISLAND VIBES

Date unknown, Inis Bigil, Co. Mayo

A group of men listening to a gramophone in Inis Bigil. Gramophones were available from the 1890s, but this photograph appears to be from between 1900 and 1930.

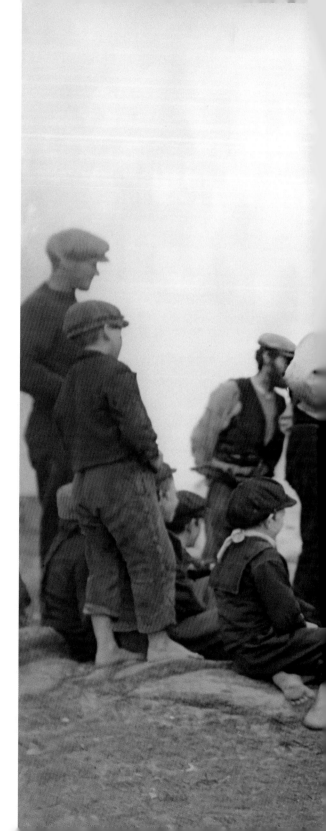

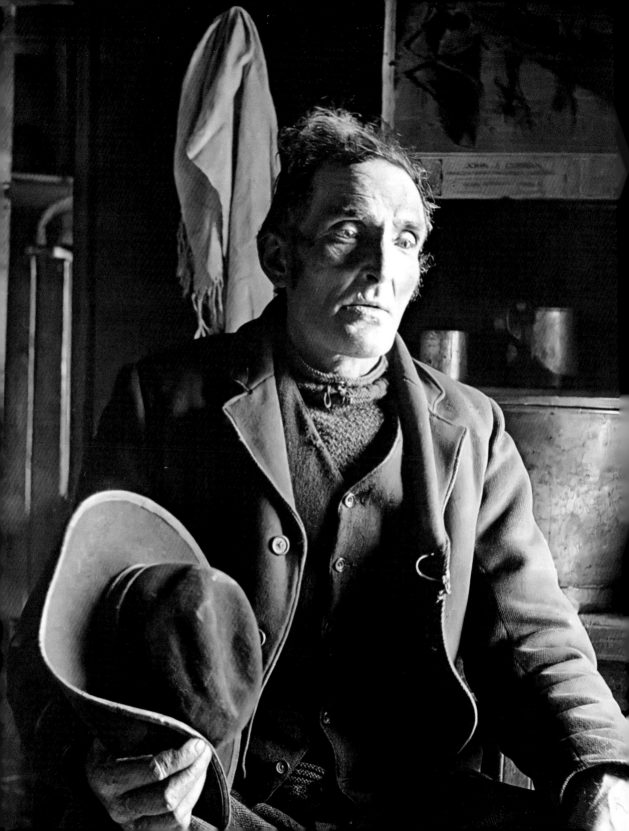

TOMÁS Ó CRIOMHTHAIN

*c.*1924, Great Blasket Island, Co. Kerry

Tomás Ó Criomhthain, a native of the
Irish-speaking Great Blasket Island,
wrote two books, *Allagar na hInise (Island
Cross-Talk)*, written over the period
1918–23 and published in 1928, and *An
tOileánach (The Islandman)*, completed
in 1923 and published in 1929. Both
have been translated into English. Ó
Criomhthain is nearly 70 years old in
the photograph.

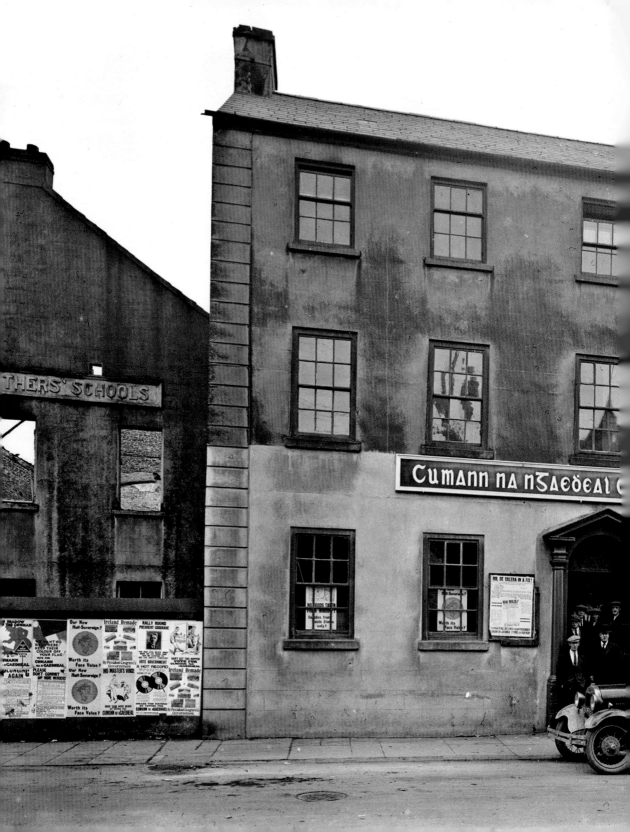

LAST DAYS OF A POLITICAL PARTY

15 February 1932, Manor Street, Waterford City

Cumann na nGaedheal was a political party in the Irish Free State that formed the government from 1923 to 1932. W.T. Cosgrave was the leader and Taoiseach during this time. The 1932 general election was held soon after this photo, where Fianna Fáil won seventy-two seats, Cumann na nGaedheal fifty-seven and Labour seven. In 1933, the party merged with two smaller groups, the National Centre Party and the National Guard, to form the Fine Gael party. For this photograph, we sourced images of the original posters to help colourise those visible on the walls and in the windows.

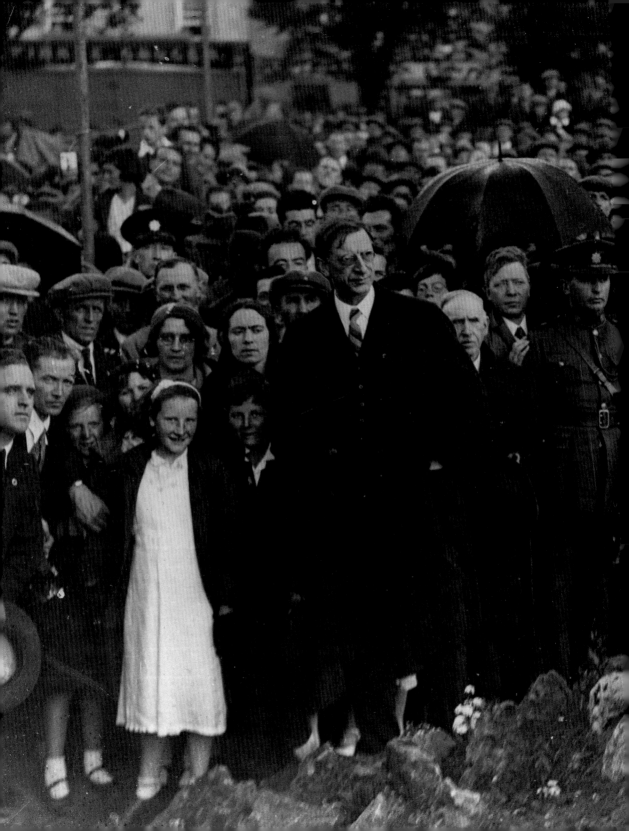

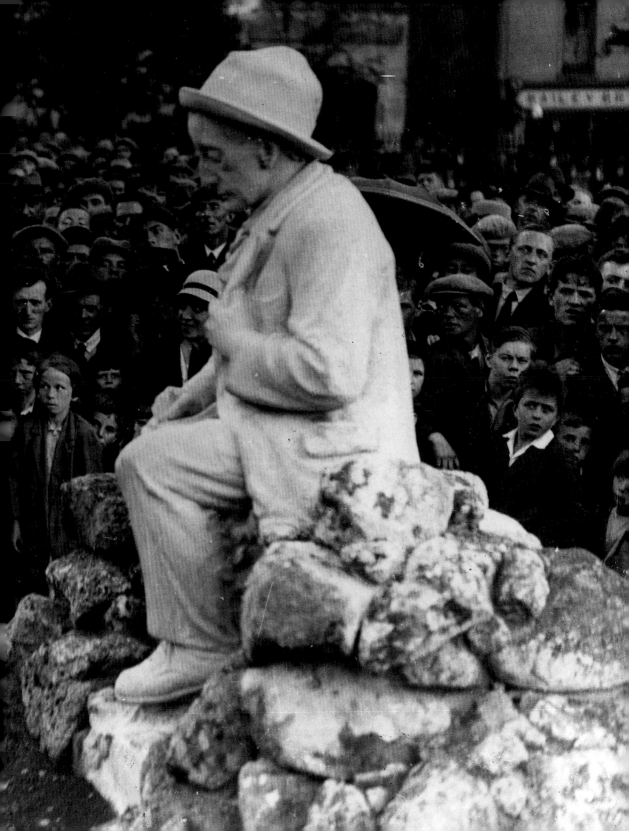

THE UNVEILING

9 June 1935, Eyre Square, Galway City

Éamon de Valera (then President of the Executive Council of the Irish Free State) unveiling the Pádraic Ó Conaire statue. Ó Conaire was the first modern writer to earn his living writing exclusively in the Irish language. The sculptor was Albert Power.

PÁDRAIC Ó CONAIRE

Pádraic Ó Conaire, a writer whose work was published in the Irish language. He was a prolific writer who wrote 26 books, 473 stories, 237 essays and 6 plays. Ó Conaire was involved in the work of the Gaelic League and was a pioneer of the Gaelic revival. We know that he often wore brown tweed suits. Also, the poet F.R. Higgins wrote a letter to 'Dear Padraic of the wide and sea-cold eyes', hence the eye colour we have used.

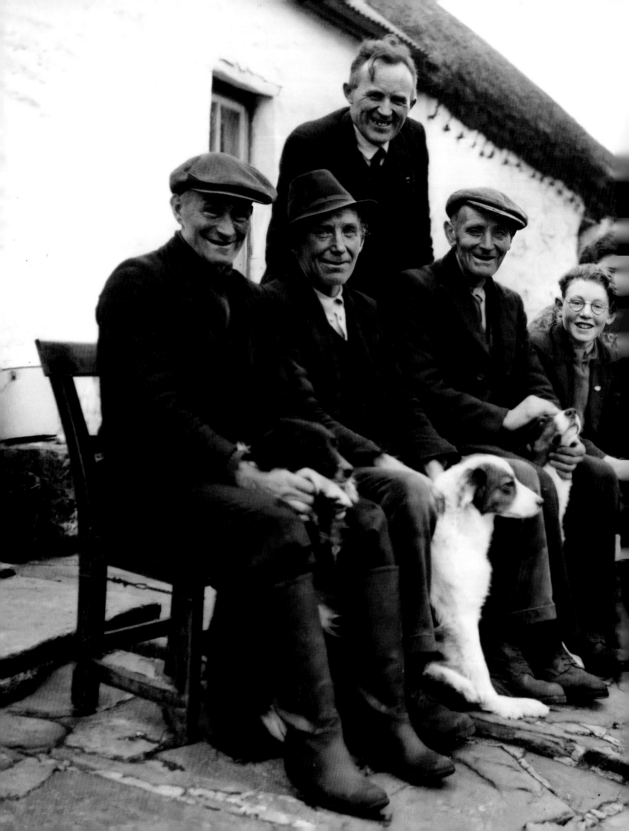

IN THE BLUE STACK MOUNTAINS

1950, Croveenananta, Co. Donegal

This image depicts folklore collecting in Donegal. Pictured here: Niall de Búrca, Joe Mac an Luain, Seán Ó hEochaidh, John Mac an Luain, Joe Beag Mhic an Luain, Máire Bean Mhic an Luain and Pat Mac an Luain. The Blue Stack Mountains, also known as the Croaghgorms, are a major mountain range in the south of County Donegal. The highest mountain in the range is Croaghgorm, which is 674 metres high.

● WAITING FOR MASS

1930–1950, Inis Meáin, Aran Islands, Co. Galway

This image of a group of men waiting for mass was taken by Tomás Ó Muircheartaigh, who was a prolific and talented amateur photographer best remembered for capturing the everyday life of ordinary people living in rural Ireland, especially in Gaeltacht districts. He worked for the Department of Education for much of his life and his love of hill walking and Irish culture/language is reflected in his photographic work. A selection of this work was published posthumously in 1970, in a book titled *An Muircheartach*. Thank you to Deirdre at Aran Songs for her recommendation on the red of the woman's shawl/skirt.

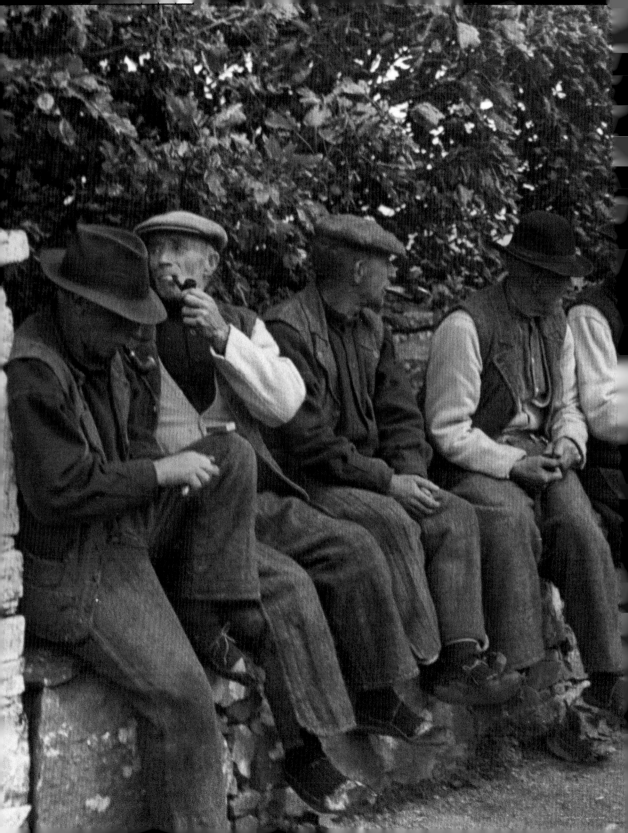

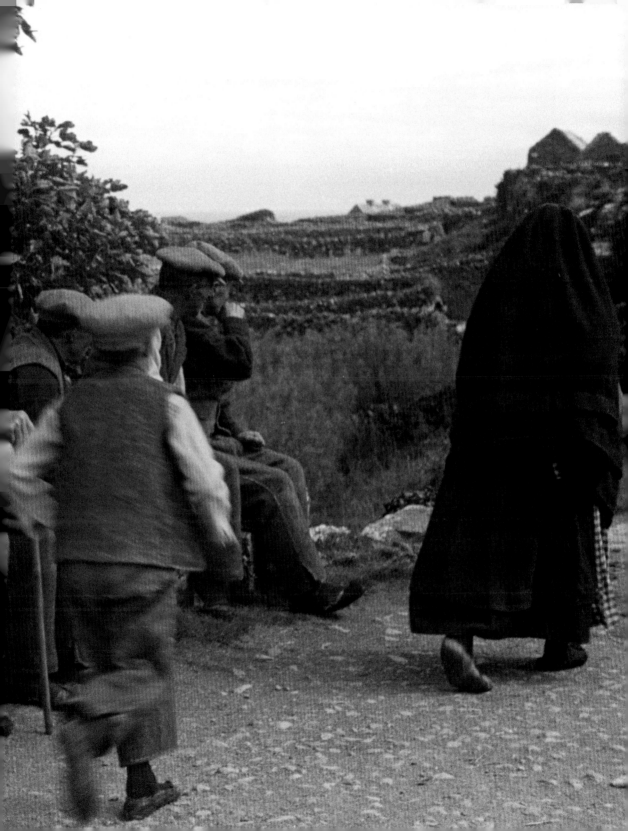

DIGGING PEAT

1880–1930, location unknown

A man and woman digging peat in Ireland. There is evidence that the use of turf for heating in Ireland can be traced to over a thousand years previous. By the seventeenth century, turf was widely used and by the late eighteenth century it was the main fuel in Ireland. In the late nineteenth century, the emphasis on peatlands changed to encouraging their development for fuel and improving the quality of turf. In the 1930s, the Irish Free State Government formed the Turf Development Board for these purposes which later became Bord na Móna.

SINGING BY THE FIREPLACE

1952, Inis Mór, Aran Islands, Co. Galway

George Pickow captures Pat Pheaidí Ó hIarnáin (1903–1989) from Cill Mhuirbhigh singing a song while his neighbour Neain Mhaidhc Mhóir Uí Iarnáin sits in the fireplace of the *Man of Aran* cottage. Deirdre Ní Chonghaile from the Aran Songs project explains that the choice of location was deliberate, as the thatched cottage had a skylight that enabled visiting photographers to photograph indoor scenes.

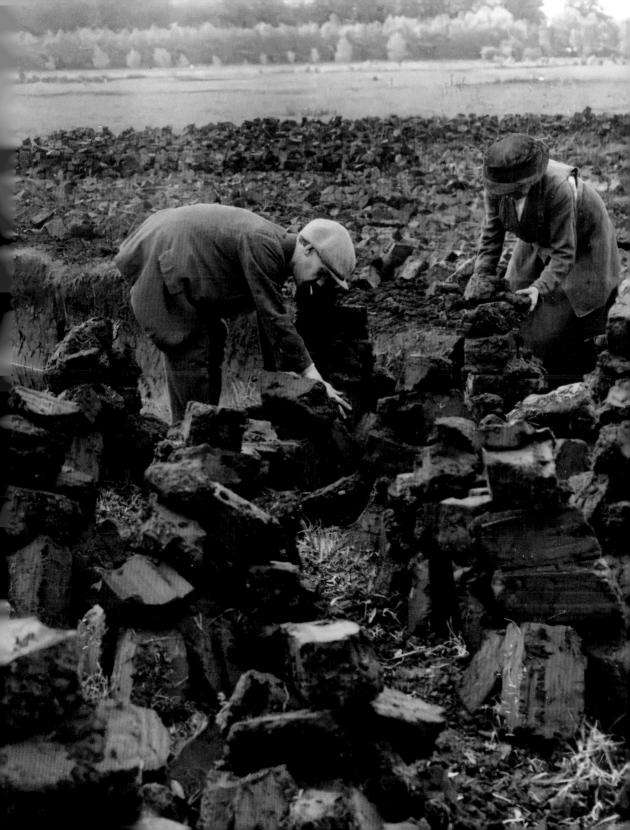

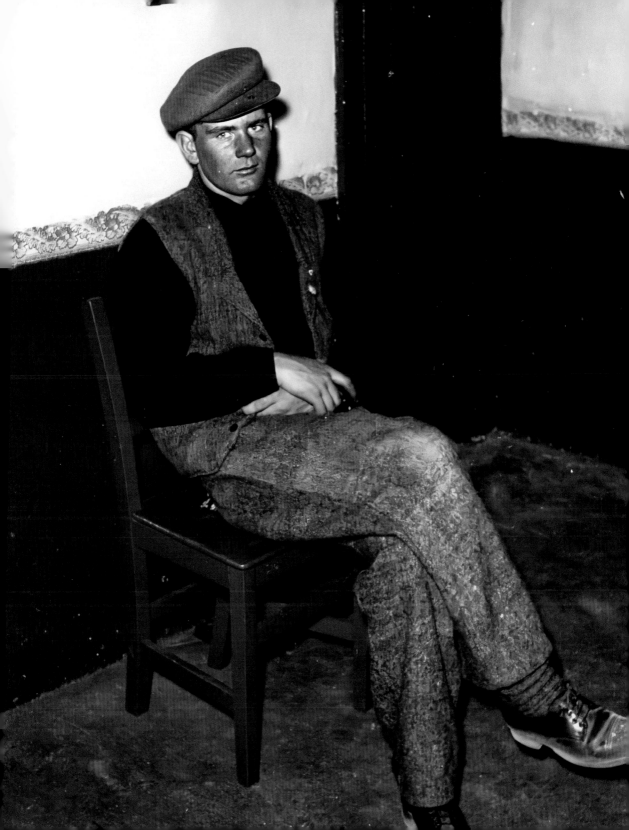

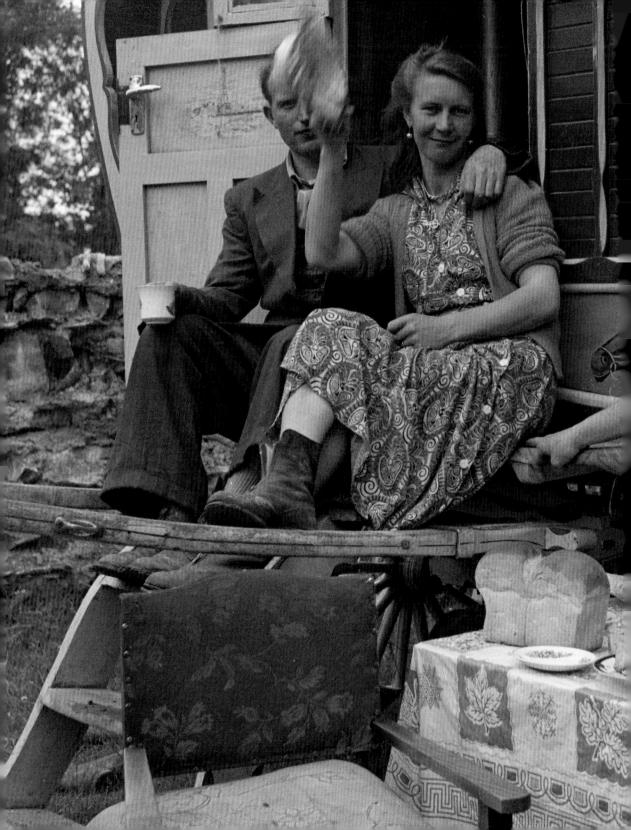

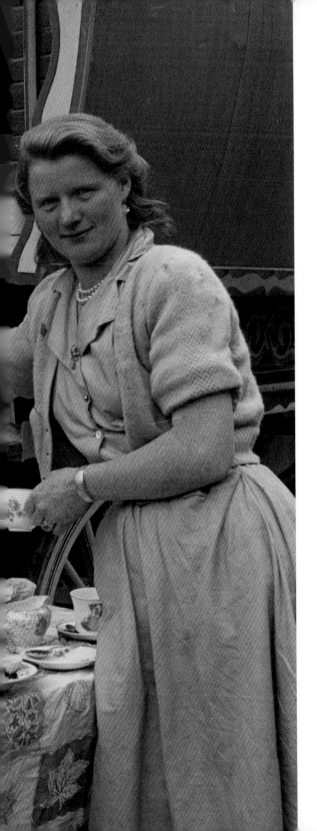

YOUNG MAN OF ARAN

May 1957, Inis Oírr, Aran Islands, Co. Galway

Inis Oírr, or Inisheer, is the smallest and most eastern of the three Aran Islands in Galway Bay. With about 260 permanent residents (2016 census), Irish is still the daily language on the island. Pictured here is Michael Anthony Ó Domhnaill, who is named in another image in the Folklore Collection.

TEATIME

May 1954, Loughrea, Co. Galway

Members of the Sheridan and O'Brien families at mealtime. This image is part of the Wiltshire Collection which comprises of black-and-white photographs by Elinor Vere O'Brien (1918–2017), and audio and film material of Patrick Kavanagh by Elinor's husband Reginald Wiltshire (d.1968). Elinor and Reginald Wiltshire owned The Green Studio Ltd, Dublin (1958–1968, St Stephen's Green).

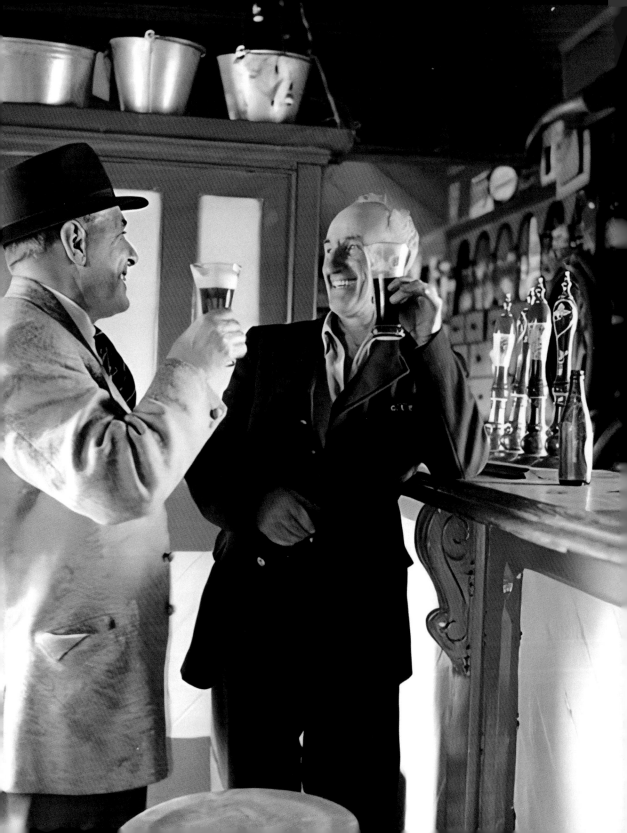

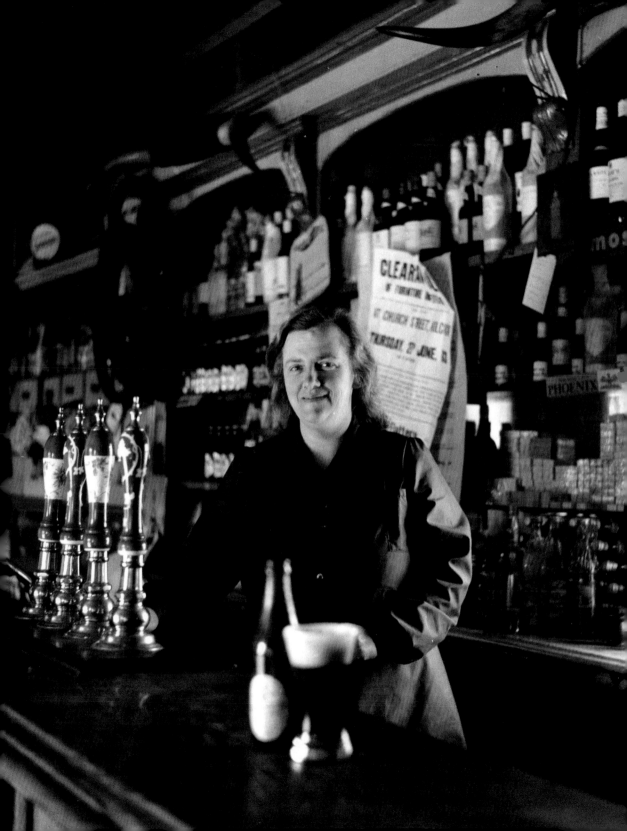

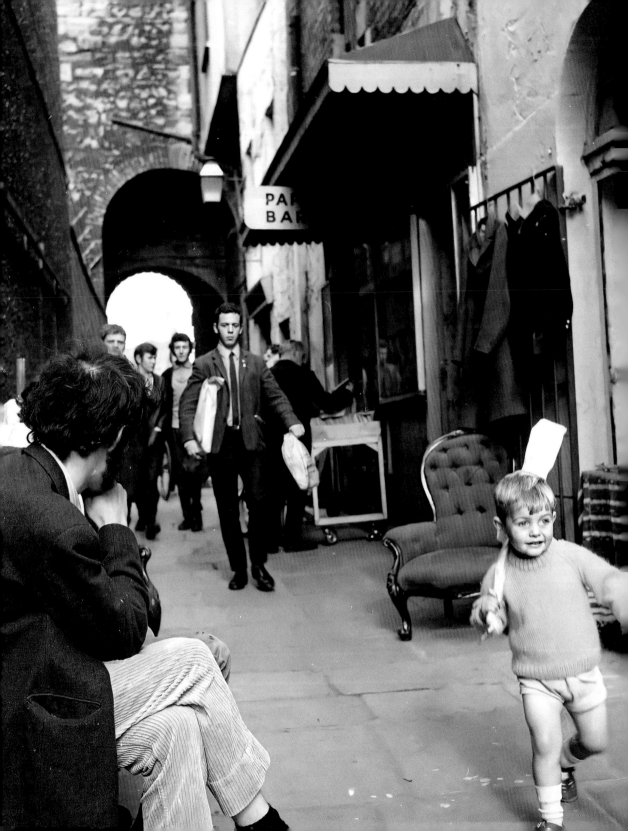

PINT ANYONE? *(left)*

23 August 1961, Furey's Bar, Moyvalley, Co. Kildare

James P. O'Dea enjoying a drink with his friend Fred McDonagh in Furey's Bar. O'Dea was the photographer responsible for many of the train and railway photos in the National Library Collection. He was a founding member of the Irish Railway Records Society in 1946 and a nephew of the famous Dublin comedian and entertainer Jimmy O'Dea.

SERVING TIME *(right)*

22 June 1963, Furey's Bar, Moyvalley, Co. Kildare

Miss Furey from Furey's Bar. There is a bottle and glass of Guinness on the counter and an array of spirits and minerals behind the bar. For centuries, the Irish pub has been an integral part of Irish social culture. In 1872, it became a legal requirement to display the proprietor's name over the front door of the premises. The legacy of this is that often a pub today operates under a long-obsolete family name.

FUN TO BE HAD

1969, Merchant's Arch, Temple Bar, Dublin City

We were in touch with Colm Irwin, the boy pictured in this photograph, who told us that he has blue eyes and was probably wearing a mustard-coloured top and beige pants, with red-brown sandals. Apparently, it is a wrapped-up toy gun in his hand!

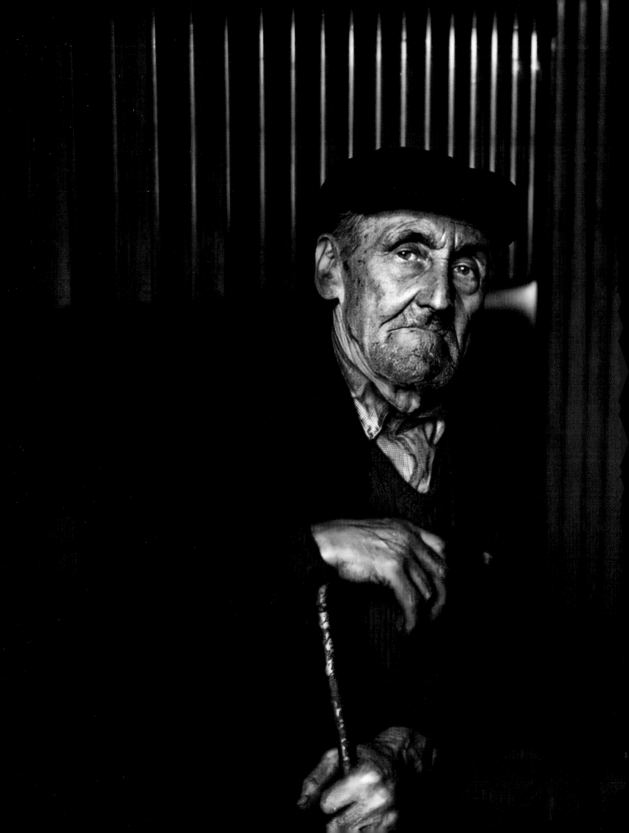

FRANK 'WINGS' CAMPBELL

1969, Forkhill/Forkill, Mullabawn Parish, Newry, Co. Armagh

Frank Campbell, aged 75, known popularly as 'Wings' Campbell. He is holding his walking stick and drinking a bottle of Guinness. In 1969, Guinness decided to replace the corks used in bottled stout with metal caps. In the 1960s there were still publicans in Ireland who bottled Guinness from the keg on their own premises, with a hand-corking machine.

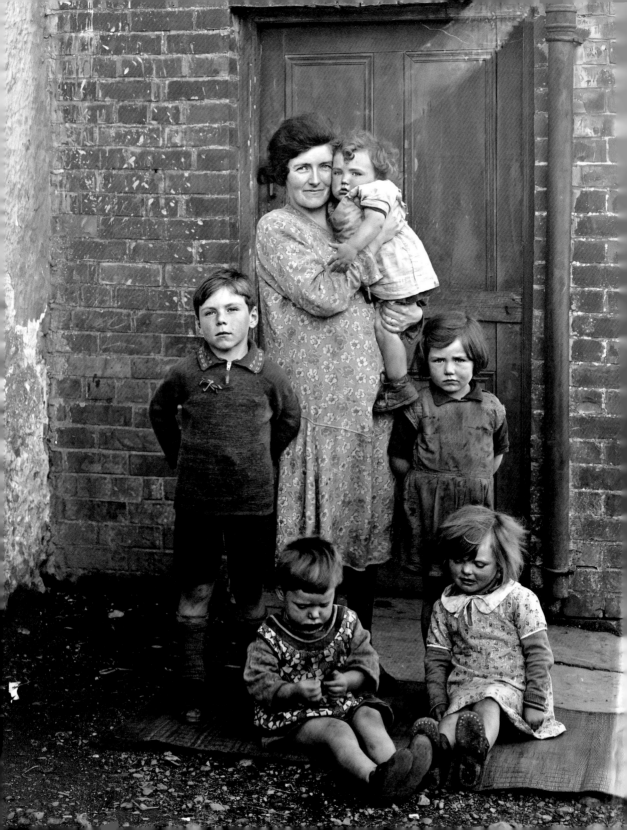

WOMEN AND CHILDREN

POSING ON THE DOORSTEP

21 September 1933, Leperstown,
Dunmore East, Co. Waterford

This photograph depicts Mrs Bridget
Flynn and five of her children – Francis
(boy standing), Bridget (mother),
Margaret (toddler), Philomena (girl
standing), Norbert and Mary (seated). It
is part of the Poole Whole Plate series
and the index books state that it was
commissioned by Mrs Flynn.

SISTERLY LOVE

22 September 1883, Ahascragh,
Co. Galway

The Dillons were a Norman family
who initially received grants of land
in Westmeath and who later acquired
properties in neighbouring counties,
including Roscommon and Galway.
Lord Clonbrock was listed as a resident
proprietor in Co. Galway in 1824, and
in the 1870s the Clonbrock estate in
Galway amounted to over 28,000 acres.
This photograph depicts the daughters
of Augusta and Luke Gerald Dillon
(who would become 'Baron' Clonbrock
in 1893) – Edith (1878–1964) and Ethel
(1880–1978). In 1905, Edith went on
to marry William H. Mahon from the
Castlegar estate close by in Ahascragh
village. Their second son, Luke, inherited
Clonbrock in the 1970s.

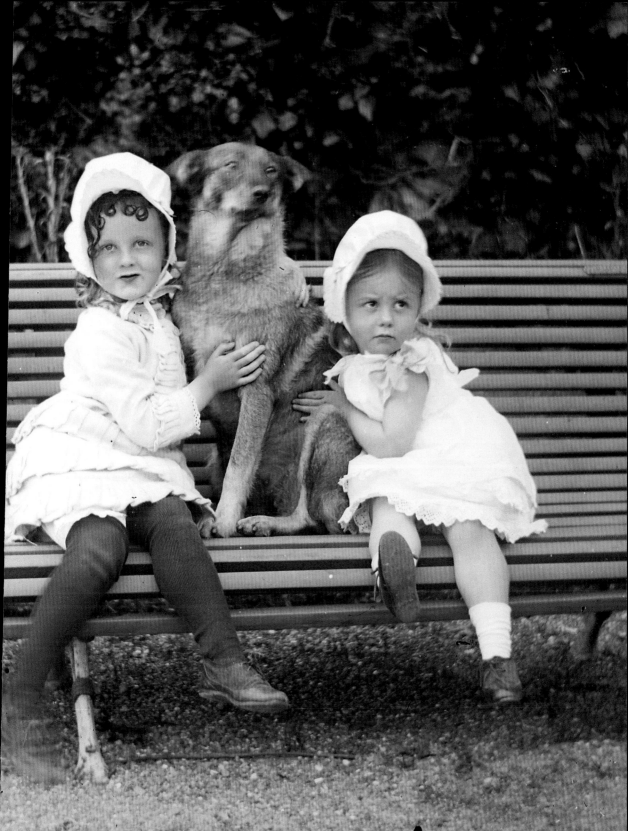

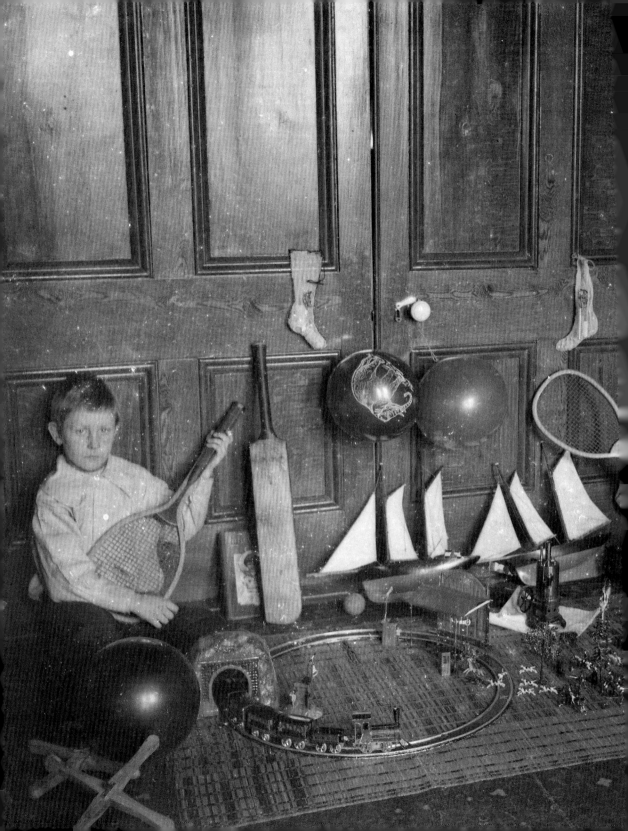

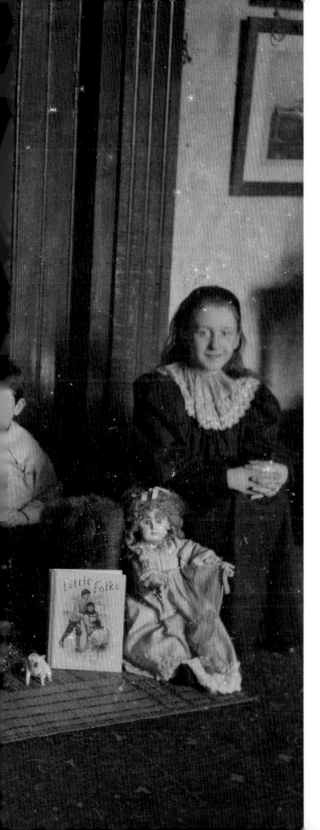

CHRISTMAS DAY

*c.*1894, Clonbrock (or Mote Park)

Although from a National Library of Ireland collection titled the Clonbrock Photographic Collection, not all images were taken on the estate itself. This Christmas Day image may be of a visiting family at Clonbrock or a family from Mote Park, the seat of Augusta's Crofton family in Roscommon. Toys pictured include tennis racquets, a train set, a doll, books, a cricket bat and sailing boats, which were most likely sent from Europe and were quite expensive at the time.

IT'S A DOG'S LIFE

*c.*1903, Ahascragh, Co. Galway

This photo is possibly of Ellen Quinn (left) and her sister Maggie Quinn (right), daughters of Joseph, a gardener on the Clonbrock estate. Clonbrock was one of a number of landed estates on the island. The Connacht and Munster Landed Estates Project (NUI Galway) includes details of one of a large number of houses from 1700–1914.

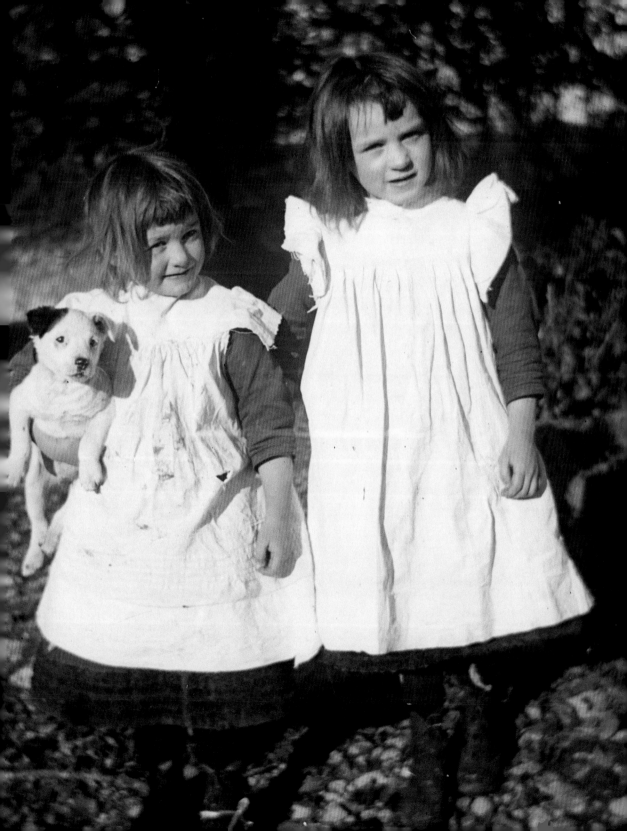

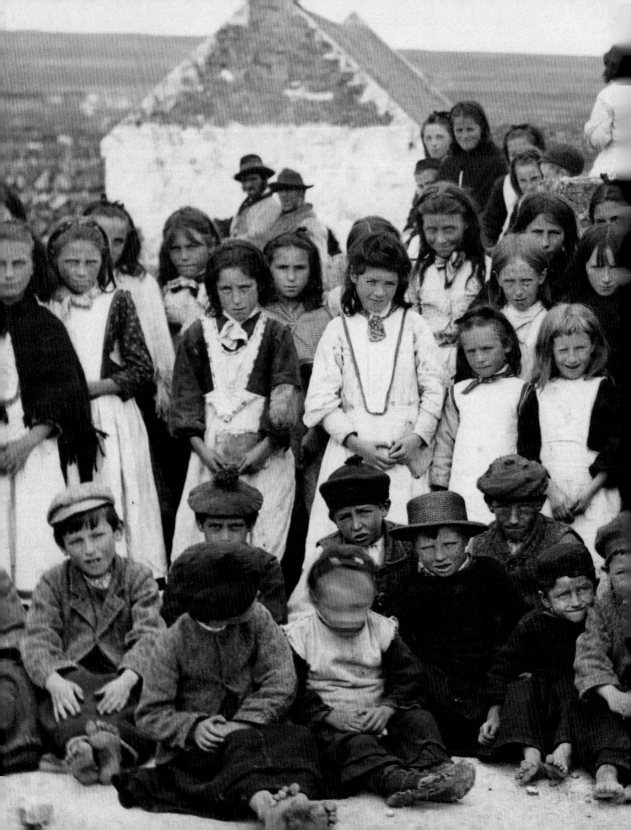

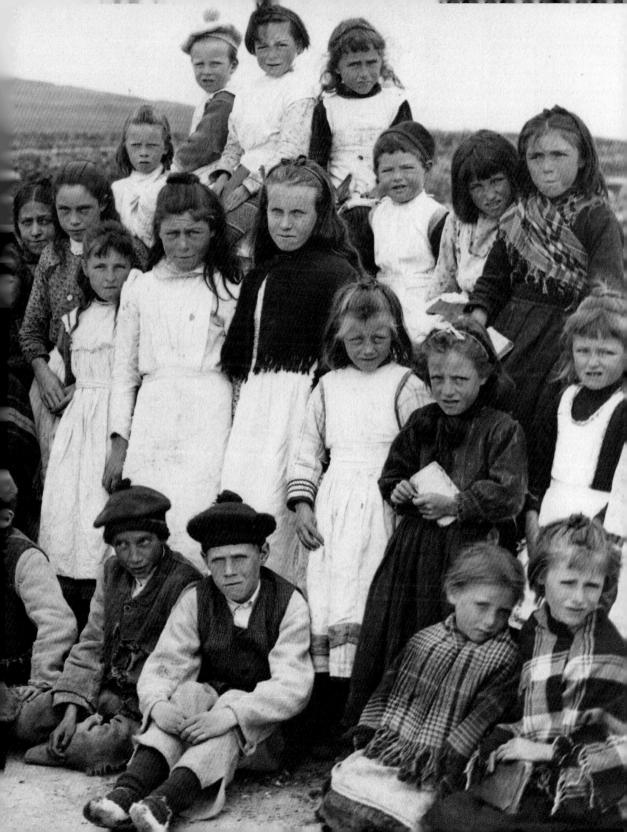

'THE YOUNG FIRBOLGS'

c.1894, Inis Mór, Aran Islands, Co. Galway

A large group of children, both boys and girls, mostly facing the camera. They are standing in front of a cottage whose partially white-washed gable is visible. Many of the girls are wearing white pinafores, while some of the boys are wearing traditional Aran knitted clothing. Photographer Robert Welch's use of the word 'Firbolgs' in the caption recalls a troupe of antiquarianism and its efforts to determine the islands' prehistory.

THE WOMEN FUELLING IRELAND

c.1903, Dooagh, Achill Island, Co. Mayo

The caption under the image reads 'A great fuel for Ireland'. Peat harvested from local bogs was used for cooking and heating in Ireland for centuries. With the depletion of natural woodland in the seventeenth century, peat became an important source of indigenous fuel, and throughout the twentieth century, it was an essential source of rural employment and an alternative fuel for heating and electricity generation.

ERIN'S SONS AND DAUGHTERS

1903, Ballidian, Ballybay, Co. Monaghan

Girls playing 'Green grow the rushes, O' while boys do gymnastic exercises and the teacher watches outside of Ballidian National School. Stereographs, or stereoviews, date back to the late nineteenth century, where two separate photographs were taken by cameras in slightly different positions but pointing at the same objects. A special viewer (basically a set of spectacles mounted on a stick, with a holder for the stereograph photo card at the end) allowed one to view the scene with a sort of 3D effect. They were very popular with Irish emigrants, who could reminisce about home. We are told by locals that the teacher's name was Mrs Rowland, and the tall girl was a monitor named Letticia Young.

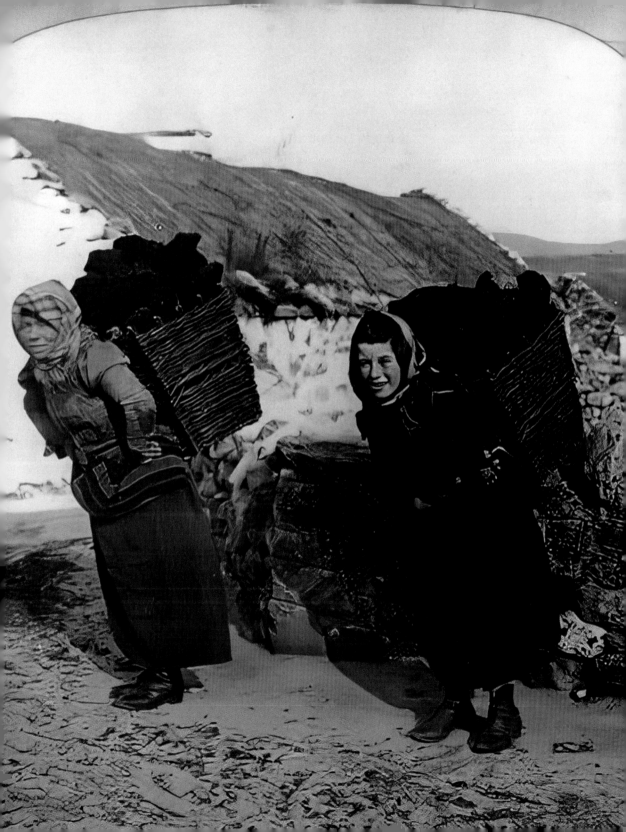

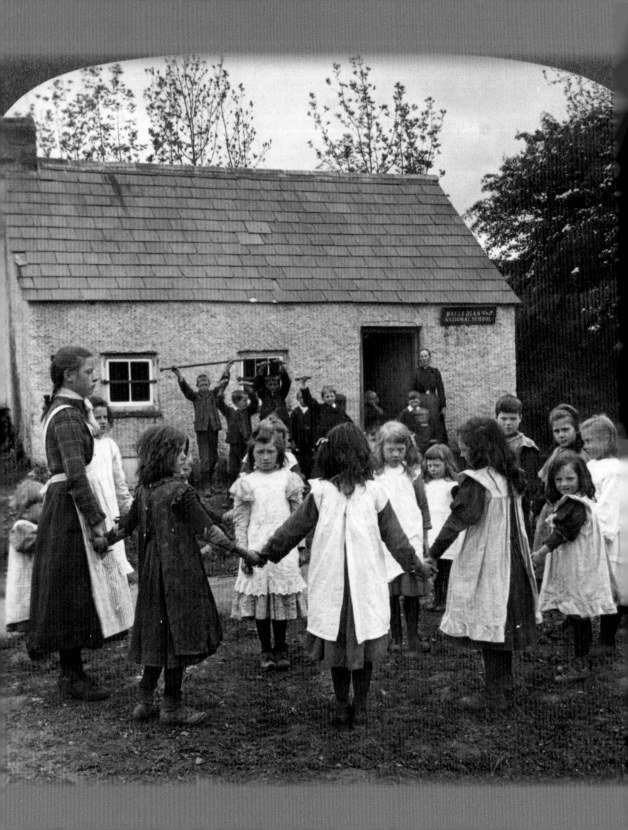

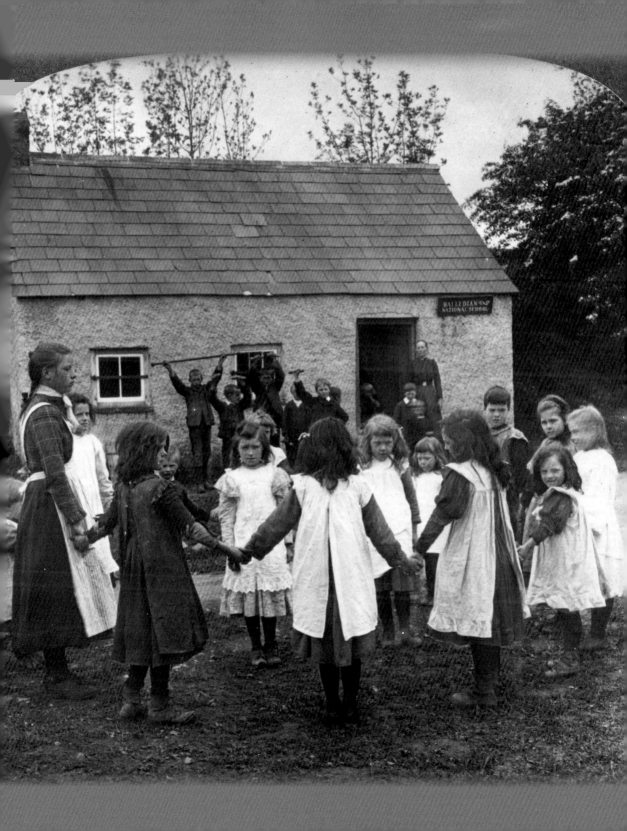

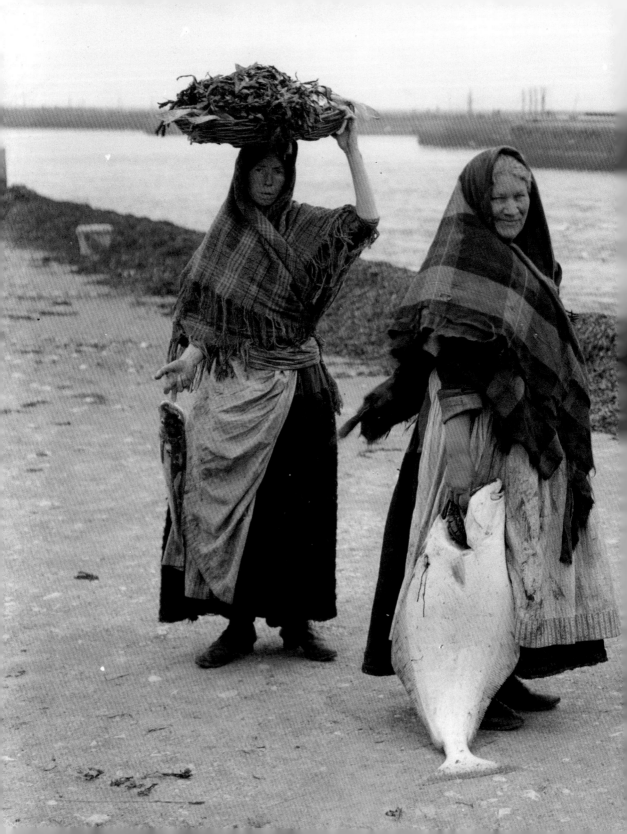

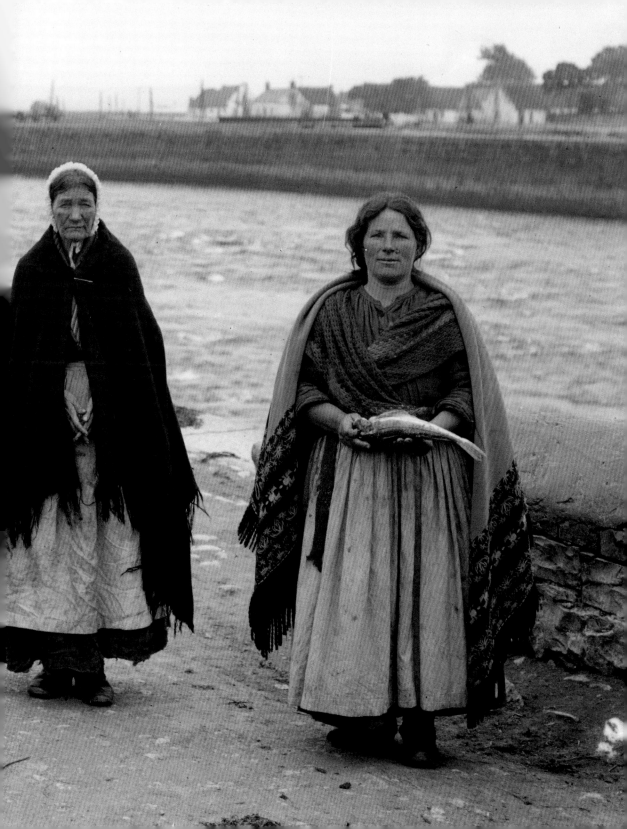

THE CLADDAGH CATCH

*c.*1905, Spanish Parade, Galway City

Pictured here are Nonnie, or Nannie, O'Donnell, Mary Rodgers, Kitty Conneely and Mrs Gill, all from the Claddagh, Galway City. The women are wearing the Galway shawl, which was a heavy-weight shawl that became popular at the end of the nineteenth century. At the time in which this photograph was taken, the famous Claddagh fishing industry was in decline following the onset of modern trawlers.

MOTHER AND BABY

*c.*1898, Co. Waterford

Beatrix Frances Beauclerk, the Duchess of St Albans, and the Marchioness of Waterford, was born Lady Beatrix Frances Petty-FitzMaurice in 1877. She was a member of the Anglo-Irish aristocracy, both by birth and through her two marriages – the first to Henry Beresford, the 6th Marquess of Waterford; the second to Osborne Beauclerk, the 12th Duke of St Albans. In recognition of her work as a hospital administrator during the First World War, she was appointed to the Order of the British Empire (Knight Grand Cross, GBE) and the Order of St John of Jerusalem (Dame of Grace, DGStJ). She died in 1953. She is pictured here with her baby daughter, who would go on to be Lady Blanche Maud de la Poer Beresford Girouard (1898–1940), an Irish journalist and writer. Girouard died tragically in a car accident in 1940.

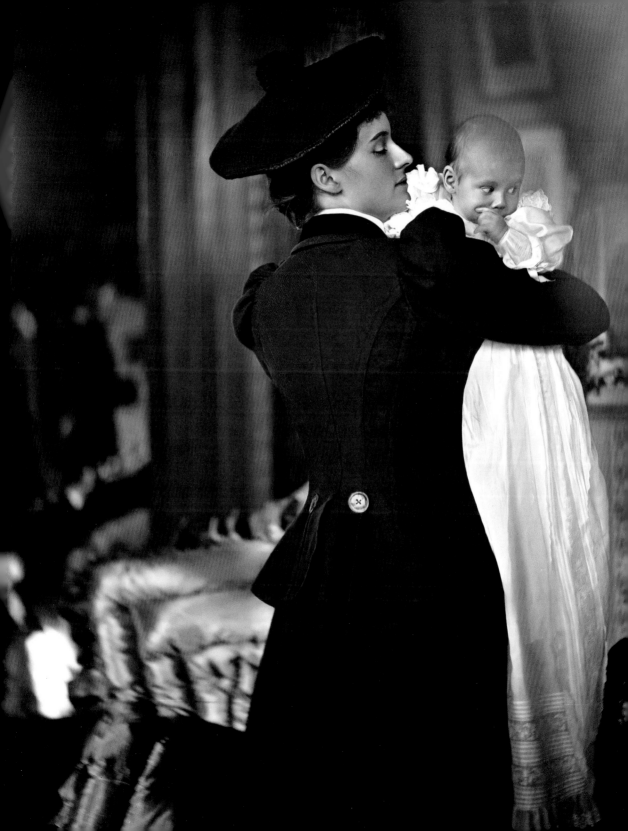

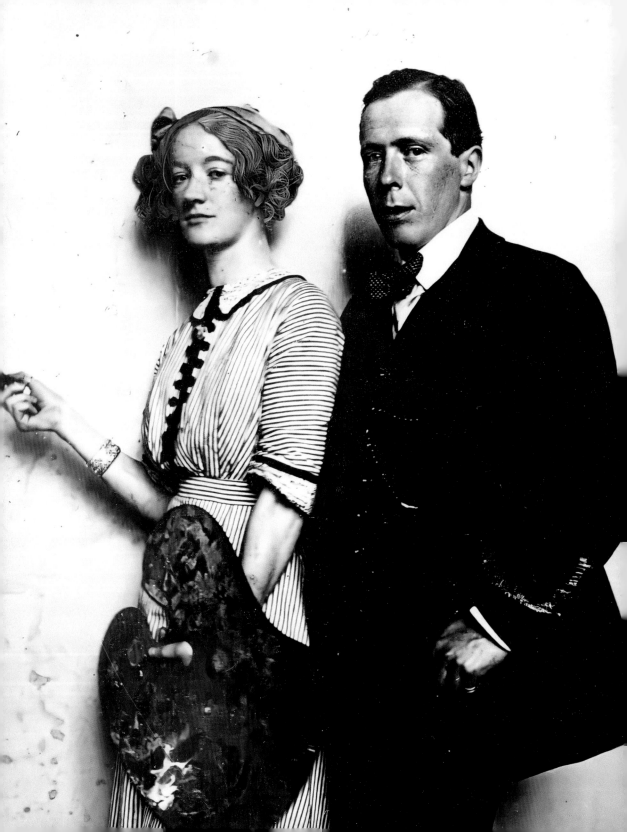

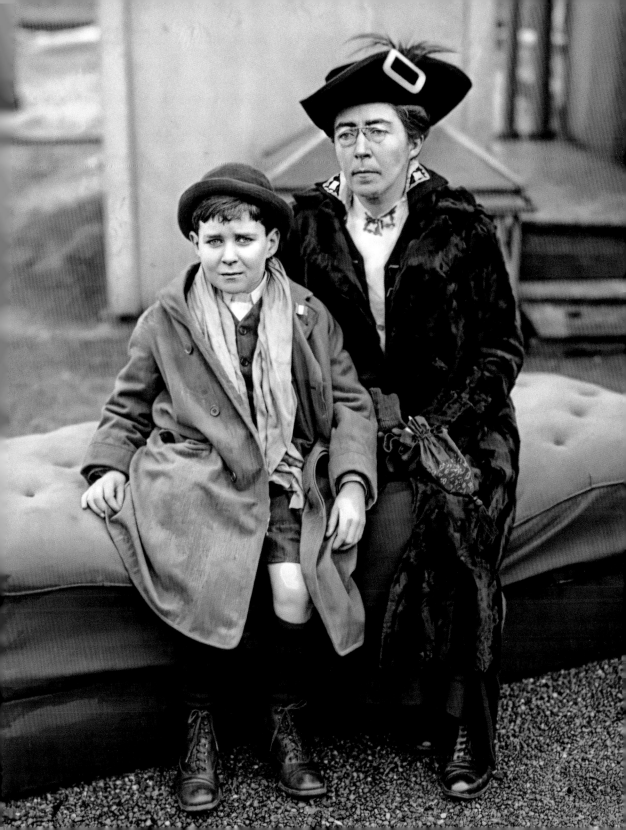

GIFFORD AND ORPEN (left)

1904–1910, Co. Dublin

Grace Gifford was an Irish caricature artist and a self-professed republican. She married Joseph Plunkett, one of the seven signatories of the Proclamation, in Kilmainham Gaol hours before his execution in the 1916 Easter Rising. She is pictured here with William Orpen, an Irish artist who served as an official war artist for the British Army during the First World War and was later knighted. Gifford studied under the direction of Orpen at the Dublin Metropolitan School of Art from 1904 to 1907.

HANNA AND OWEN IN NEW YORK (right)

6 January 1917, New York City, USA

Hanna Sheehy-Skeffington (1877–1946) was an Irish feminist, socialist and republican. She was a founder member of the Irish Women's Franchise League (IWFL) in 1908. In 1903, she married Francis Skeffington and the couple took each other's surnames as a feminist statement of equality. She is pictured here with her son, Owen Sheehy-Skeffington (1909–1970), who would go on to be a prominent and radical voice in twentieth-century Ireland. The picture was taken before she spoke to a crowded Carnegie Hall on 6 January 1917, the first of over 250 speeches on an eighteen-month speaking tour of the USA to raise attention to the circumstances surrounding her husband's death in 1916 and the situation in Ireland. She opposed the Treaty and remained an active feminist and socialist throughout her life.

'THE SPRING'

18 November 1925, USA

Lady Hazel Lavery (née Martyn) (1880–1935) dressed as Flora in Botticelli's painting *The Spring*. Born in Chicago to a family of Irish descent, Lavery was an actress, painter and socialite. In 1909, she married Belfast-born John Lavery, who was twenty-four years her senior. During the Treaty negotiations, Hazel and John's South Kensington house was used by the Irish delegation led by Michael Collins. Her portrait by John featured on all Irish Series A banknotes from 1928 until 1976. From then until the adoption of the euro, her likeness was used as the watermark on all Irish banknotes.

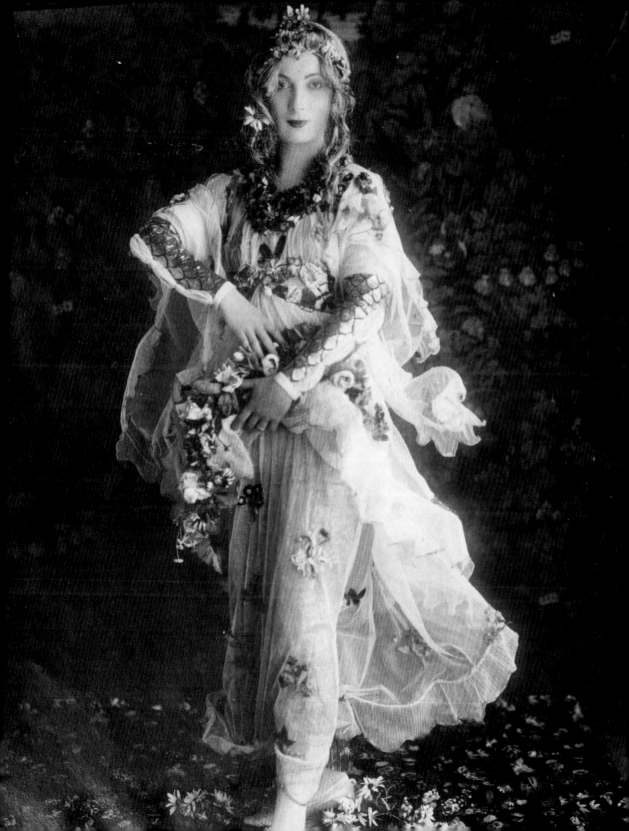

POVERTY IN THE IRISH FREE STATE

2 February 1924, Alexander Street, Waterford City

This photograph depicts a family – parents, grandmother and children – outside their 'home'. It shows the absolute poverty many were living in, both in urban and rural Ireland, before and after independence. The photograph was paid for by Mrs E. White, who commissioned similar images to show the conditions in Waterford City at the time. While Dublin was often the focus of slum conditions and poor housing, in 1936 Waterford was the focus of complaints on slum conditions being described in *The Irish Press* as being 'as bad as' the capital, with some 1,300 families being in need of rehousing.

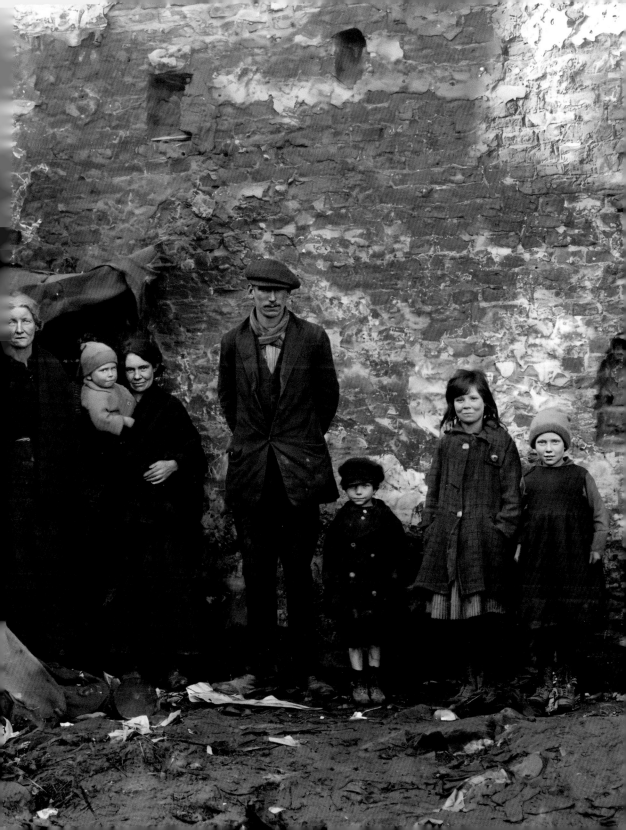

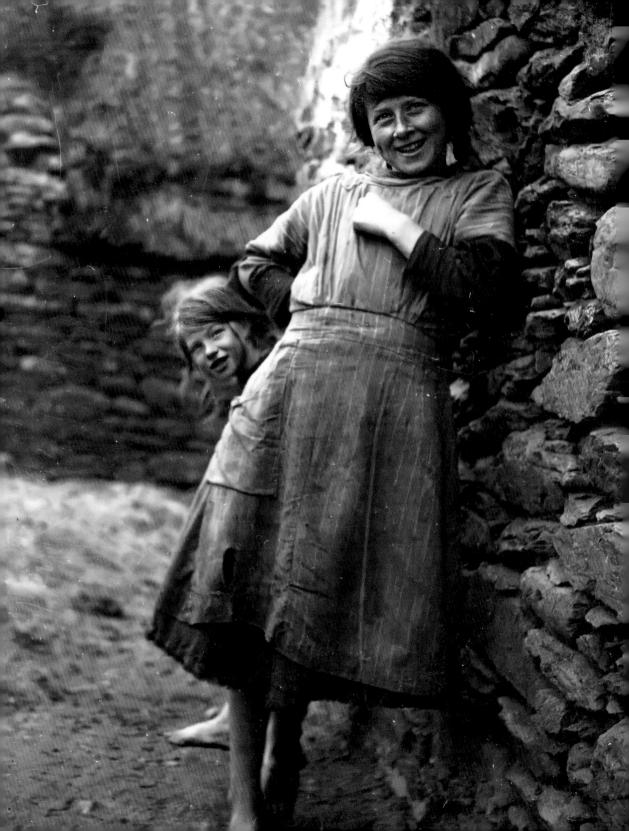

SMILING AND CURIOUS

*c.*1924, Great Blasket Island, Co. Kerry

Two young girls from the Blasket Islands, which were inhabited until 1953 by an Irish-speaking population. At their height, the islands had 175 residents; there were twenty-two by 1953. Carl W. von Sydow, the photographer and father of actor Max von Sydow, was one of the world's leading folklore scholars and encouraged the growth in comparative folklore studies from 1927 onwards. His trip to Ireland demonstrates the importance of Irish folklore studies at the time.

MIGRATION AND TRAGEDY

14 November 1935, Arranmore, Co. Donegal

This photograph was taken after the Arranmore Boating Tragedy in which nineteen people lost their lives. On the boat were fifteen islanders who were returning from harvesting in Scotland and five friends/family. They were travelling from Burtonport Harbour to the island in a yawl when it capsized in heavy swell. There was only one survivor. The tragedy affected everyone on the island, none more so than the wife of Edward Gallagher, the boatman, who lost her husband, four sons and two daughters. It was one of many similar tragedies from the nineteenth and twentieth century connected with seasonal migration – the most well-known being the Achill Island tragedy in 1894.

BAREFOOT AND SMILING

1935, Garmna, Ceantar na nOileán,
Co. Galway

Gorumna Island (Garmna in Irish) is
on the west coast of Ireland and has
been linked to the mainland by Béal an
Daingin Bridge since the mid-1890s.
In 1936, it had a population of 1,363
people. This photograph is taken from
the Muintir Uí Nia album.

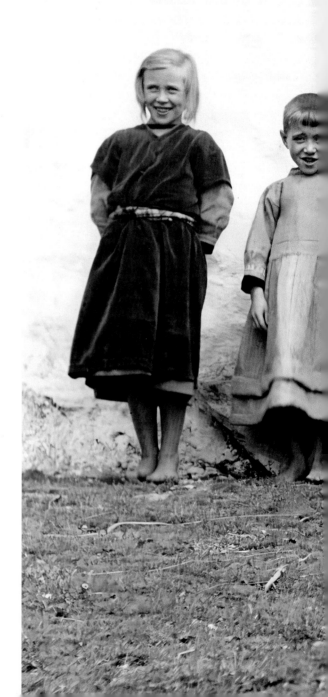

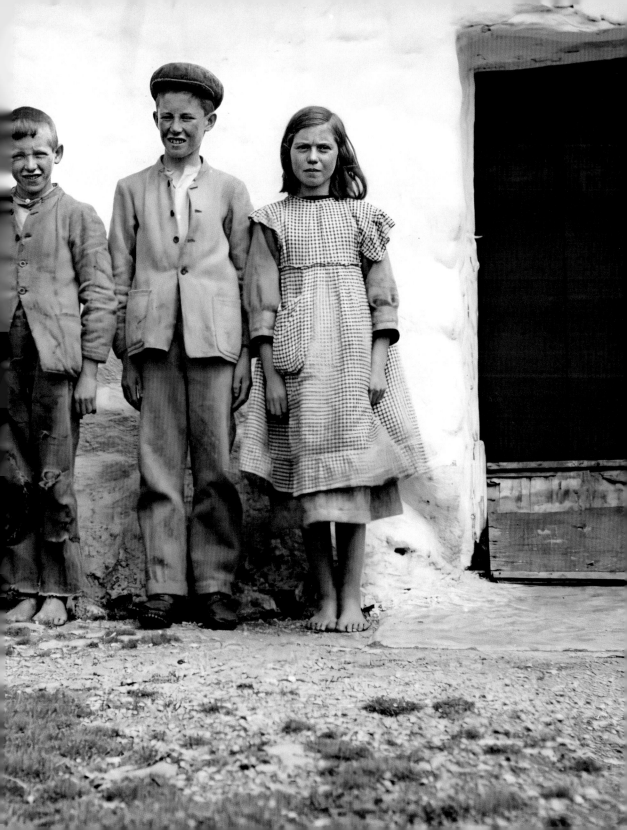

SPINNING

1935, Letterbrone, Co. Sligo

Mary Barlow at work on the spinning wheel. The pedal wheel in the photo was introduced to Ireland by the Huguenots and was most commonly used for spinning flax, which was then woven into linen. A larger wheel was used for spinning wool.

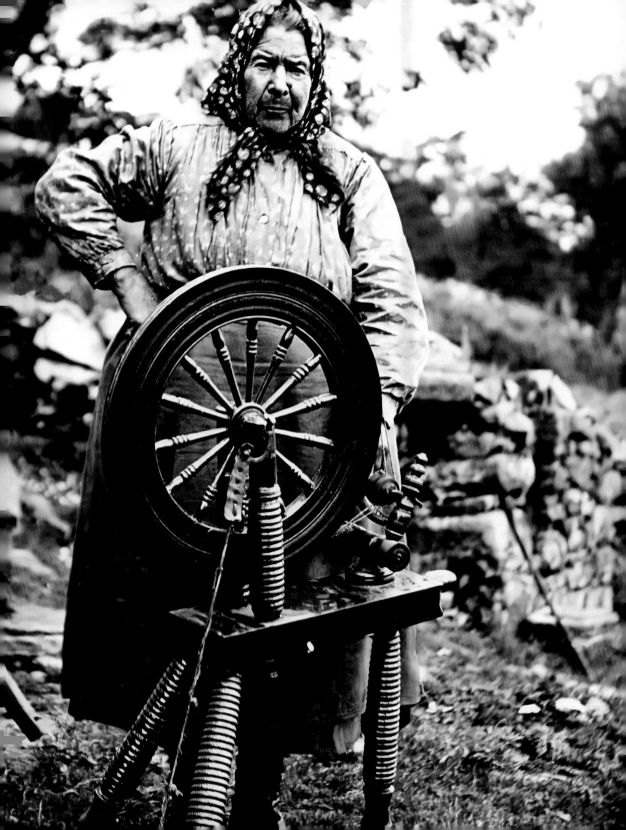

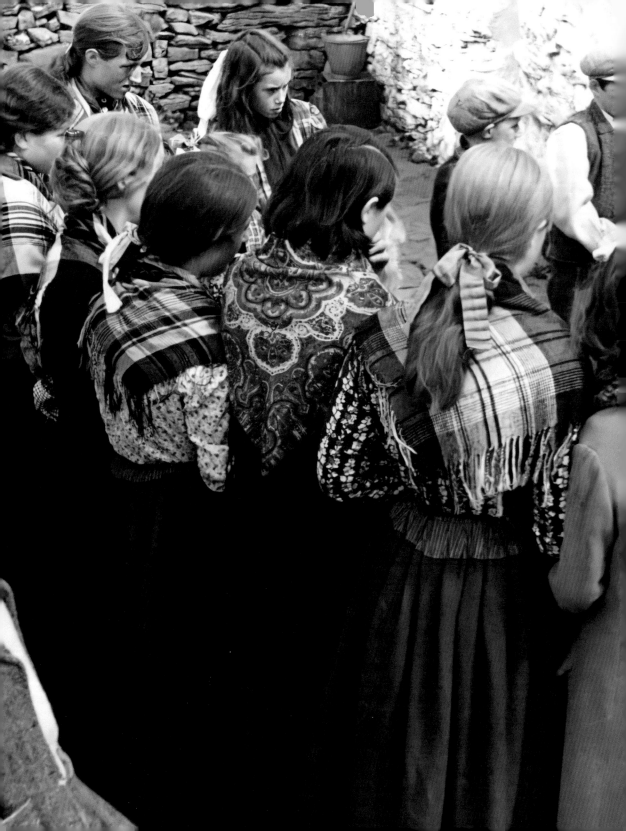

GATHER ROUND

1930s–1950s, Inis Meáin, Aran Islands, Co. Galway

A group of islanders gather round a young girl who is handing out the mail recently delivered by boat. Most are in traditional dress for the islands. When John Millington Synge visited Inis Meáin, he described men's clothes in the following manner, 'The simplicity and unity of dress … the natural wool, indigo, and grey flannel that is woven of alternate threads of indigo and the natural wool.'

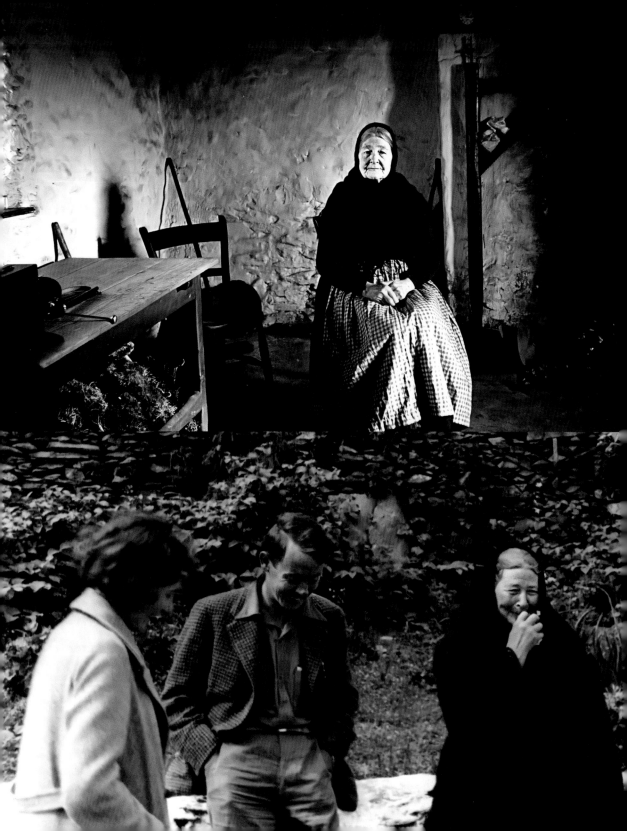

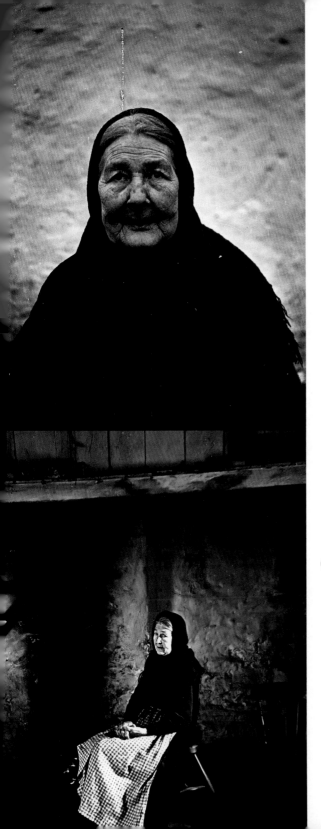

PEIG SAYERS

Peig Sayers was born Máiréad (Margaret) Sayers in Dunquin, Co. Kerry in March 1873. She was the youngest child of Tomás Sayers and Máiréad Ní Bhrosnacháin (Margaret 'Peig' Brosnan) Sayers and was educated at Dunquin National School until she was 12 years old. She married Pádraig Ó Guithín in February 1892 and would go on to have six children. She was a storyteller who dictated her famous autobiography, *Peig*, as well as imparting hundreds of stories to the Irish Folkore Commission. In many ways, Peig spoke for generations of Irish rural and island women, who have often been less represented in the canon of Irish literature, as well as in Irish history.

❯ AN TOBAR BEAG

1930–1940, Saint Colmcille's Well, Baile na hAbhann, Co. Galway

Holy wells were, and still are, places of popular religious devotion where people prayed and left simple offerings. They tend to date from pre-Christian times, where they served as a form of natural religion in which the well was held to be sacred.

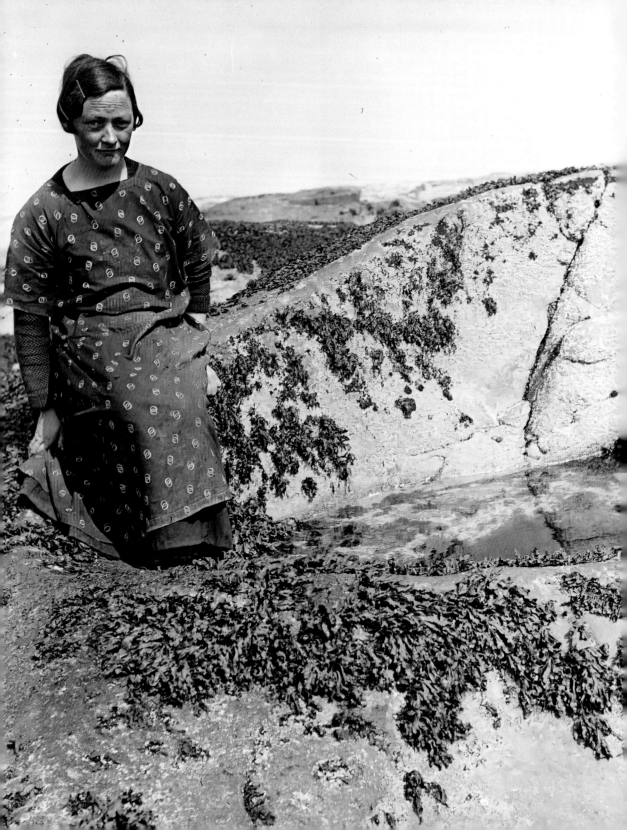

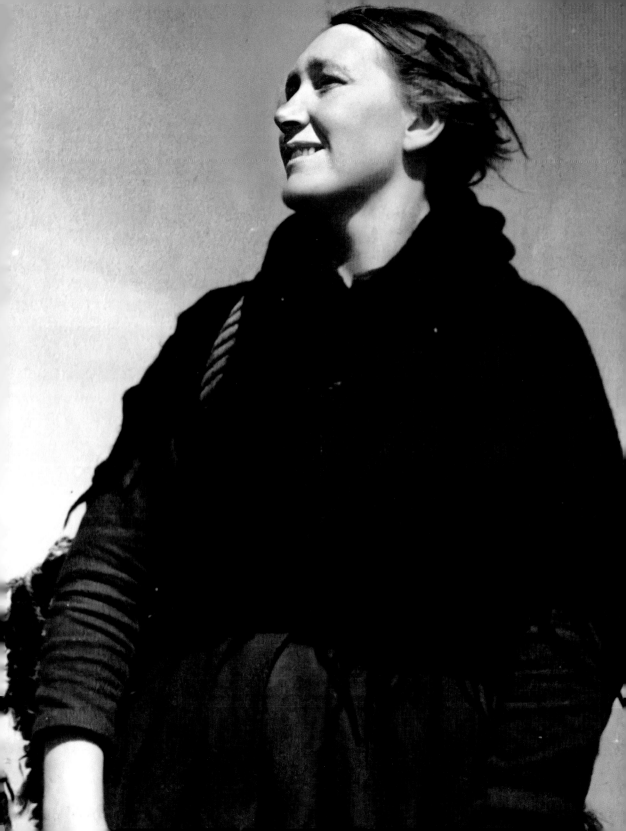

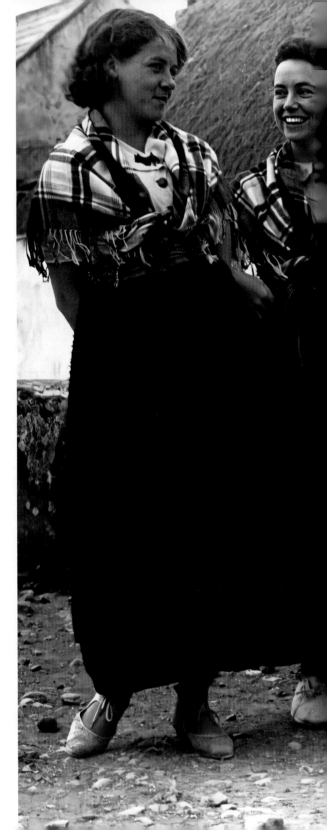

MAGGIE FROM *MAN OF ARAN*

1930s, Inis Mór, Aran Islands, Co. Galway

This is a photograph of Maggie Dirrane (1899–1995) wearing a traditional Aran shawl. Known locally as Maggie Tom, she played leading roles in the documentary film *Man of Aran* and in the first Irish-language sound-film ever made, *Oidhche Sheanchais*, both directed by Robert J. Flaherty and released in 1934.

EPHEMERAL ISLANDERS

1930s, Inis Meáin, Aran Islands, Co. Galway

Four visiting girls in traditional dress on Inis Meáin. Some of those pictured are originally from Dublin, according to their children and grandchildren, who contacted us via social media.

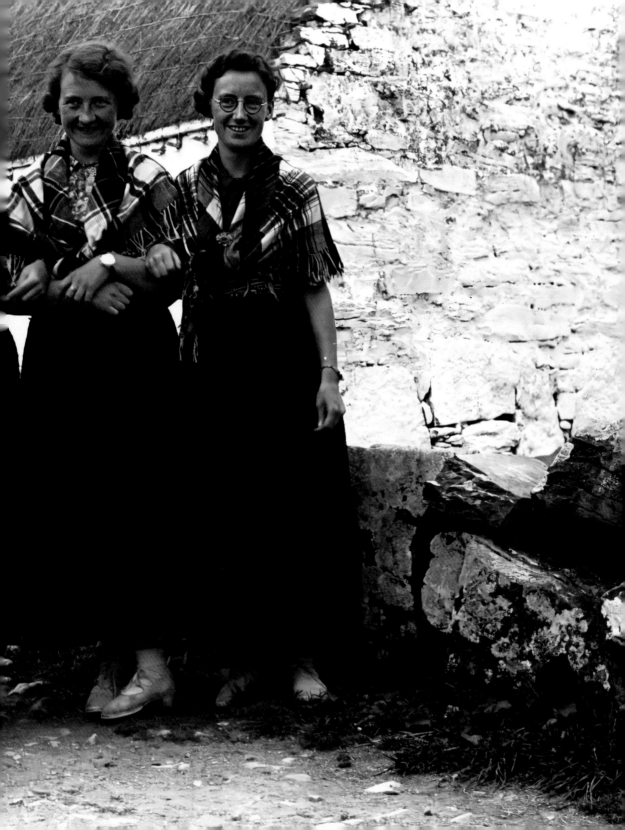

BIDDING THE TIME OF DAY

1950, Rathlin Island, Co. Antrim

Pictured here is islander Sarah Anderson.
The Irish language was primarily spoken on
the island until the 1960s and, famously, the
world's first commercial wireless telegraphy
link was established by employees of
Guglielmo Marconi between East
Lighthouse on Rathlin and Kenmara House
in Ballycastle on 6 July 1898. Marconi
had many Irish connections, including
his mother Annie of the famous Jameson
whiskey family, and his first wife, Beatrice
O'Brien, daughter of Baron Inchiquin.

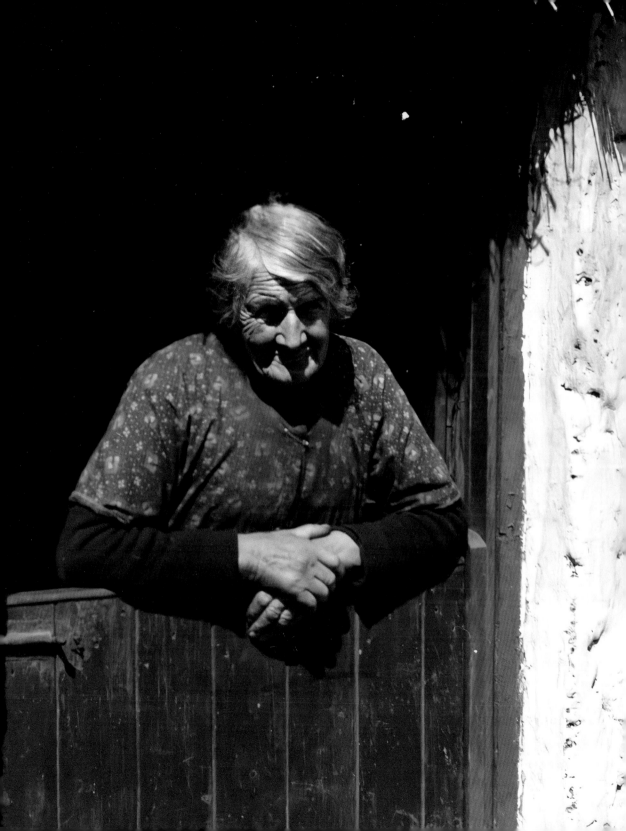

SUBLICHS

May 1954, Loughrea, Co. Galway

This photograph depicts members of the Sheridan and O'Brien families from the Irish Travelling community. Sublichs is the Cant (a language spoken by the Travelling community) term for boys. Mincéiri (or Irish Travellers) have experienced discrimination in Ireland, particularly since the 1960s, after the implementation of recommendations made by the Commission on Itinerancy (1963). It recommended assimilation of Travellers by settling them in fixed dwellings, which was pursued through the effective criminalisation of nomadism. The health of Irish Travellers is significantly poorer than that of the general population in Ireland. In 2017, Irish Travellers were recognised as a distinct ethnic group.

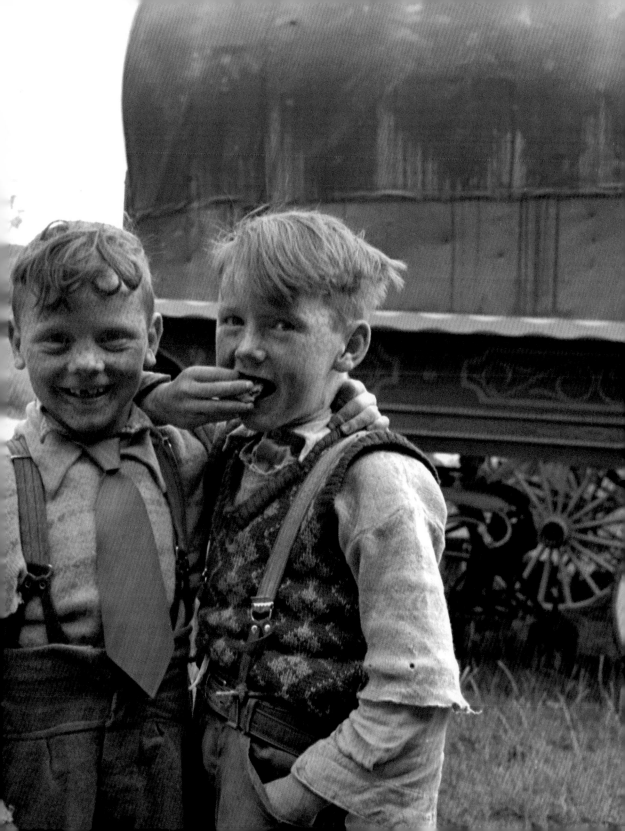

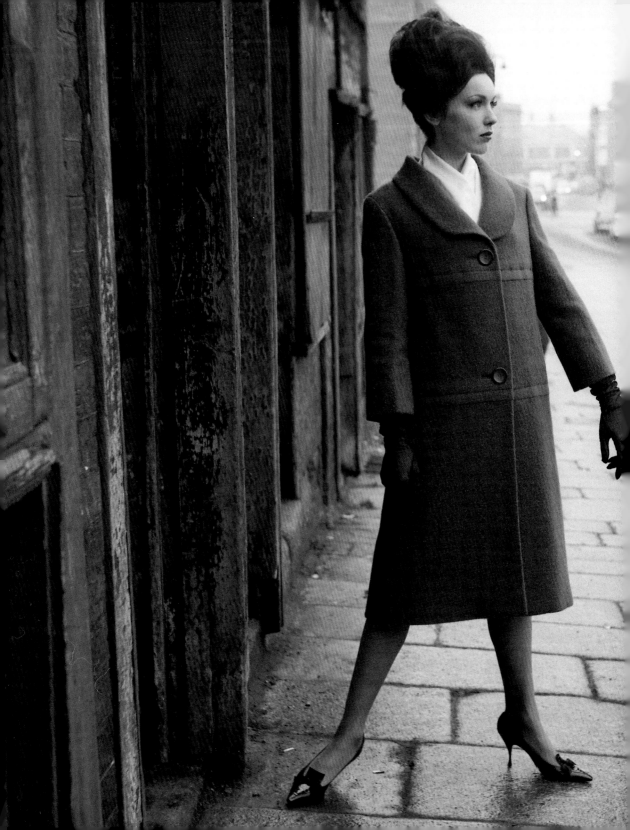

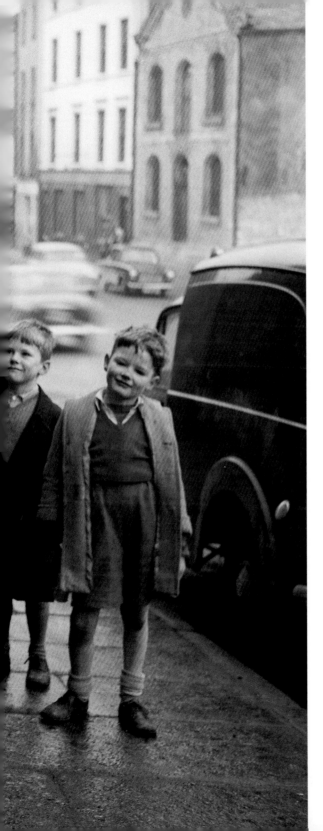

SIXTIES STYLE

1960–1966, Winetavern Street, Dublin City

Linda O'Reilly (née Ward) was an American model who married Brendan O'Reilly, a presenter on *Sports Stadium* on RTÉ Television. Pictured here on a photoshoot in Dublin, she swapped New York for Dublin's modelling scene, and this picture shows two local boys admiring her fashionable outfit. This photograph was taken by renowned photographer Colman Doyle and is thought to be dated between 1960 and 1966.

POSING IN 'THE GREEN'

1964, Dublin City

Surrounded by Georgian buildings, 'the Green' is one of Dublin's iconic parks, containing many historic monuments and scenic areas to walk and play; this particular fountain is the one where the water emerges from bulrushes.

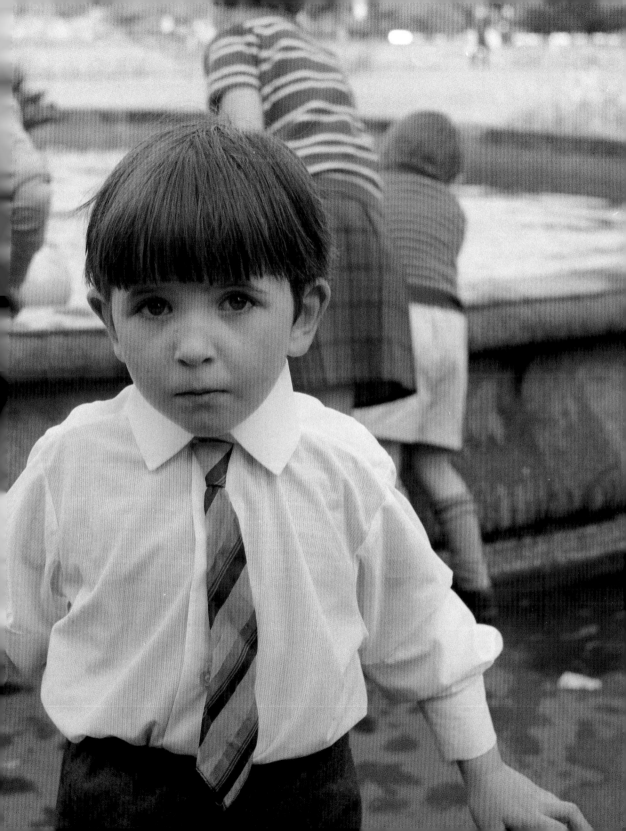

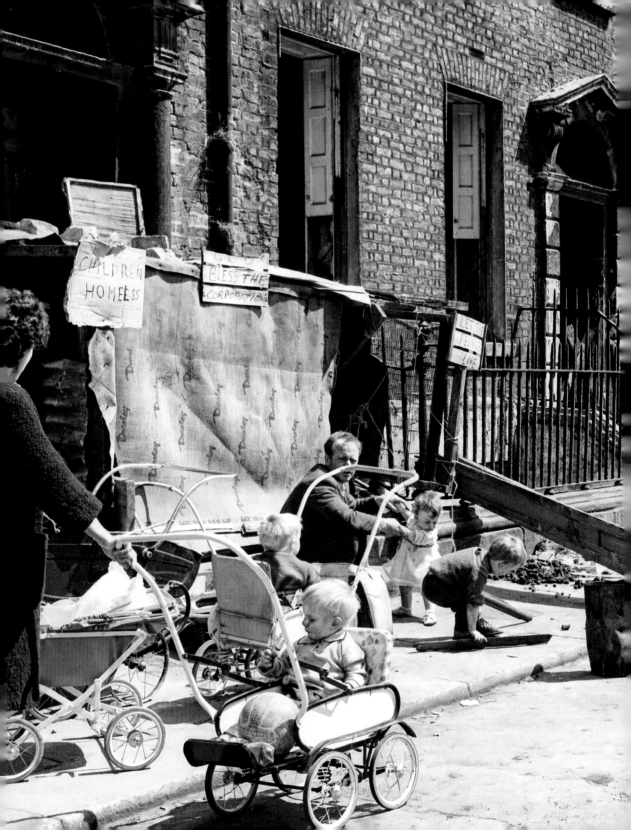

'GOD BLESS THE CORPORATION'

July 1964, Dublin City

Captured by Elinor Wiltshire on her Rolleiflex camera, signs at this protest against evictions from the tenements include 'God Bless the Corporation', 'Let People Live' and 'Children Homeless'. The last tenants in the former tenements in York Street left in 2005.

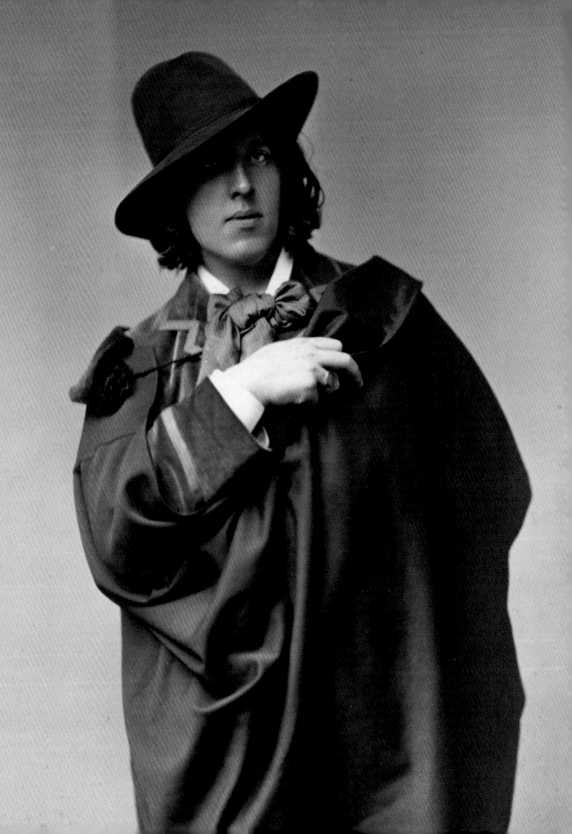

THE IRISH ABROAD

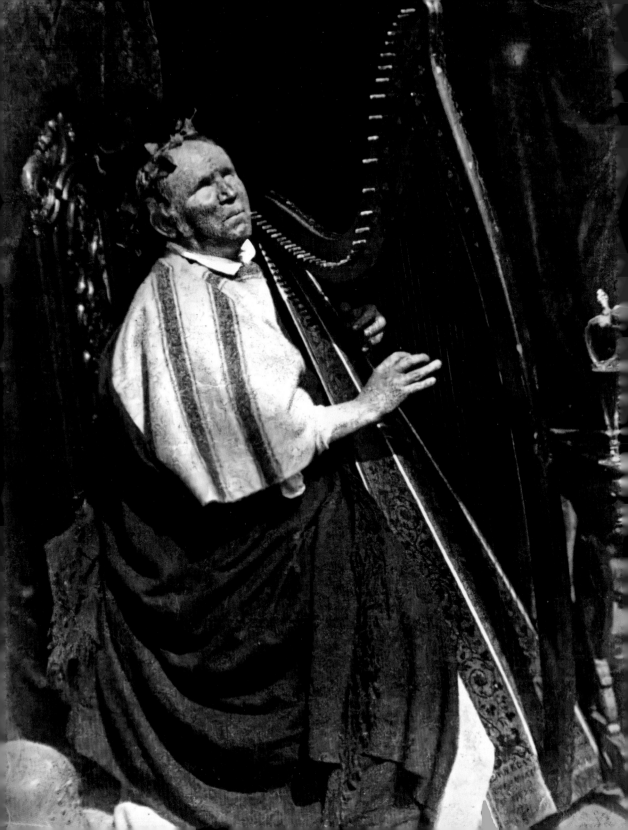

THE LAST OF THE GREAT IRISH HARPERS

1845, Edinburgh, Scotland

Patrick Byrne, or Pádraig Dall Ó Beirn (born *c.*1794 on the Monaghan–Cavan border, died 1863). He is the first Irish traditional musician to be photographed that we know of. This photograph is part of a series of calotype – one of the earliest photographic techniques – images.

OSCAR WILDE

1882, New York

Oscar Wilde was born in Dublin in 1854 and died in Paris in 1900. He was a poet, writer and dramatist, who is known for his works *The Picture of Dorian Gray* (1891) and the comic masterpieces *Lady Windermere's Fan* (1892) and *The Importance of Being Earnest* (1895).
He was a spokesman for the Aesthetic Movement in England and was involved in a number of court cases, both criminal and civil, involving the 'crime of homosexuality'. He was imprisoned prior to his death, from 1895 to 1897.

1ST DUKE OF WELLINGTON *(left)*

1 May 1844

Arthur Wellesley was born in Dublin on 1 May 1769. This would have been taken on his 75th birthday. After the end of his active military career, during which he defeated Napoleon at the Battle of Waterloo, Wellesley returned to politics and was twice British Prime Minister as a member of the Tory party – from 1828 to 1830, and for a little less than a month in 1834. He oversaw the passage of the Roman Catholic Relief Act 1829 but opposed the Reform Act 1832.

ADMIRAL WILLIAM BROWN *(right)*

*c.*1857, Argentina

William Brown, also known in Spanish as Guillermo Brown or Almirante Brown, was born in Foxford, Co. Mayo in 1777 and was an Argentine admiral. His family left Ireland when he was 9 years old and he fought in numerous wars. To this day, he is still regarded as one of Argentina's national heroes and is commonly known as the 'father of the Argentine navy'.

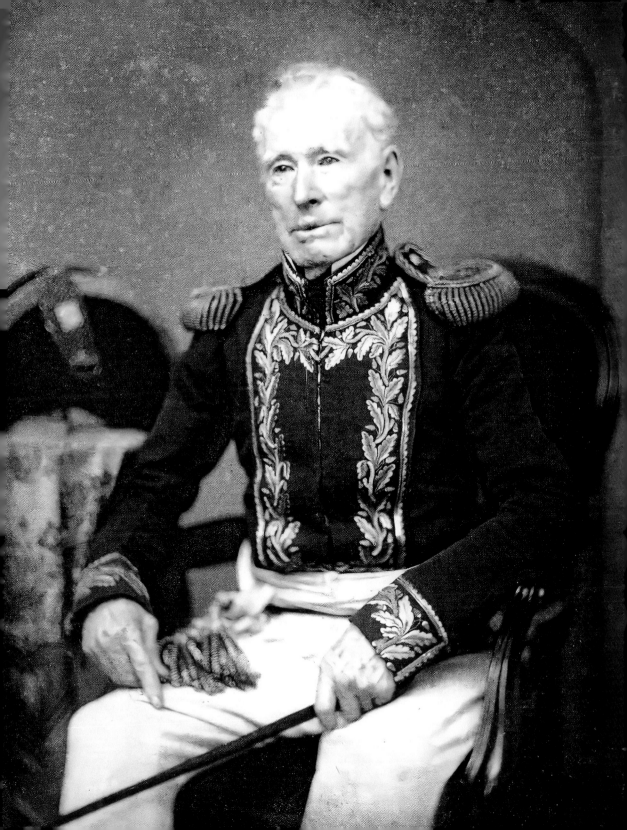

THE CATALPA RESCUE (CATALPA SIX)

The Catalpa rescue involved the escape of six Irish Fenian prisoners from the then British penal colony of Western Australia on 17–19 April 1876. The prisoners had arrived in Freemantle, on 9 January 1868, on the convict ship *Hougoumont*. In 1869, pardons had been issued to many of the imprisoned Fenians, with a further round of pardons coming in 1871. In 1874, one of the remaining prisoners smuggled a letter to America, to Fenian John Devoy. He and John Boyle O'Reilly (shown on right) mounted a rescue operation involving the purchase of the ship *Catalpa*. It dropped anchor in international waters off Rockingham and dispatched a whaleboat to the shore. At 8.30 a.m., six Fenians who belonged to work parties outside the prison walls, Thomas Darragh, Martin Hogan, Michael Harrington, Thomas Hassett, Robert Cranston and James Wilson, all successfully escaped and made it back to America.

John Boyle O'Reilly

November 1866, Mountjoy Prison, Dublin

John Boyle O'Reilly, one of the architects of the Catalpa rescue, was born in Co. Meath in 1844 and was a poet and journalist. After joining the British Army and being stationed in Ireland briefly, he joined the IRB in October 1864. He would go on to recruit over eighty soldiers to his regiment. He was arrested on 14 February 1866 and sentenced to twenty years in prison.

Overleaf, top left to right, bottom left to right

Sergeant Thomas Darragh

November 1866, Mountjoy Prison, Dublin

Sergeant Thomas Darragh was born in Co. Wicklow in 1834. He served in the 2nd Queen's Royal Regiment of the British Army for eighteen years, primarily in South Africa, although he

was decorated with bravery in the Second Opium War in China. He was married with two children and swore an oath to the Fenians in 1860. He was arrested in 1865 on a charge of mutinous conduct and was sentenced to life imprisonment.

Robert 'Big Bob' Cranston

November 1866, Mountjoy Prison, Dublin

Robert Cranston was born in Stewartstown, Co. Tyrone in 1840. He was a farmer prior to joining the 61st Regiment of Foot, stationed in Richmond Barracks, Dublin. He joined the Fenians in 1864 and was arrested in April 1866. He was court-martialled in June 1866 and was given a life sentence.

Michael Harrington

November 1866, Mountjoy Prison, Dublin

Michael Harrington was born in 1826 in Co. Cork and served with distinction in the 61st Regiment of Foot from 1844. He was decorated for his bravery during the Indian Mutiny in 1857. He took his oath to the Fenians in 1864 and was arrested in February 1866.

James Wilson

November 1866, Mountjoy Prison, Dublin

Wilson was born in 1834 in Co. Down. He joined the 5th Dragoon Guards in 1860 and the Fenians in 1864, where

he was a recruiter for John Devoy. After deserting with Martin Hogan, another of the Catalpa Six, in November 1865, he was arrested on 10 February 1866 in Dublin. He was court-martialled on 20 August 1866 and sentenced to life imprisonment.

Martin Hogan

November 1866, Mountjoy Prison, Dublin

Hogan was born in Limerick in 1839 and joined the 5th Dragoon Guards in 1857. He was sworn in as a Fenian in 1864 before deserting with James Wilson the following year. On 21 August 1866, he was court-martialled and sentenced to life imprisonment.

Thomas Henry Hassett

Mountjoy Prison, Dublin or Pentonville Prison, London

Thomas Henry Hassett, was born in 1841 in Doneraile, Co. Cork. A description of him from 1866 says he was 5ft 8in and had brown hair, hazel eyes, an 'oval' visage, a 'fresh' complexion and a 'middling stout' appearance. Hassett worked as a carpenter until he joined the 24th Regiment of Foot in 1861. In 1864, he took the Fenian oath. He deserted in 1866 and was arrested in Dublin in February 1866. He was court-martialled and, after pleading guilty to treason, was sentenced to life imprisonment in Australia. He died in 1893 in New York.

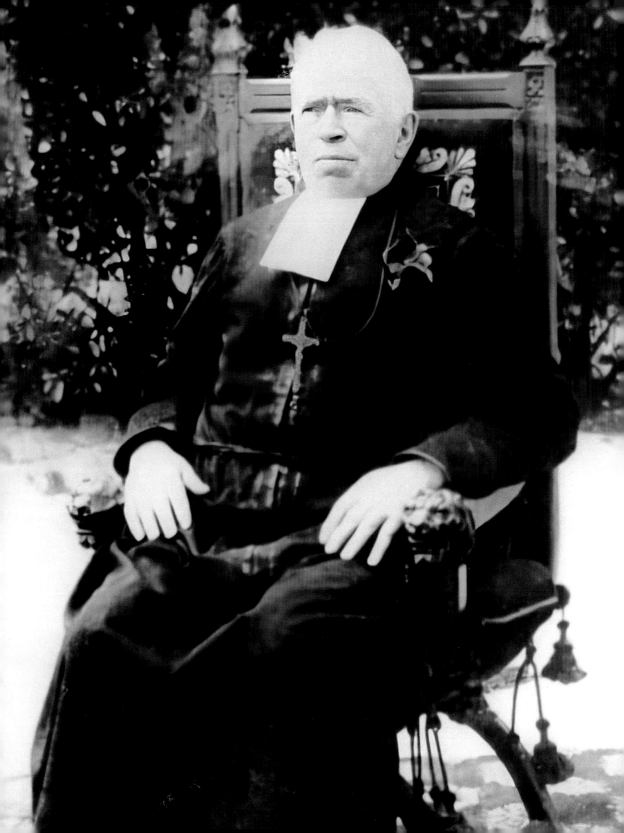

FOUNDER OF CELTIC FC

*c.*1910

Sligo-born Andrew Kerins (1840–1915),
known by his religious name Brother
Walfrid, was an Irish Marist Brother
and the founder of Celtic Football
Club. Aged about 70 years here, a
commemorative sculpture of Walfrid
was erected outside Celtic Park on 5
November 2005. In 1893, Walfrid was
sent by his religious order to London's
East End, where he continued his work.
He founded a charity named 'The Poor
Children's Dinner Table'. He is pictured
here wearing a sprig of shamrock.

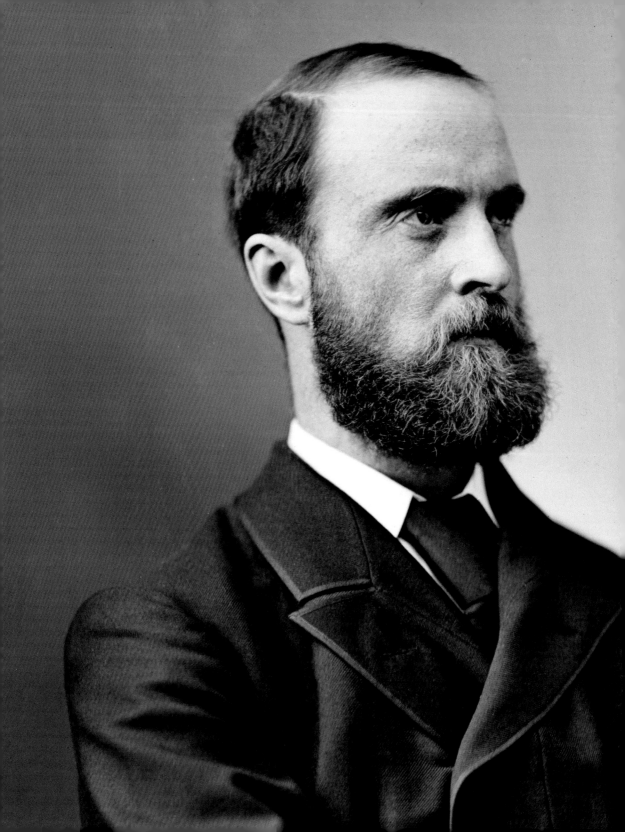

CHARLES STEWART PARNELL

1870–1880

Charles Stewart Parnell was born on 27 June 1846 in Co. Wicklow, and in 1878 he became an active opponent of the Irish land laws. In 1879, Parnell was elected president of the newly founded National Land League. In December 1889, William O'Shea, formerly one of Parnell's most loyal supporters, filed for divorce from his wife Katherine (Kitty) on the grounds of her adultery with Parnell. She had in fact been in a relationship with Parnell for some years, and Parnell was the father of three of her children. The scandal provoked a split in the Irish Parliamentary Party, of which he was the leader, and he was replaced. He was politically sidelined and died in Brighton on 6 October 1891.

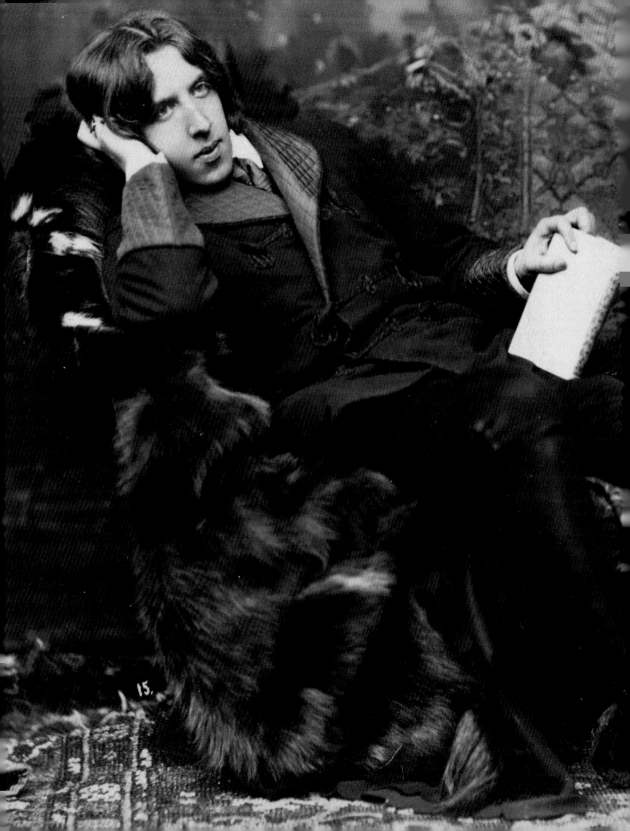

OSCAR WILDE

1882, New York

This image of Oscar Wilde is from a series of photographs taken by the famous photographer Napoleon Sarony at his New York studio. Sarony is known for his posed photographs of various theatre actors, politicians, and celebrities in the late nineteenth-century (including Sarah Bernhardt, Nikola Tesla, and Michael Davitt, as seen earlier in this book). Wilde arrived in New York for a lecture tour in January 1882, which is when he posed for these photographs.

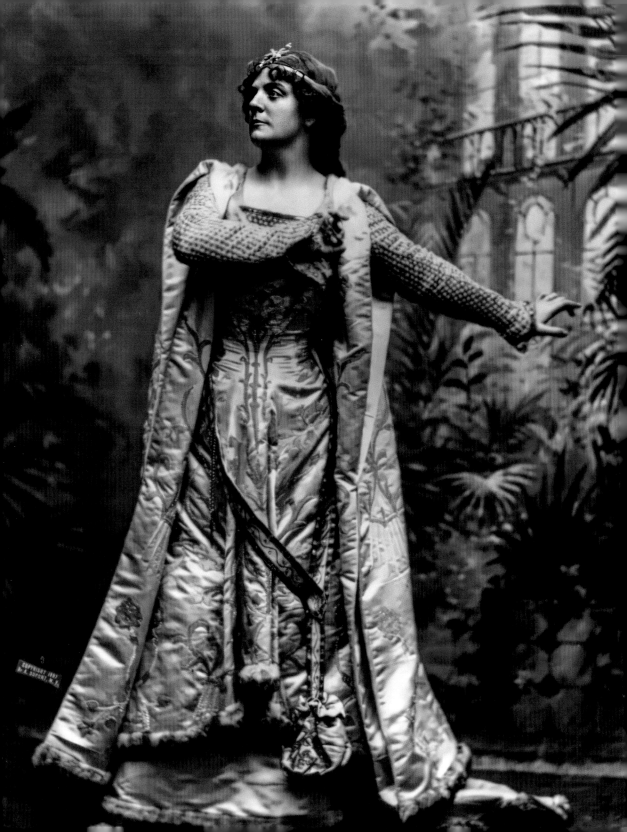

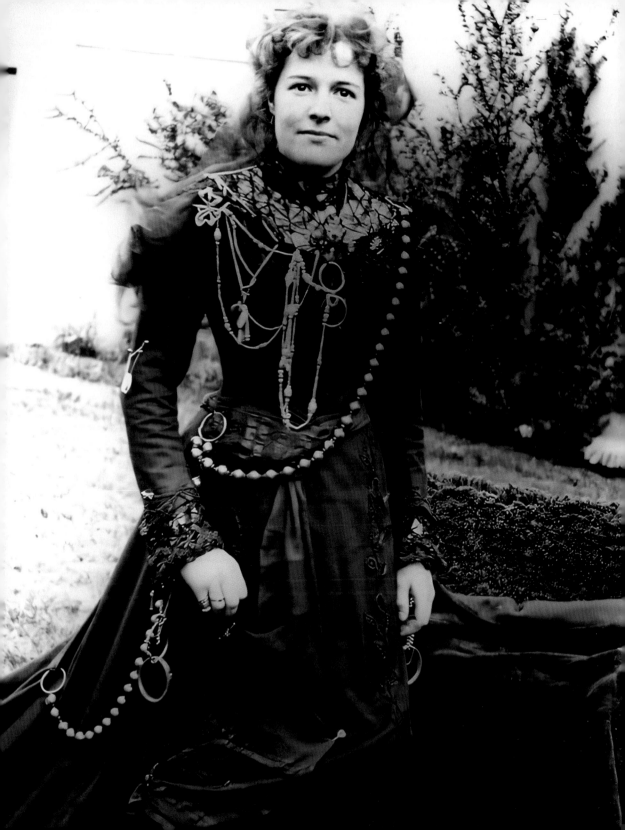

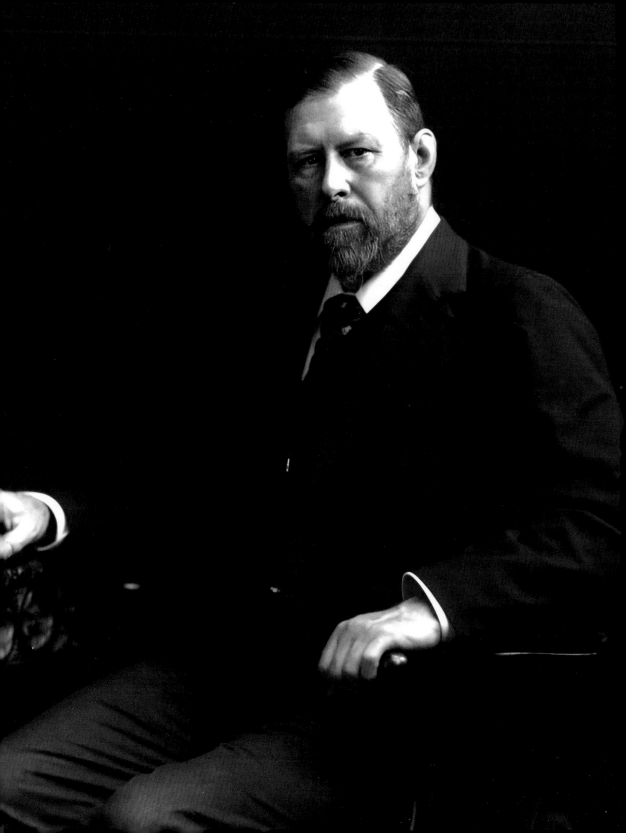

ADA REHAN (1857–1916) *(left)*

*c.*1897, New York, USA

Ada Rehan, born in Co. Limerick, was one of the most famed stage actresses in the world by the end of the nineteenth century. She was born Bridget Crehan and was one of five children born to Thomas Crehan and Harriet Ryan Crehan. George Bernard Shaw, Mark Twain and Oscar Wilde (who called her 'a brilliant and fascinating genius') were among her admirers.

MARGARET TERESA DOHERTY PENDER *(right)*

*c.*1880–1890

Margaret Teresa Doherty Pender, born in Ballytweedy, Co. Antrim, was a prolific Irish poet, writer and nationalist whose 1891 serialised novel *O'Neil of the Glen* was the source for the Film Company of Ireland's first indigenous Irish feature in 1916.

DRACULA

*c.*1906, London, UK

Bram Stoker (1847–1912) was born in Clontarf, Dublin. He was employed in the Irish civil service, during which time he also acted as a newspaper editor and theatre reviewer. He moved to London in 1878 and was a prominent member of the Irish Literary Society there in the 1890s. He is best known as the author of the 1897 Gothic masterpiece *Dracula*, of which there have been over 200 film adaptations.

Reg N° 52
Michael Mulvaney
North Shield
14 - 8 -

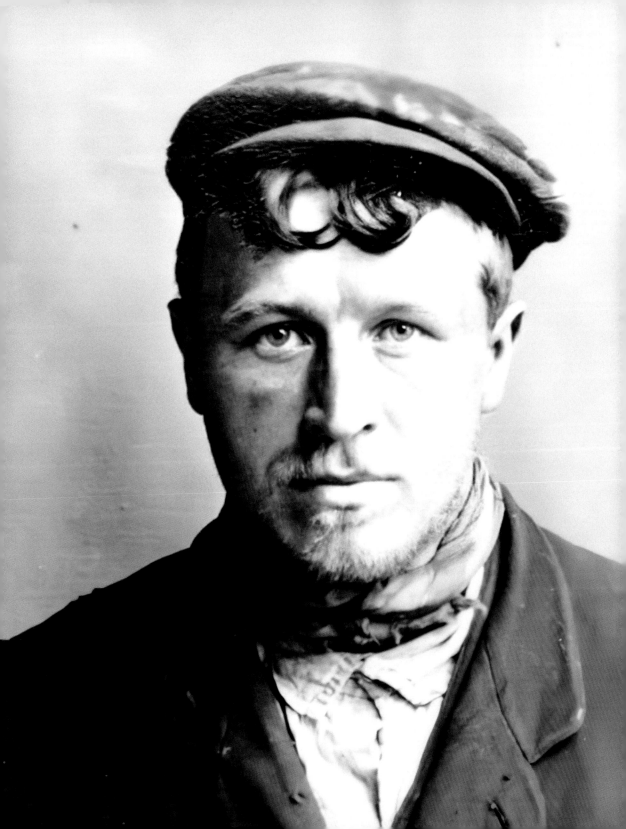

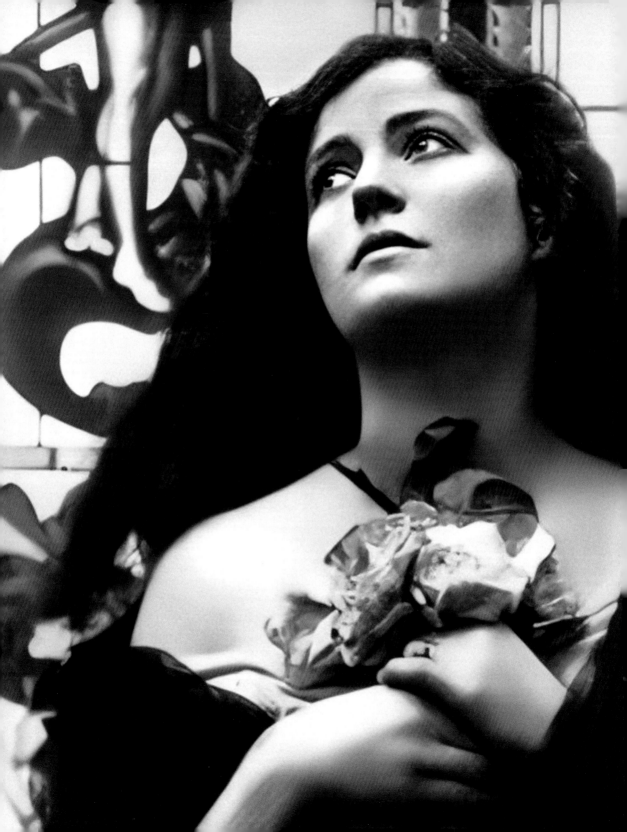

DRUNK AND DISORDERLY *(left)*

17 August 1904, Tyne and Wear, England

The *Shields Daily Gazette*, on the 17 August 1904, reported, 'Michael Mulvaney (63), a tramp of no fixed abode, was charged at North Shields with being drunk in Duke Street, and with begging. The offences were admitted. He was fined 2s 6d and costs or seven days imprisonment in each case.'

TRAMPING *(right)*

13 July 1906, Trefechan, Wales

Joseph O'Connor, 28 years of age, 5ft 8ins, blue eyes, light brown hair, a 'tramping labourer', born in Galway. He was charged in 1906 with stealing a parcel of peddling goods from a common lodging house in Trefechan.

ALICE RUSSON

1907

Born in Dublin, Alice Russon was an actress, singer and dancer who appeared in musical comedies and silent films. She was also a keen photographer and worked in Britain, the United States and Australia.

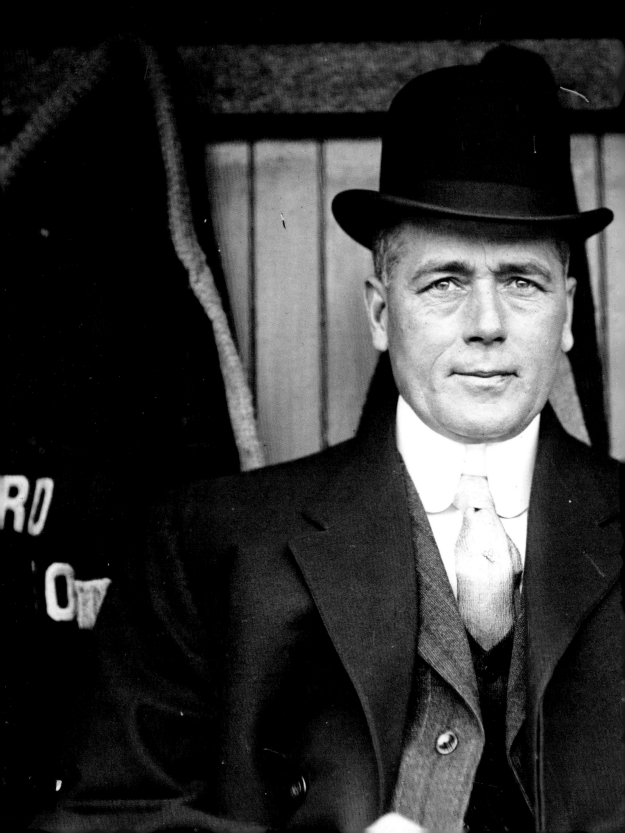

IRISH MAJOR LEAGUER

*c.*1911, Boston, USA

At the time of this photograph, Patsy Donovan (1865–1953) was the manager of the Red Sox baseball team. Born in Cobh, Co. Cork, Donovan was the most successful Irish-born major leaguer: a right fielder and manager in Major League Baseball from 1890 to 1911. Donovan died on Christmas Day 1953 after a long illness. He was buried in St Mary's Cemetery in Lawrence, Massachusetts.

JAMES CECIL PARKE
(1881-1946)

31 August 1909, USA

James Parke was an Irish rugby union player, a tennis player, a golfer, an Olympic silver medallist and an Australasian Championships winner. Parke was born in Clones, Co. Monaghan in 1881. He played rugby with Monkstown, Dublin University and Leinster, and between 1903 and 1909, he won twenty Ireland caps. As a tennis player, he won numerous singles and doubles competitions, including the Wimbledon Mixed Doubles title in 1914 and the Australian Men's singles and doubles tennis titles in 1912. He recorded his greatest feats in the Davis Cup, where he defeated Norman Brookes and Rodney Heath in the Challenge Round in 1912. He was also a top-class track and field sprinter. He died in Llandudno, Wales in 1946.

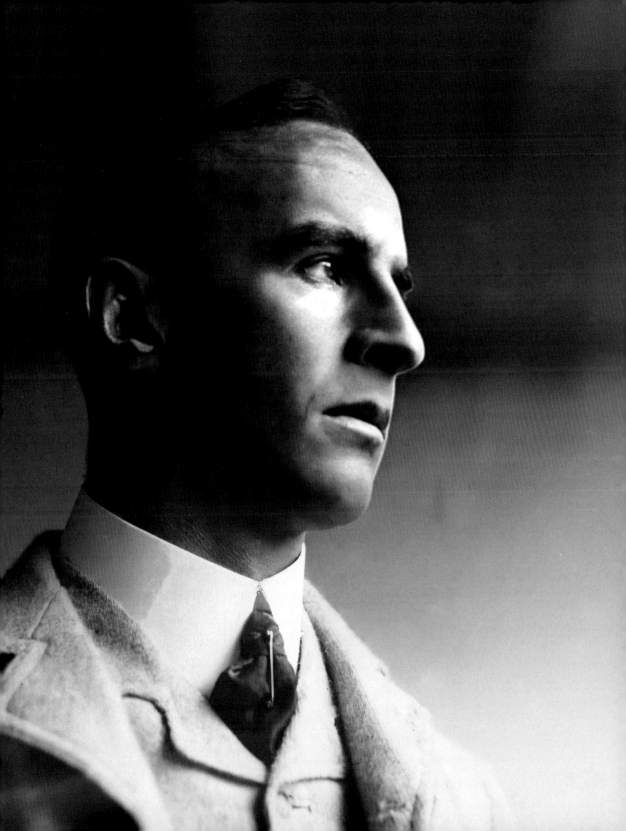

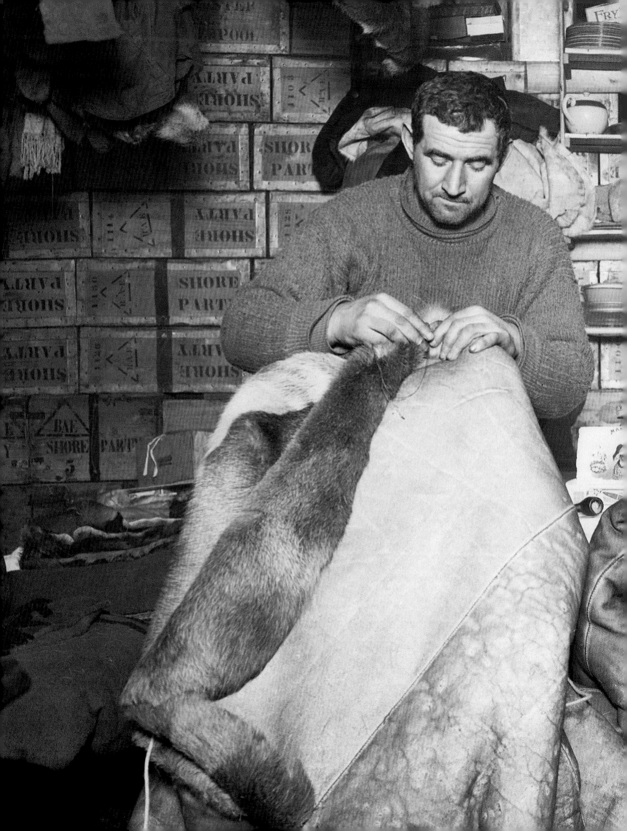

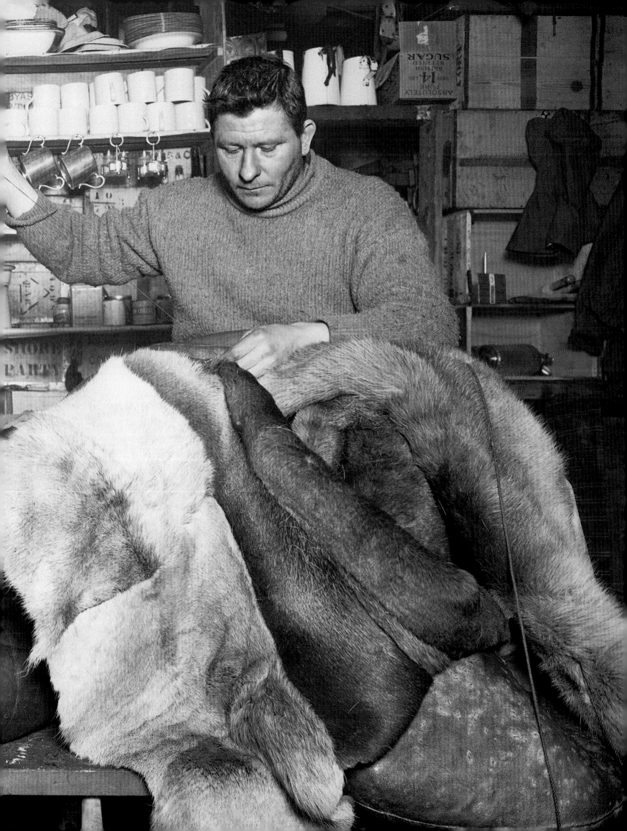

MENDING THE BAGS

16 May 1911, Antarctica

Taken during the British Antarctic Expedition (also known as the Terra Nova Expedition) from 1910 to 1913, this photo shows petty officers Tom Crean (1877–1938) and Edgar Evans (1876–1912) mending sleeping bags. Crean, originally from the farming area of Gortacurrane near the village of Annascaul, Co. Kerry, was an Irish seaman and Antarctic explorer who was a member of three major expeditions to Antarctica. He began his exploring career after volunteering to take part in Robert Falcon Scott's 1901–4 Discovery Expedition. On his second expedition, the Terra Nova, Crean was not chosen by Scott to be part of the final polar party. Evans was, and on 17 January 1912 they attained the Pole, only to find that the Norwegian team led by Roald Amundsen had preceded them by thirty-four days. The party perished as they attempted to return to the base camp. After his experience on the Terra Nova, Crean's third and final Antarctic venture was as second officer on Ernest Shackleton's Imperial Trans-Antarctic Expedition. After the ship *Endurance* became overwhelmed in the pack ice and sank, Crean and the ship's company spent 492 days drifting on the ice before taking the ship's lifeboats to Elephant Island.

SALLY'S PUPS

1914–1916, Antarctic

Tom Crean pictured in the Antarctic on the Shackleton Expedition holding Sally's quadruplets (the pups by Sally and Samson: Roger, Nell, Toby and Nelson). The Imperial Trans-Antarctic expedition of 1914–1917 is considered to be the last major expedition of the Heroic Age of Antarctic Exploration. Conceived by Sir Ernest Shackleton, the expedition was an attempt to make the first land crossing of the Antarctic continent. The expedition failed to accomplish this objective but became recognised instead as an epic feat of endurance. In the absence of a Canadian dog-handling expert who was hired but never came on the expedition, Crean took charge of one of the dog-handling teams, and was involved in the care and nurture of the pups born to one of his dogs, Sally, early in the expedition.

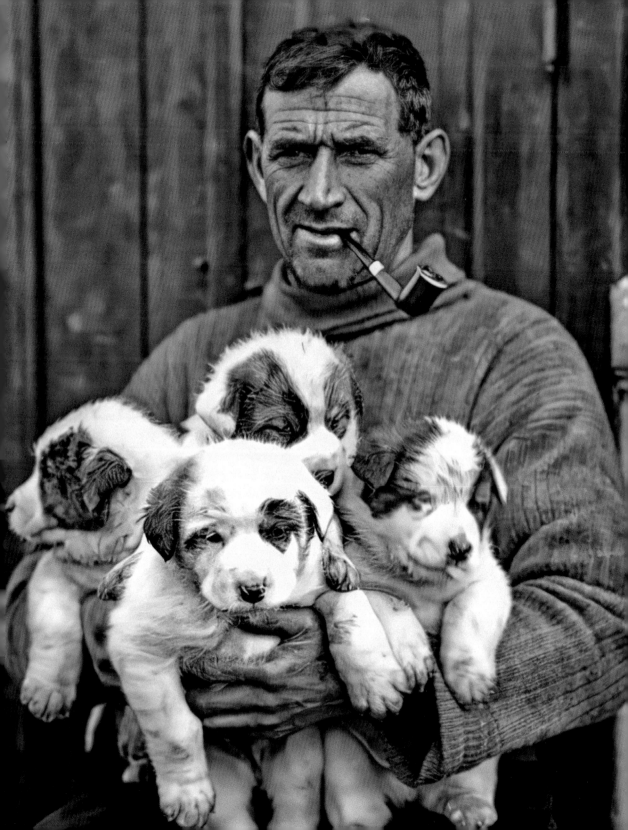

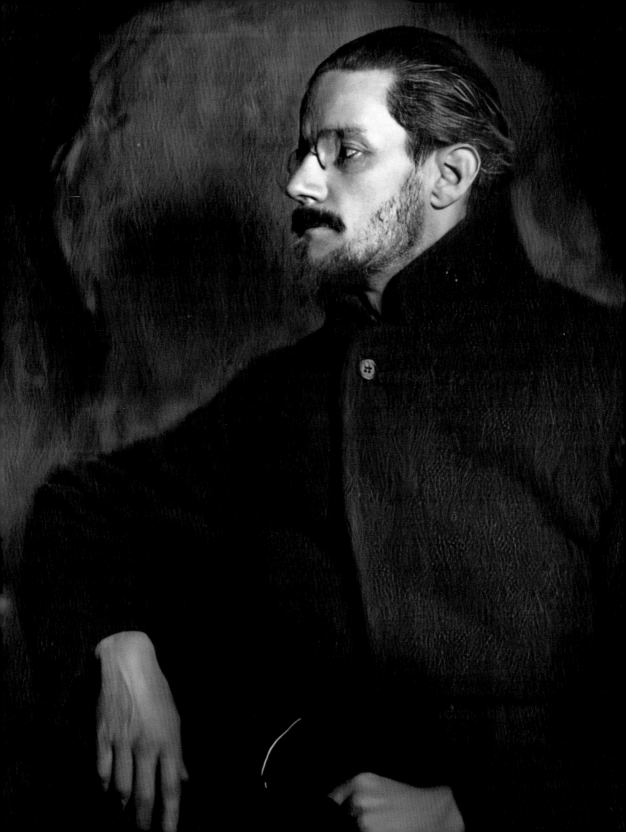

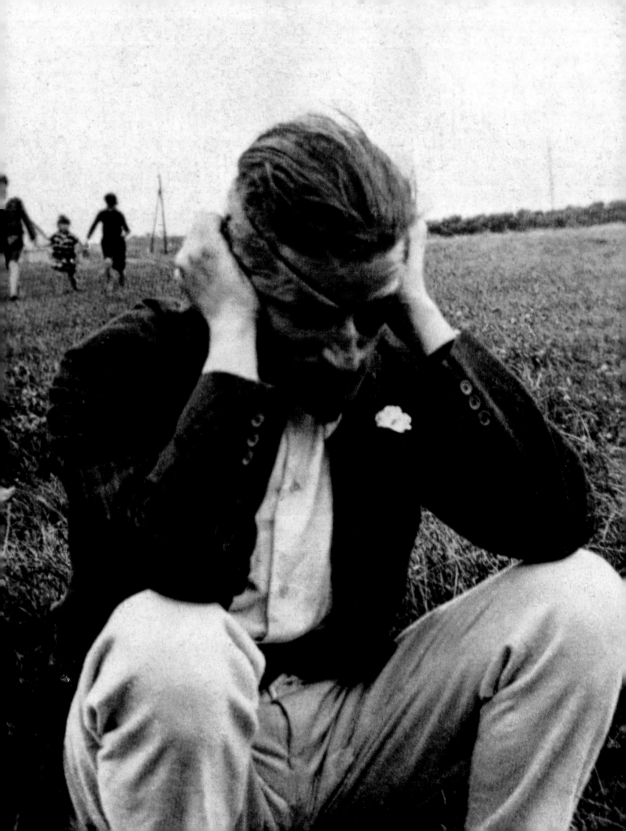

'REVOLUTIONARY' JOYCE
(left)

*c.*1918, Zurich, Switzerland

James Joyce was born in Dublin in 1882 and died in Switzerland in 1941. He is the world-renowned author of *Dubliners* (1914), *A Portrait of the Artist as a Young Man* (1916), *Ulysses* (1922) and *Finnegans Wake* (1939). In 1904, he met his future wife, Galway woman Nora Barnacle. They would have two children and live in France for much of their lives. Joyce died on 13 January 1941 in Zurich, where he and his family had been given asylum during the Second World War. He is buried in Fluntern Cemetery, Zurich. This image was included in a printed subscription order form for *Ulysses*.

TORMENT IN FRANCE
(right)

1922, France

Joyce spent many years in France, including Paris, where he finished his novel *Ulysses*, and in Nice, where he started to work on *Finnegans Wake*. He frequently travelled to Switzerland for eye surgery during his years in France, and later returned there in 1940 to flee the Nazi occupation of France.

IRELAND'S MOST FAMOUS TENOR

30 April 1921, RMS *Aquitania*

John McCormack (1884–1945), known for his performances of both operatic and popular songs, was born in Athlone, Co. Westmeath in 1884. McCormack sang in the Palestrina Choir of Dublin's Pro-Cathedral, where he was discovered by choirmaster Vincent O'Brien. O'Brien's other pupils included Margaret Burke Sheridan and a young James Joyce, who also knew McCormack. McCormack took vocal lessons in Italy in 1905, and started to perform opera in many countries including England, Australia, and the USA. We obtained John McCormack's blue eye colour from a 1910 Ellis Island passenger record.

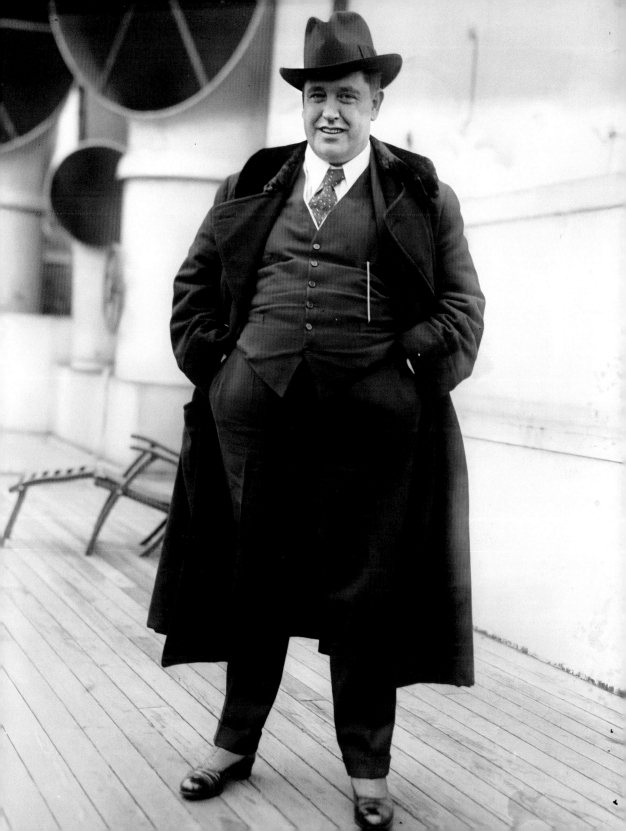

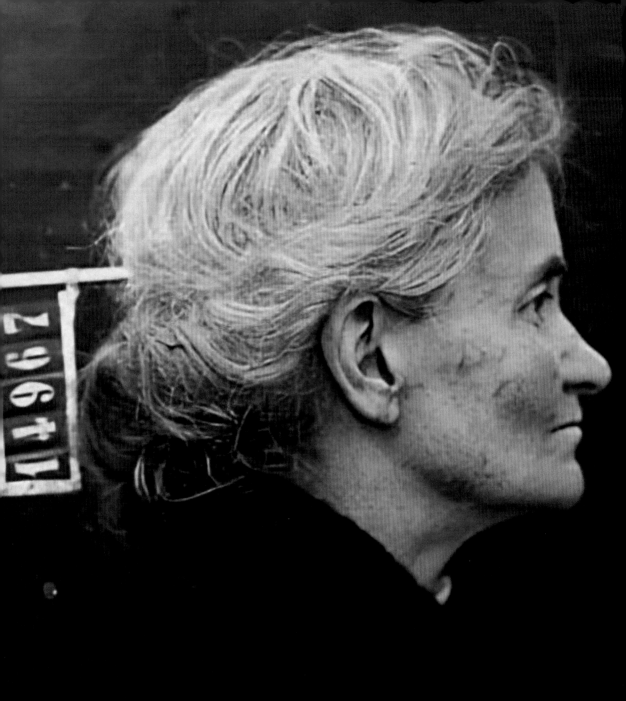

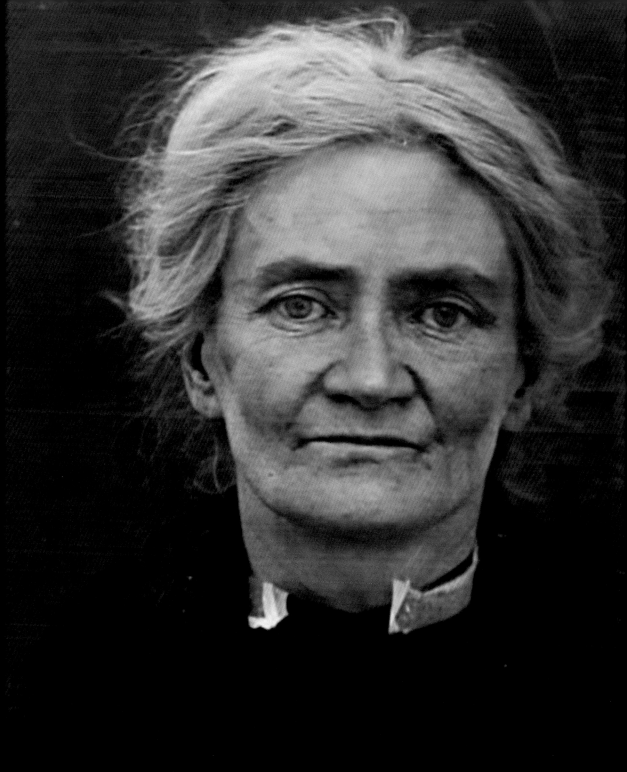

THE IRISHWOMAN WHO SHOT MUSSOLINI

7 April 1926, Rome, Italy

Violet Gibson shot Mussolini in the nose as he walked among the crowd in the Piazza del Campidoglio in Rome. She was born in Dublin in 1876, the daughter of Irish lawyer and politician Baron Ashbourne. After the attempted assassination, she lived the rest of her life in St Andrew's Hospital, dying in 1956.

IRELAND'S MOST FAMOUS WOBBLIE

1 May 1929, USA

Mary Harris Jones (otherwise known as 'Mother Jones') was a union activist who founded the Social Democratic Party and helped establish the Industrial Workers of the World (or 'Wobblies'). Jones was born in Co. Cork in the late 1830s, and her family migrated to Canada and later America, after the Great Famine. She would tragically lose all her family to a yellow fever outbreak and then her home in the great Chicago fire.

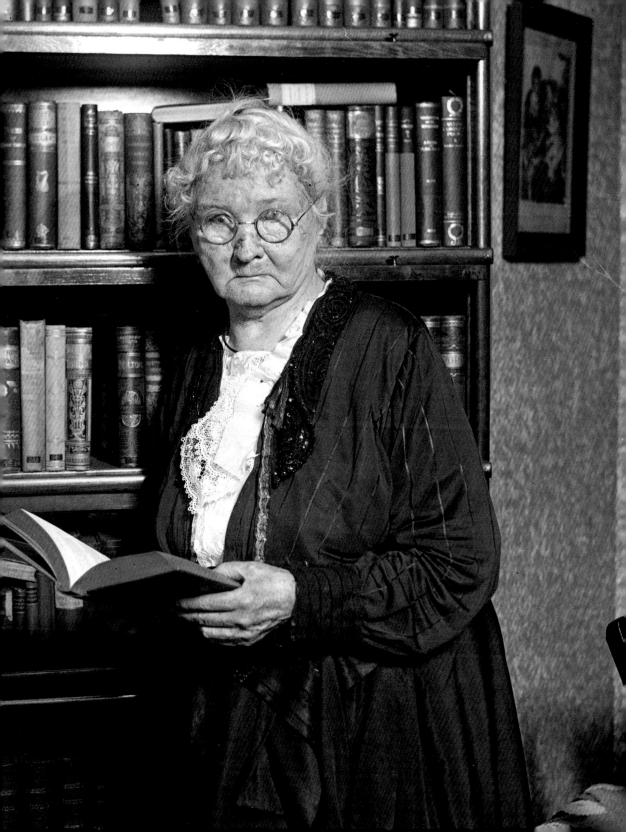

MAGGIE FROM MAYO

1938, London, England

Margaret Burke Sheridan (1889–1958) was an Irish opera singer and Ireland's second prima donna after Catherine Hayes. Born in Castlebar, she was known as 'Maggie from Mayo'. When she played the part of Madama Butterfly, Giacomo Puccini was said to have been 'spellbound'. She is pictured here with Italian conductor Vincenzo Bellezza (1888–1964).

◗ PEGGY CUMMINS (1925–2017)

1950, USA

Peggy Cummins was an Irish actor with twenty-eight credits; she was born in Wales and lived most of her early life in Killiney, Dublin. She is best known for her performance in *Gun Crazy* (1950), playing a trigger-happy femme fatale who robs banks with her lover.

Peggy Cummins

◉ GRACE

*c.*1954, USA

Grace Kelly (1929–1982) was an Irish American actress with Mayo roots. She married Prince Rainier III of Monaco to become Princess Grace. Prior to this, she starred in eleven motion pictures. Kelly was born into a wealthy Irish Catholic family in Philadelphia; her father was John B. Kelly, a gold-medal winning oarsman, and her uncle was the playwright George Kelly. She was educated in convent and private schools before attending the American Academy of Dramatic Arts in New York City in 1947. In 1954, she won an Oscar for best actress for her performance in *The Country Girl*.

PRESIDENT JOHN F. KENNEDY'S VISIT TO IRELAND

29 June 1963, Co. Limerick

President Kennedy visited Limerick City on Saturday, 29 June 1963 on the last day of his Irish tour. He was introduced to his Limerick cousins from his maternal Fitzgerald side and honoured as a Freeman of Limerick. Here, he entertains the crowds gathered at Greenpark Racecourse as he receives the Freedom of the City. The *Limerick Chronicle* stated, 'Never before had a President of the Great United States stood for nearly 30 minutes on Limerick soil. We were prouder still because of the fact that his maternal ancestors came from the plains of Limerick.'

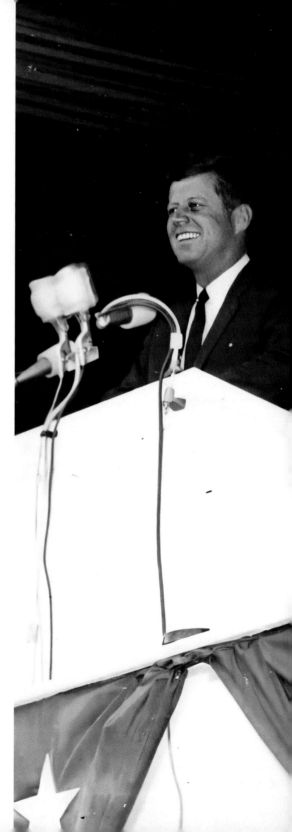

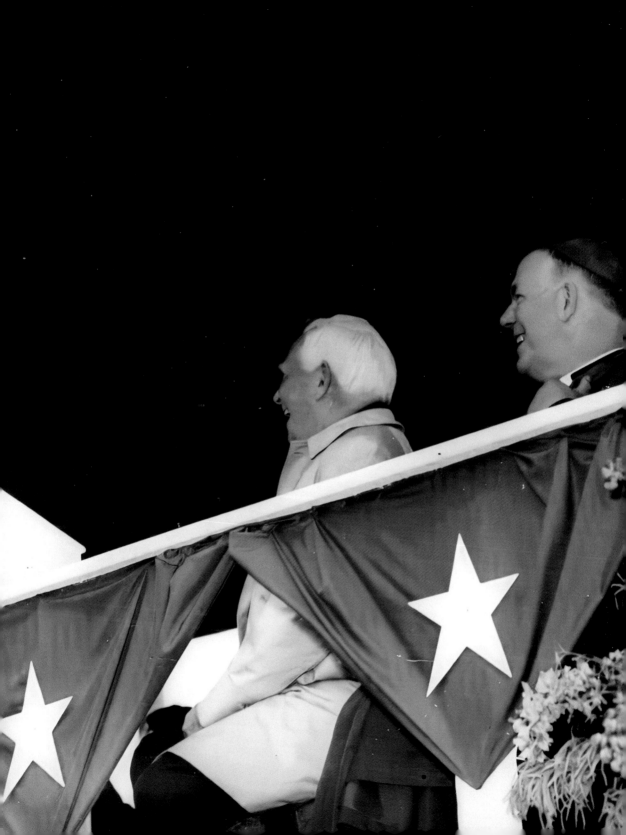

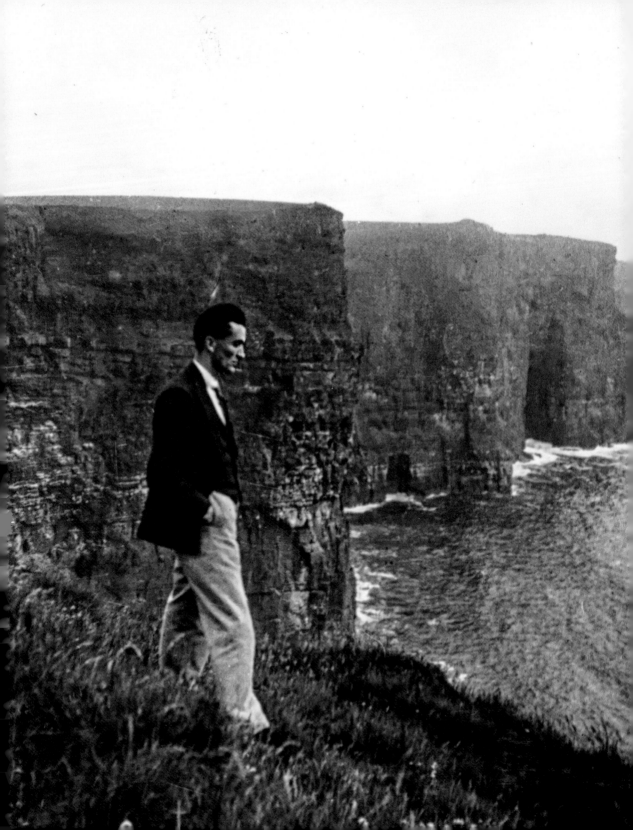

SCENIC IRELAND

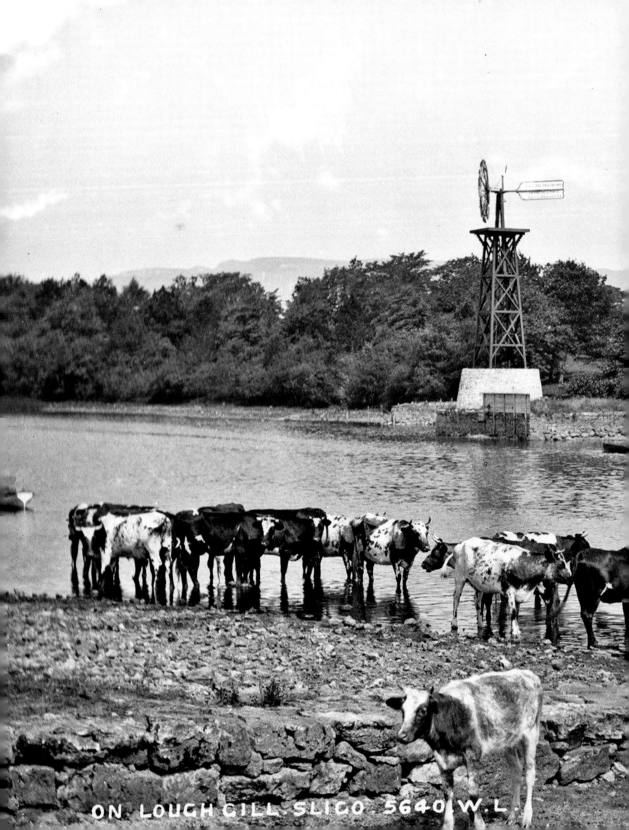

ON LOUGH GILL. SLIGO. 5640 W.L.

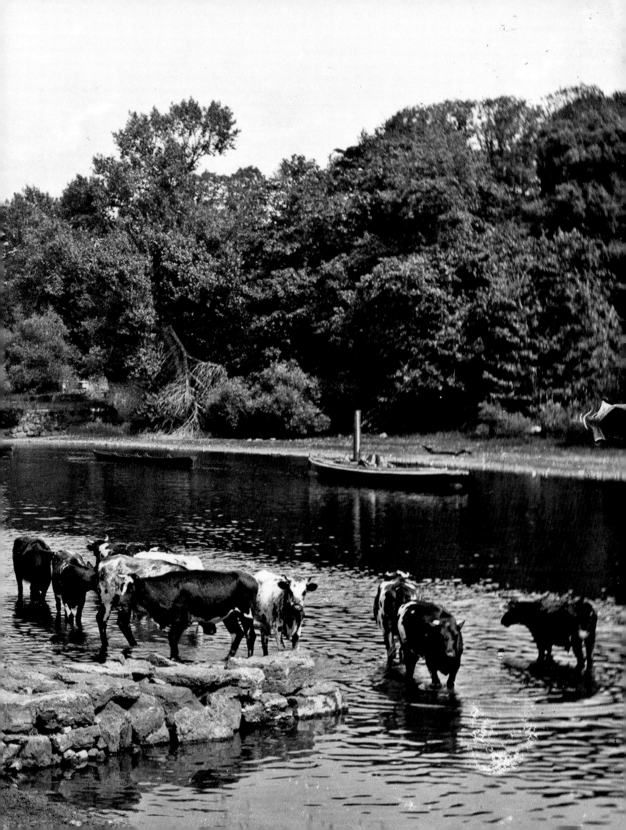

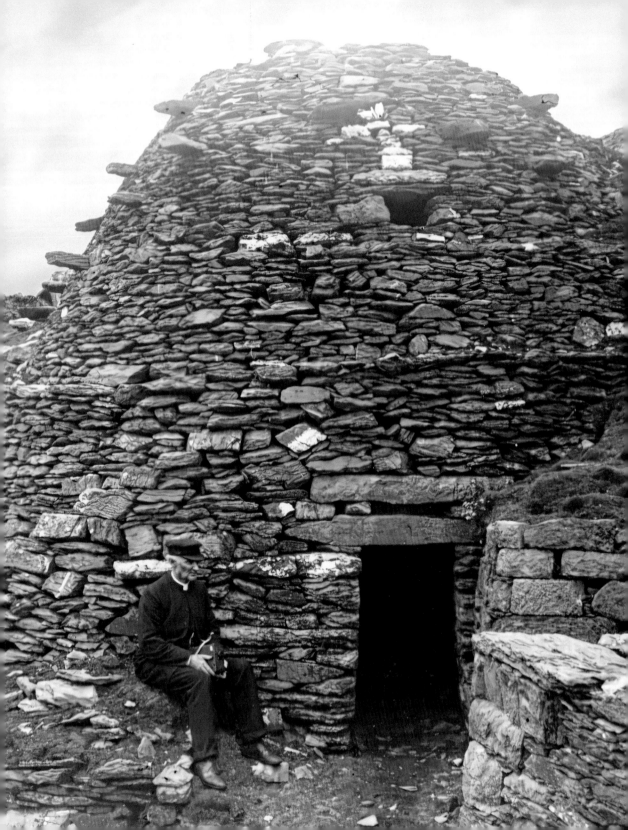

CLIFFS OF MOHER
(chapter opening)

1935

Seán Ó Súilleabháin, prolific folklore collector, at the Cliffs of Moher. Now part of the Burren and Cliffs of Moher UNESCO Geopark, the Cliffs are one of Ireland's most spectacular and visited tourist attractions. Kerryman Seán Ó Súilleabháin was Archivist at Coimisiún Béaloideasa Éireann (the Irish Folklore Commission) for the duration of its existence (from 1935 to 1971).

IRISH SHORTHORN CATTLE

1880–1914, Lough Gill, Co. Sligo

The National Library of Ireland's Flickr followers established that the windmill was a Halladay aermotor pump attached to Hazelwood (or Hazlewood) House. The house is situated on a peninsula protruding into Lough Gill, east of Sligo town. It has views of Ben Bulben to the north and stands in a wooded estate originally 15,000 acres (6,100 ha) in extent, but now reduced to 81 acres.

SKELLIG MICHAEL

1890–1910, Co. Kerry

A priest with a camera sitting at the entrance to a cell on Skellig Michael. Skellig Michael is a twin-pinnacled crag 11.6 kilometres west of the Iveragh Peninsula in Co. Kerry. It has been a UNESCO World Heritage Site since 1996. 618 stone steps lead up to the summit. In recent years, the island has gained worldwide attention as a location site for the *Star Wars* films.

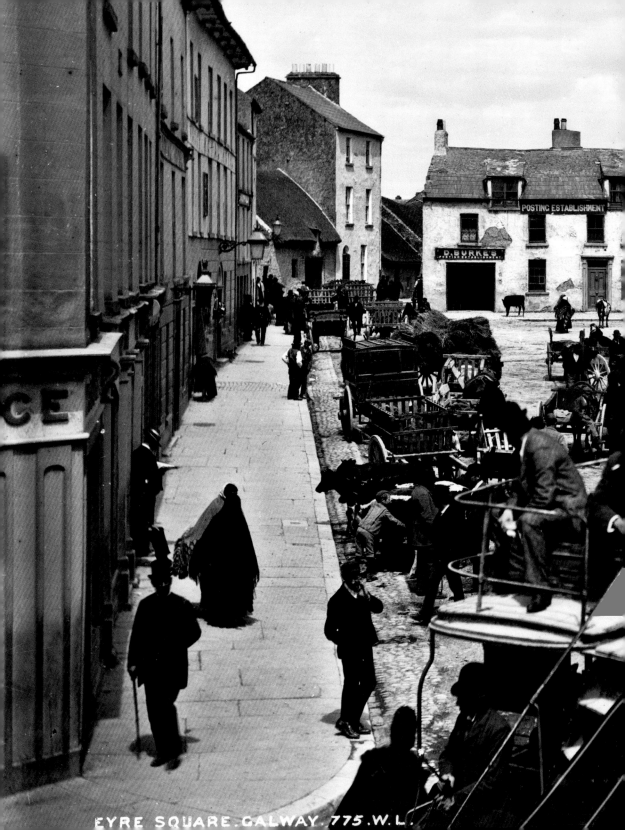

EYRE SQUARE. GALWAY. 775. W.L.

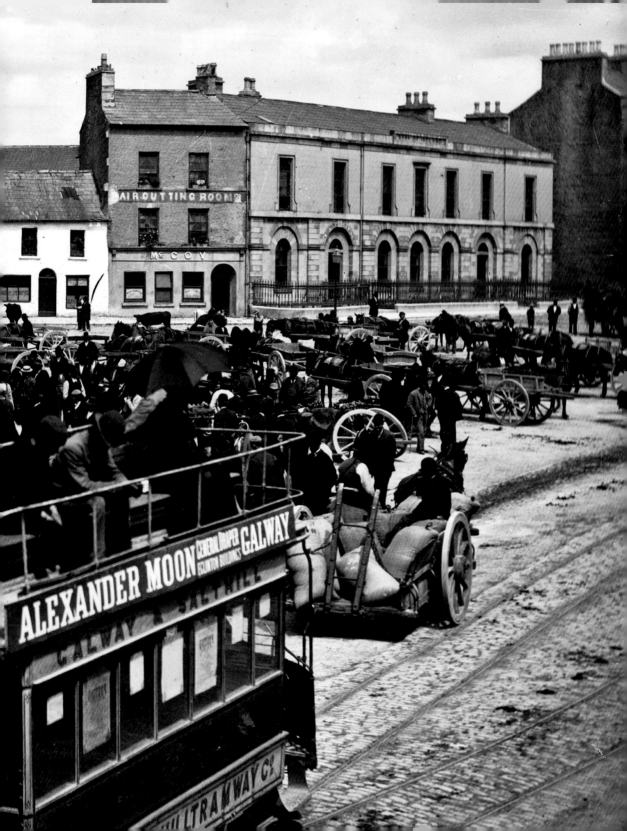

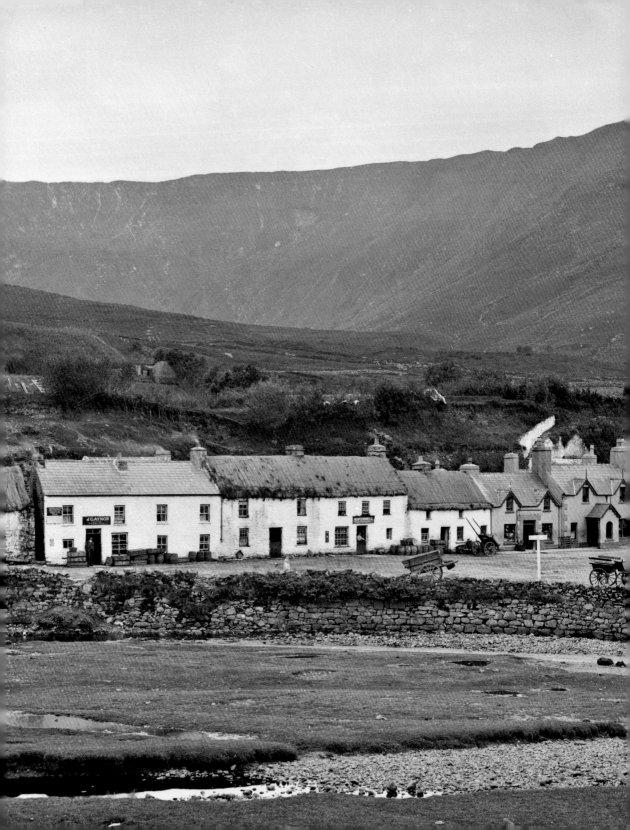

ENANE VILLAGE. 346.W.L.

TRAVELLING IN STYLE

1880s, Eyre Square, Galway City

On the Galway and Salthill Tramway Co. tram. The area of land that became Eyre Square was officially presented to the city of Galway in 1710 by Mayor Edward Eyre, from whom it took its name. On the tram, an advertisement can be seen for Alexander Moon, General Draper, Eglinton Buildings. In the background, shops include: Joyce, D. Burke's, Posting Establishment, Haircutting Room and McCoy.

LEENANE

c.1900, Leenane, Co. Galway

Located beneath the Maamtrasna and Maamturk mountains, Leenane is a village on the Mayo–Galway border, at the head of Killary Harbour – Ireland's only fjord. The village of Leenane evolved in the 1880s as the area recovered from the effects of successive famines. A weaving school was established by the Congested Districts Board, and soon a weaving industry commenced operation from the hotel in the village. Several scenes in Jim Sheridan's 1990 movie *The Field*, based on the play by John B. Keane, were filmed on location here.

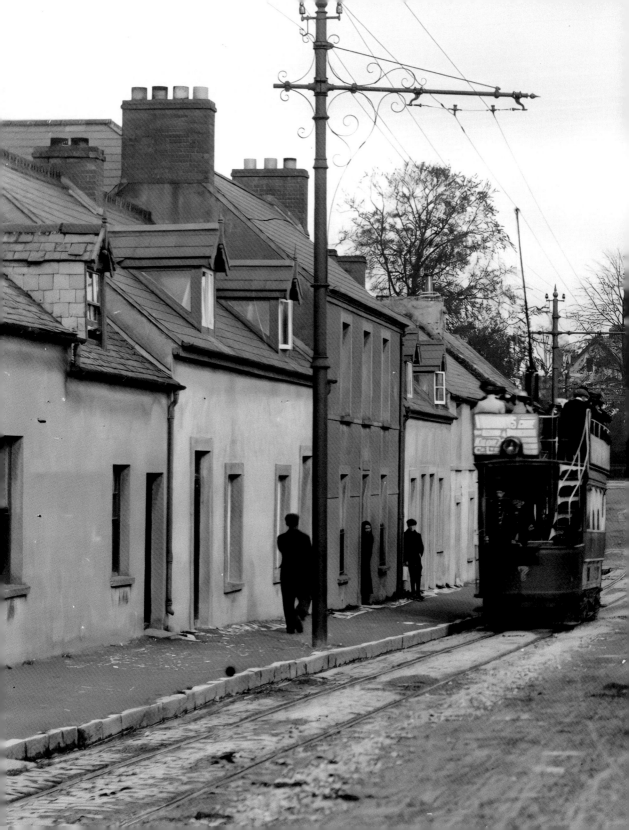

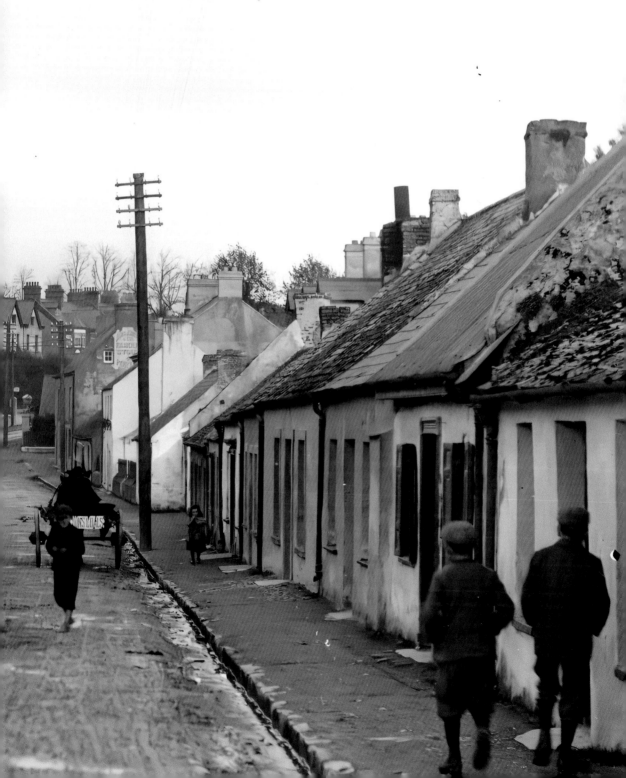

CORK FROM AN OPEN-TOP TRAM

1904–1920, Blackrock Road, Cork City

The Cork Electric Tramways and Lighting Company operated a passenger tramway service in Cork City from 1898 to 1931. The three cross-city routes were from the statue of Theobald Mathew on St Patrick's Street and were Blackpool to Douglas, Summerhill to Sunday's Well and Tivoli to Blackrock. This tram is going up the Blackrock Road. Colours for the tram are taken from the 1987 An Post stamp. On the street, there are signs visible for Vaughan's Cure for Asthma & Bronchitis, Suttons Coals, and James J. Murphy & Co. Famous Stout & Porter on what is today's Temple Inn Bar.

WALT DISNEY AT LADIES' VIEW

November 1946, Derrycunihy, Killarney, Co. Kerry

Séamus Ó Duilearga (left), Walt Disney (centre) and Larry Lansburgh (right). Ladies' View, located about twelve miles from Killarney, remains a popular tourist attraction to this day. Queen Victoria's ladies-in-waiting visited here during the royal visit in 1861 and they were so taken with the view that it was named after them. Walt Disney's great-grandfather Arundel Disney was born in Kilkenny and some of his ancestors are buried in Carlow.

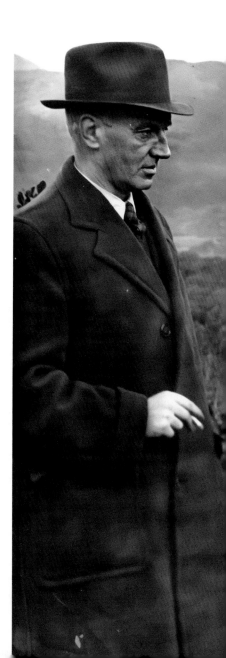

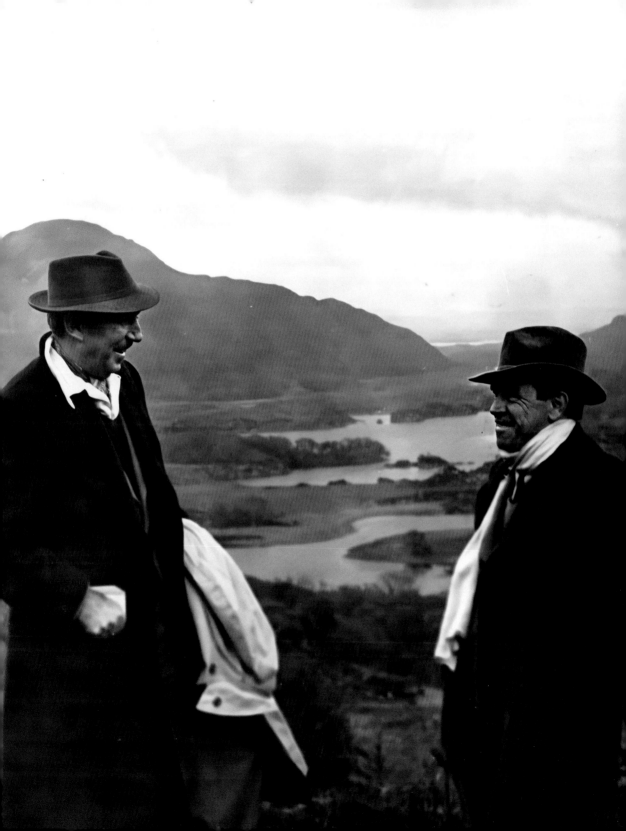

GIORRAÍONN BEIRT BÓTHAR

*c.*1930, An Cheathrú Rua, Co. Galway

Two women and the Carraroe landscape can be seen in this image. It is a particularly nice illustration of the Irish proverb about two shortening the road and the journey seeming shorter when travelling with someone else.

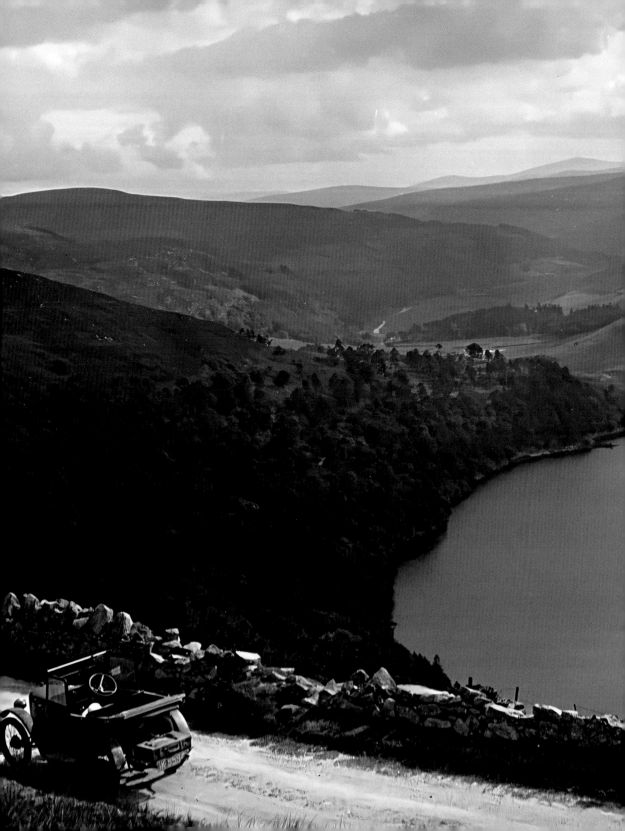

THE GUINNESS LAKE

*c.*1920s, Lough Tay, Co. Wicklow

Lough Tay is an often-photographed location in Co. Wicklow. The lake is on private property in Luggala, formerly the Guinness Estate. The white sand imported by the Guinness family and the shape of the lake makes it look somewhat like a pint of Guinness, hence the name. The car registration plate, starting with IK (Dublin) and four digits, indicates the manufacturing of the car in the 1920s.

GATHERING STONES

1940, Inis Mór (Árainn), Aran Islands,
Co. Galway

The image depicts two men and a
donkey and trap lifting heavy stones and
boulders for fencing. Heinrich Becker,
the photographer, was born in Germany
in 1907. By 1934 he had written a book
on the Elbe boatmen of which he is
one himself and had been awarded a
doctorate in folklore. He then moved to
Ireland to study the Irish language and
oral tradition. He spent seven months
in University College Galway learning
the language, and many years to follow
on the Aran Islands and in Connemara
learning Irish and collecting folklore.

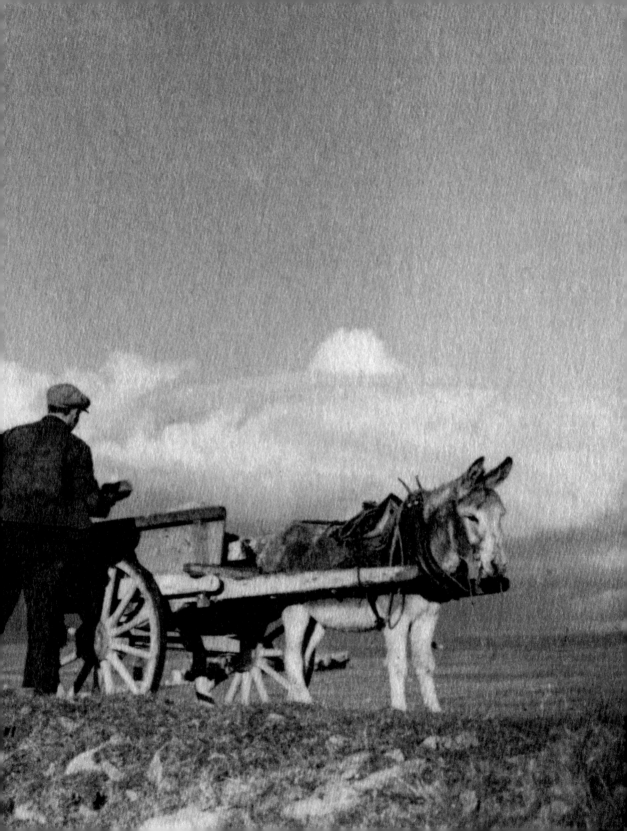

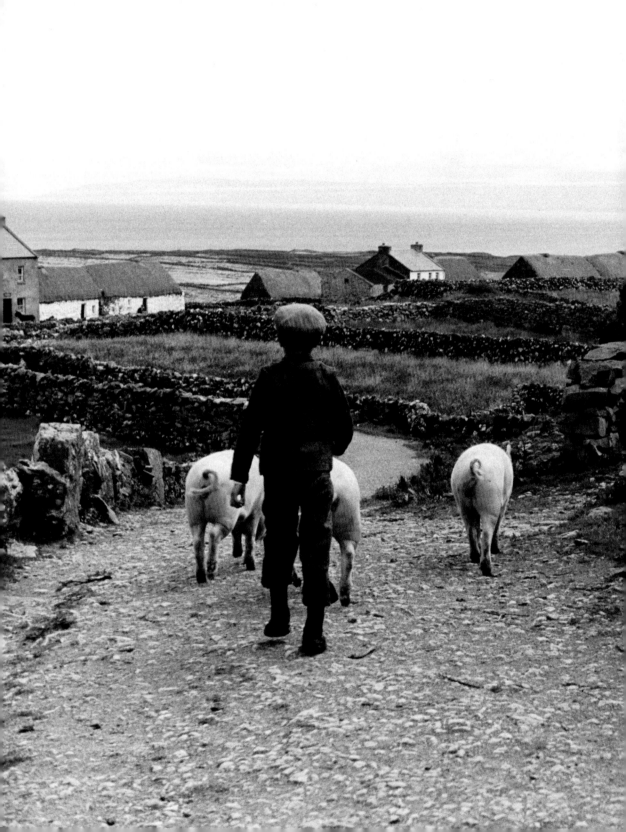

HERDING PIGS

1930s–1950s, Inis Meáin, Aran Islands, Co. Galway

There was some debate as to whether these were pigs or sheep. But they clearly have curly tails and could be large whites! If you look closely, you can also see a donkey trying to enter what looks like a public house (or maybe acting as a taxi for someone inside).

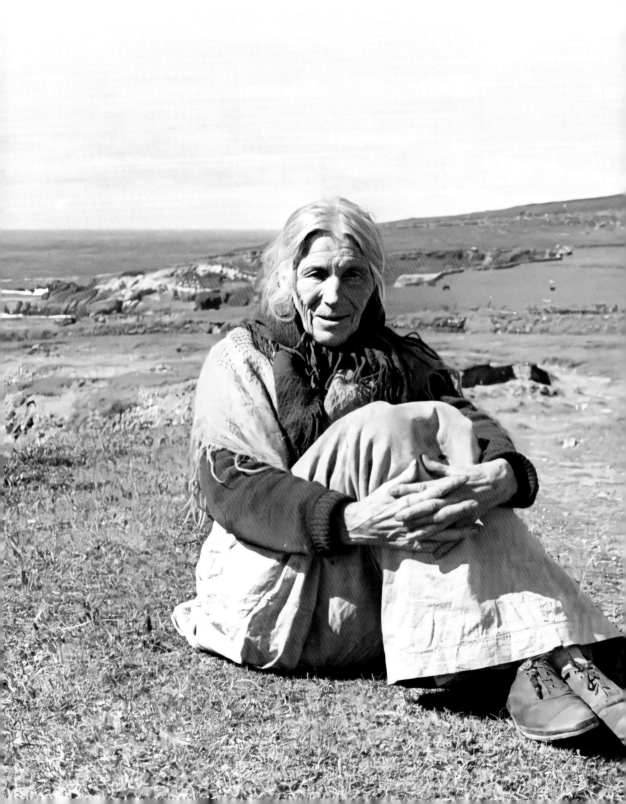

MÁIRE RUISÉAL

1930s, Ballyickeen, Co. Kerry

Máire Ruiséal in her shawl sitting alone on the grass. Máire was interviewed by Seosamh Ó Dálaigh for the Folklore Collection. Themes addressed by collectors included vernacular dwellings and other manmade features, livelihoods, crafts, commerce, transport, the sea, education, the practice of religion, food, dress, festivals and rites of passage, storytellers, musicians, pastimes and sport.

HARVESTING SEAWEED

1930s, Co. Galway

Seaweed harvesting in Ireland currently employs around 400 people in a mostly part-time capacity. Historically, seaweed was commercially used as a raw material in the production of high-volume, low-value commodities such as animal feed and raw material for alginate production. Today, it is accepted as a sea vegetable and it has an ever-increasing role as a raw material in the cosmetic and pharmaceutical industries. This image shows two boys gathering it from the shore.

❯ WANTED ON THE WILD WESTERN WAY

c.1890–1899, Market Street, Sligo

A 'Wanted' poster is attached to the streetlight for 'Several Good Men' needed by a tailoring business called Clinchy's seeking journeymen tailors. The lamppost was later replaced by a statue of Lady Erin. In the nineteenth century, Sligo Town went from being a retailing, craft manufacturing and market town, to being predominantly a retailing and wholesaling centre for goods produced by large-scale manufacturers elsewhere. This was largely the result of the Dublin to Sligo railway which was completed in 1862 and meant that large-scale manufacturers, especially Dublin firms, could now sell their products in Sligo in competition with local craft producers.

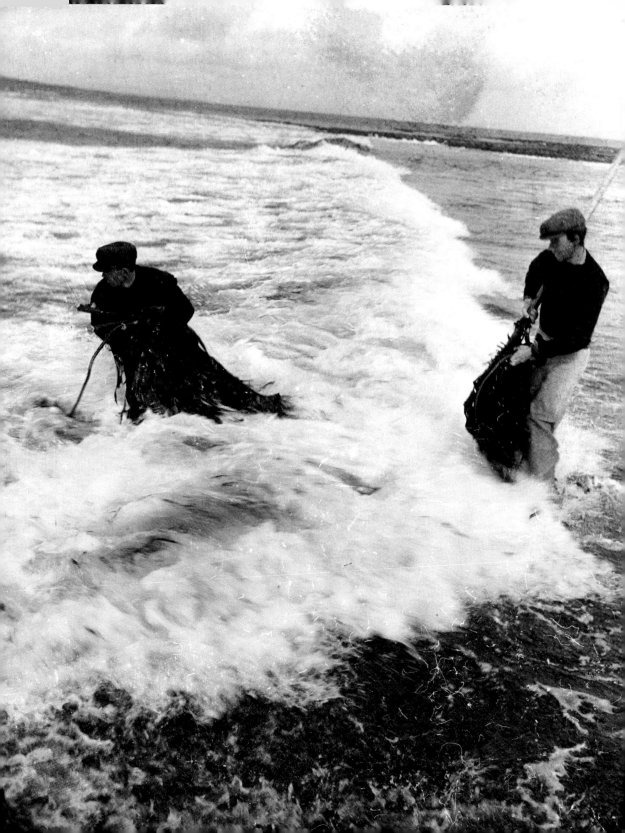

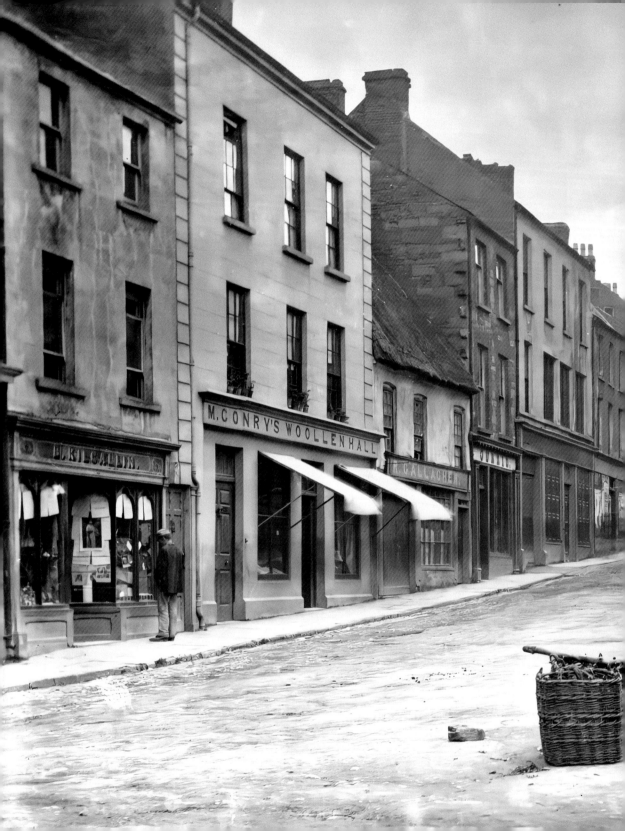

SLIDING ON THE LEE

1902–1903, River Lee, Cork

This image depicts fun on a water chute that was erected on the River Lee for the Cork Exhibition. It appears to be during the summer months of 1902 or 1903 given that the trees are in full leaf. The Cork International Exhibition was held in the Mardyke and was a marketing display of all things Cork and Irish. The Great Water Chute was close to the Industrial Hall and measured seventy feet in height. Cars carried passengers up a gradual ascent to the summit, when a seat was taken in one of the boats, which then started down the incline, hitting the water at speed. Towards the close of the Exhibition of 1902, over a million people had visited and the organisers decided to run it the following year. The official opening of the renamed 1903 Greater Cork International Exhibition occurred on 28 May 1903.

JAUNTING

*c.*1920

A jaunting car is a light two-wheeled carriage for a single horse. It was a popular mode of transportation in nineteenth century Dublin, popularised by Valentine Vousden in a song called 'The Irish Jaunting Car'. Jaunting cars remain in use for tourists in some parts of the country, particularly Killarney in Co. Kerry where they are used for tours of the lakes and national park.

◉ BRICKEEN BRIDGE

*c.*1870–1919, Killarney, Co. Kerry

The three main lakes of Killarney occupy a broad valley stretching south between the mountains. The lakes and the mountains that surround them are all within the Killarney National Park. Nearest the town is the lower lake (Lough Leane) dotted with islands and on its eastern shore Muckross Abbey and Ross Castle. The wooded peninsula of Muckross separates the lower lake from the middle lake sometimes called Muckross Lake. At the tip of the Muckross Peninsula is the eighteenth-century Brickeen Bridge.

GONE FISHIN'

1946, Upper Lough Skeagh, Co. Cavan

A man with some trout caught on Lough Skeagh, a freshwater lake located northwest of Bailieborough.

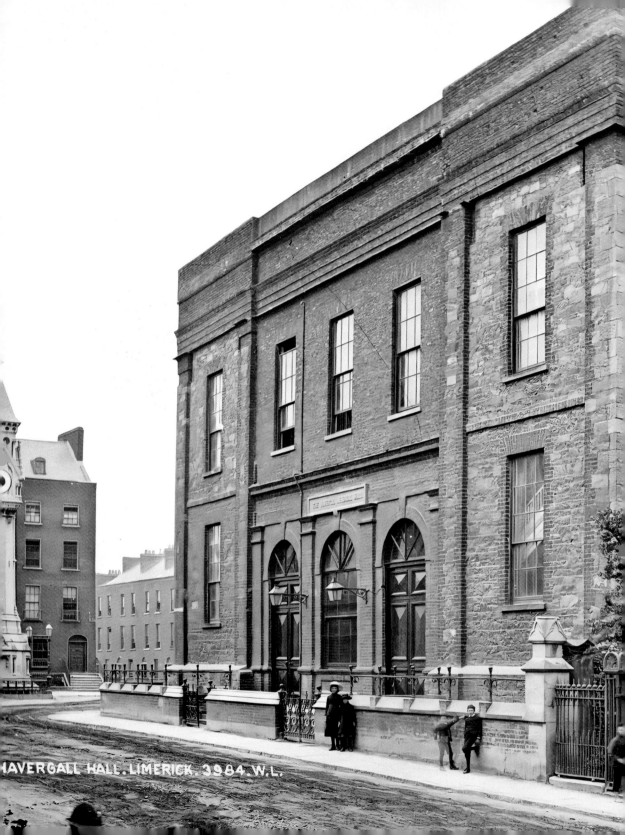

HAVERGALL HALL. LIMERICK. 3984. W.L.

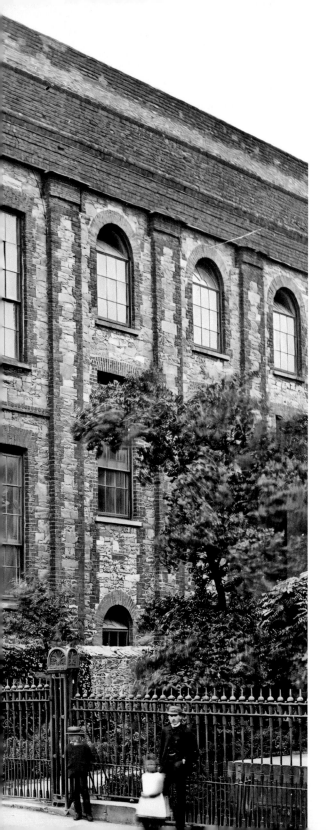

HAVERGAL HALL

*c.*1880–1914, Glentworth Street,
Limerick City

After the formation of the 'Limerick
Philosophical and Literary Society' in
1840, it was decided a suitable residence
would be needed. This building was
opened in 1843, also housing a public
library and museum, and for many
years was known as the Philosophical
Buildings. It was later renamed as the
Havergal Memorial Hall after the
English religious poet and hymnwriter
Frances Ridley Havergal, whose family
were regular visitors to Limerick. The hall
was replaced by the Lyric Cinema, which
in turn was demolished in 1981, and the
latest modern building on the site from
2004 houses a casino. Tait's Clock is
visible in the background.

BLOWING UP BRIDGES

1938, Humphreystown Bridge,
Blessington, Co. Wicklow

This beautiful bridge (as well as two
others at Baltyboys and Burgage) was
blown up between 1938 and 1940, before
flooding of the valley during construction
of a hydroelectric generating station and
artificial lake known as Poulaphouca
Reservoir. It is likely that the remains of
this bridge are lying at the bottom of the
lake. In the photograph, some different
coloured stones and repaired stonework
are visible on the bridge, including the
keystone: this was due to repairs carried
out in 1923 after the Civil War.

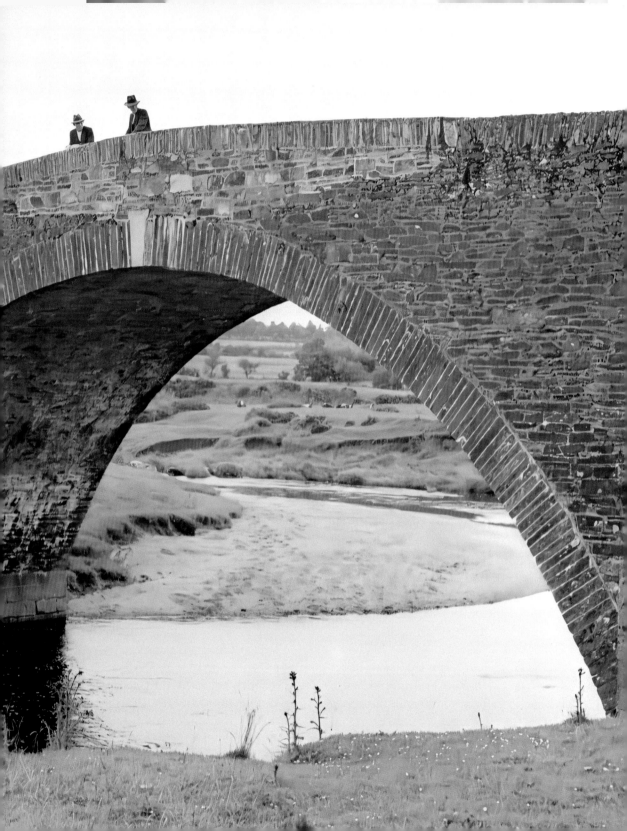

Photographic and Archival Collections

For this book, we have tried to use either public domain or Creative Commons photos as much as possible. There are some fantastic national resources available in Ireland, including the National Folklore Collection and the National Library of Ireland, who have given us generous access to their photographic collections. There are also international sources like the Library of Congress, the Getty Museum Open Content and Wikimedia Commons, all of which have many wonderful photographs of Ireland and the Irish abroad. The Public Record Office of Northern Ireland has also kindly provided some of the photographs used.

We have chosen photographs from key collections, such as the Poole Collection, the R.J. Welch Collection, the Lawrence Collection, the Keogh Collection and the Elinor Wiltshire Collection. We have used works from both professional and amateur photographers, as well as key collectors from the Folklore Commission. Irish photographers such as Colman Doyle, James P. O'Dea, Seán McKeown, Kathleen Price and M. Glover. Images from collectors/folklorists like Caoimhín Ó Danachair, Tomás Ó Muircheartaigh, Domhnall Ó Cearbhaill and Carl W. von Sydow. Work from Fergus O'Connor, H.F. Cooper and Mary Alice Young. Sometimes it is an image from someone in the right place at the right time.

The National Folklore Collection

The Irish Folklore Commission (1935–70), now the National Folklore Collection, was the first state-funded body to employ full-time collectors of folklore in Ireland, and it is one of the world's best and largest folklore collections. Some of the better-known collectors included Seán Ó hEochaidh in Donegal, Tadhg Ó Murchú and Seosamh Ó Dálaigh in Kerry, Michael J. Murphy in counties Tyrone, Armagh, Louth and Derry, and Seán Ó Cróinín in Cork. Now housed in University College Dublin, with many sources digitised and available via Dúchas. ie, it contains about two million manuscript pages, 500,000 index cards, 12,000 hours of sound recordings, 80,000 photographs and 1,000 hours of video material.

The R.J. Welch Photographic Collection

> Few books or articles published in the first half of this century (twentieth century) . . . were without photographic illustrations from R.J. Welch.
>
> E. Estyn Evans and Brian S. Turner, *Ireland's Eye: The Photographs of Robert John Welch*

The R.J. Welch photographic collection, held in the National Museum of Northern Ireland, consists of glass negatives, original prints, lantern slides, original photographic albums, and published series of views. Dating from *c*.1880–*c*.1935, it contains material of topographical, scientific, anthropological, archaeological, transport

and industrial interest, covering the whole of Ireland, with emphasis on the north and west. In addition to the photographical material, the museum holds Welch's diaries and field notes, and also his annotated maps. Welch was born in Strabane in Co. Tyrone on 22 July 1859, the second son of David Welch, a Presbyterian shirt manufacturer. His mother was Martha Welch, previously Martha Graham. David became interested in photography and took it up professionally in 1863. After his father's death in 1875, the Welch family moved to 49 Lonsdale Street, Belfast, where Welch would live for sixty years. Welch set up his own business in 1883.

A.H. Poole Collection, National Library of Ireland

The family firm of A.H. Poole operated as commercial photographers in Waterford from 1884–1954. This large collection of glass plates contains studio portraits of people from Waterford and reflects the social and economic life of the city. In addition to Waterford City and County, there are photographs from Wexford, Kilkenny and Cork, as well as individualised postcards for local business firms and other institutions.

The Lawrence Collection

On 20 March 1865, William Mervin Lawrence opened a Photographic Studio opposite the GPO in Sackville Street, Dublin. In 1880, he employed Robert French as his chief photographer, and he is responsible for over 30,000 photographs in the Lawrence Collection.

The Keogh Photographic Collection

The Keogh Collection comprises a range of political and social images from the 1916 Rising, the 1917 elections and the Irish Civil War. It contains many portraits of personalities (often in uniform) like Éamon de Valera, Michael Collins, Roger Casement, John Redmond, William T. Cosgrave, Constance Markievicz, Patrick Pearse and Archbishop Walsh of Dublin. Other images record key groups and buildings – from Liberty Hall, to na Fianna Éireann, Sinn Féin, the Irish Citizen Army, Irish Women Workers' Union and the National Volunteers.

Elinor Wiltshire Collection

The Wiltshire Collection, of 1,000 negatives and 300 prints, spans a twenty-year period from 1951. The bulk of the images feature Dublin, providing a view of life in the capital during that period. They were taken by Elinor Wiltshire of the Green Studios in Dublin.

Eblana Photographic Collection

Consists of topographical views of Ireland, including cities, towns and rural areas. Also included are eviction scenes from the 1880s.

Photographer and Source

Cover images

HAPPY DAYS; Photographer: Caoimhín Ó Danachair; Source: National Folklore Collection Ref.: E003.18.00012. **FAIR DAY**; Photographer: Poole Studio; Source: National Library of Ireland Ref.: POOLEWP 2103.

Opening credits

YOUNG WOMAN IN A PONY TRAP DRAWN BY A DONKEY; Photographer: Unknown; Source: Library of Congress Ref.: 93504400. **SPINNING**; Photographer: Caoimhín Ó Danachair; Source: National Folklore Collection Ref.: B063.01.00012. **WOMAN BAKING**; Photographer: Mary Alice Young (1867–1946); Source: Deputy Keeper of the Records, Public Record Office of Northern Ireland Ref.: D3027/8/E. **GRUBBING POTATOES**; Photographer: Michael J. Murphy; Source: National Folklore Collection Ref.: B021.32.00001. **FOWL AT GALWAY MARKET**; Photographer: Unknown; Source: National Library of Ireland Ref.: EAS_4051.

The Irish Revolution

CUMANN NA MBAN; Photographer: Piaras Béaslaí Collection; Source: National Library of Ireland Ref.: BEA49. **ULSTER'S SOLEMN LEAGUE AND COVENANT**; Photographer: Unknown; Source: Public Records Office of Northern Ireland, INF/7A/2/47. **SUFFRAGE AND SOCIALISM**; Photographer: Keogh Brothers; Source: National Library of Ireland, Ke203. **THOMAS CLARKE (1858–1916)**; Photographer: Keogh Brothers; Source: National Library of Ireland: Ke235. **SEÁN MAC DIARMADA (1883–1916)**; Photographer: Keogh Brothers; Source: National Library of Ireland: Ke54. **THOMAS MACDONAGH (1878–1916)**; Photographer: M. Glover; Source: National Library of Ireland: NPAPOLF117. **PATRICK PEARSE (1879–1916)**; Photographer: Unknown; Source: Wikimedia Commons and Library of Congress. **ÉAMONN CEANNT (1881–1916)**; Photographer: Arnall; Source: National Library of Ireland: NPA POLF8. **JAMES CONNOLLY (1868–1916)**; Photographer: Unknown; National Library of Ireland 'Irish Political Figures Photographic Collection': NPA POLF52. **JOSEPH MARY PLUNKETT (1887–1916)**; Photographer: Unknown; Source: Wikimedia Commons. **TAKE AIM**; Photographer: Unknown; Source: Wikimedia Commons. **ICA AND IRISH VOLUNTEERS**; Photographer: Volunteer Joseph Cripps; Source: Kilmainham Gaol Museum, KMGLM 2011.0188. **PEARSE'S SURRENDER**; Photographer: Unknown British Army officer at the scene who was an amateur photographer; Source: Wikimedia Commons. **ELIZABETH O'FARRELL**; Photographer: Unknown; Source: National Library of Ireland. **RUINS**; Photographer: Keogh Brothers; Source: National Library of Ireland: Ke119. **REMAINS**; Photographer: Keogh Brothers; Source: National Library of Ireland: Ke121. **COURT MARTIAL**; Photographer: Bain News Service; Source: Library of Congress Ref.: 2014702602. **ORATION IN CLARE**; Photographer: Keogh Brothers; Source: National Library of Ireland: Ke132. **THE COUNTESS**; Photographer: Poole Studio; Source: National Library of Ireland Ref.: POOLED 4843. **THE COUNTESS'S RELEASE**; Photographer: Unknown; Source: National Library of Ireland Ref.: NPA POLF202. **DE VALERA TOURS AMERICA**; Photographer: Bain News Service; Source: Library of Congress Ref.: 2014709180. **AFTERMATH OF A RAID**; Photographer: Agence Rol; Source: Bibliothèque Nationale de France/National Library of France Ref.: ark:/12148/btv1b53051862h. **LILLIAN METGE (1871–1954)**; Photographer: Unknown; Source: National Library of Ireland Ref.: NPA SHE35. **MAUD GONNE (1866–1953)**; Photographer: J.E. Purdy; Source: Library of Congress Ref.: 89711046. **LADY GREGORY (1852–1932)**; Photographer: Bain News Service; Source: Library of Congress Ref.: 2014686192. **WILLIAM BUTLER YEATS (1865–1939)**; Photographer: Bain News Service; Source: Library of Congress Ref.: 2014710325. **LEINSTER HURLING FINAL, 1921**; Photographer: W.D. Hogan (Piaras Béaslaí); Source: National Library of Ireland Ref.: BEA44. **MICHAEL COLLINS (1890–1922)**; Photographer: Agence de Presse Meurisse; Source: Bibliothèque Nationale de France/National Library of France Ref.: ark:/12148/btv1b9053600p. **CYCLE COLLINS**; April 1922, Co. Wexford; Photographer: Unknown; Source: Wikimedia Commons. **MURIEL MURPHY MacSWINEY (1892–1982)**; Photographer: National Photo Company; Source: Library of Congress Ref.: 2016833657. **WAR OF INDEPENDENCE DEAD**; Photographer: Tomás Ó hEidhin (Hynes); Source: UCD Archives Ref.: P80/PH/131. **FREE STATE GENERALS**; Photographer: W.D. Hogan; Source: Wikimedia Commons. **REPUBLICANS IN GRAFTON STREET**; Photographer: Unknown; Source: Mercier Press. **AUXILIARIES**; Photographer: W.D. Hogan; Source: National

Library of Ireland Ref.: HOGW 41. **HIDE AND SEEK**; Photographer: W.D. Hogan; Source: National Library of Ireland Ref.: HOGW 112. **UP SINN FÉIN**; Photographer: Independent News; Source: National Library of Ireland Ref.: IND H 0439. **PEADAR CLANCY**; Photographer: Unknown; Source: Wikimedia Commons. **BURNING OF THE CUSTOM HOUSE**; Photographer: W.D. Hogan; Source: National Library of Ireland Ref.: HOGW 47. **REMEMBRANCE**; Photographer: Bain News Service; Source: Library of Congress Ref.: 2014716517.

Society and Culture

THE LAND FOR THE PEOPLE; Photographer: Napoleon Sarony; Source: Wikimedia Commons Ref.: File: Michael_Davitt_(Napoleon_Sarony).jpg. **THE FIREBRANDS**; Photographer: According to the *Clare Herald*, it is *Pall Mall Gazette* journalist Henry Norman; Source: National Library of Ireland Ref.: EB2665. **RESTING**; Photographer: Dillon family; Source: National Library of Ireland NLI Ref.: CLON472. **EVICTION**; Photographer: Robert French; Source: National Library of Ireland Ref.: L_ROY_02482. **YOU'VE GOT MAIL**; Photographer: Robert French; Source: National Library of Ireland Ref.: L_CAB_00895. **THE BALLAD SINGER**; Photographer: Robert French; Source: National Library of Ireland Ref.: L_CAB_06213. **WEIGHED**; Photographer: Robert French; Source: National Library of Ireland Ref.: L_CAB_07470. **WOMAN FROM KEEL**; Photographer: William H. Rau; Source: Library of Congress Ref.: 97507354. **BRIGADE TRADESMEN**; Photographer: Poole Studio; Source: National Library of Ireland Ref.: POOLEIMP 682. **GOING TO A FUNERAL**; Photographer: Frances Benjamin Johnston; Source: Library of Congress Ref.: 2003654730. **SPINNING, WEAVING AND CARDING**; Photographer: Robert French; Source: National Library of Ireland Ref.: L_ROY_06770. **FOX HUNTING**; Photographer: Fergus O'Connor; Source: National Library of Ireland Ref.: POOLED 0845. **FAIR DAY**; Photographer: Poole Studio; Source: National Library of Ireland Ref.: POOLEWP 2103. **AN EARLY AUTOCYCLE!**; Photographer: Robert French; Source: National Library of Ireland Ref.: L_ROY_09711. **WINNING OARSMEN**; Photographer: Poole Studio; Source: National Library of Ireland Ref.: P_WP_0166b. **FUNNY GEORGE CLOWNING AROUND**; Photographer: H.F. Cooper; Source: Deputy Keeper of the Records, Public Record Office Northern Ireland Ref.: D1422_B_17_85~ALL~A. **CIRCUS LIFE**; Photographer: H.F. Cooper; Source: Deputy Keeper of the Records, Public Record Office Northern Ireland Ref.: D1422_B_17_80~ALL~A. **'ERIN GO BRAGH!'**; Photographer: Poole Studio; Source: National Library of Ireland Ref.: P_WP_3455. **THE MARRIED COUPLE**; Photographer: Kathleen Price; Source: National Folklore Collection Ref.: E125.01.00001. **GWEEDORE**; Photographer: Robert French; Source: National Library of Ireland Ref.: L_ROY_01361. **TENEMENT LIFE**; Photographer: Robert French; Source: National Library of Ireland Ref.: L_CAB_08895. **WAITING AT THE QUAY**; Photographer: Carl W. von Sydow; Source: National Folklore Collection Ref.: C027.01.00002. **RMS *TITANIC* LEAVING BELFAST**; Photographer: Robert Welch, official photographer for Harland and Wolff; Source: Wikimedia Commons Ref.: File: RMS_Titanic_2.jpg. **LIFE IN FIRST-CLASS**; Photographer: Robert Welch; Source: Deputy Keeper of the Records, Public Record Office Northern Ireland and National Museums of Northern Ireland Ref.: D1403_2-030-A. **CAFÉ PARISIEN**; Photographer: Robert Welch; Source: Deputy Keeper of the Records, Public Record Office Northern Ireland and National Museums of Northern Ireland Ref.: D1403_2-032-A. **FINAL VOYAGE**; Photographer: Photograph of a drawing; Source: Library of Congress Ref.: 2006677520. **SURVIVORS**; Photographer: Poole Studio; Source: National Library of Ireland Ref.: POOLED 2725. **MASS BURIALS**; Photographer: *The New York Times*; Source: Library of Congress Ref.: 1901374. **ISLAND VIBES**; Photographer: Dr F.S. Bourke; Source: National Folklore Collection Ref.: N100.03.00001. **TOMÁS Ó CRIOMHTHAIN**; Source: National Folklore Collection Ref.: M001.18.00222; Photographer: Carl W. von Sydow. **LAST DAYS OF A POLITICAL PARTY**; Photographer: Poole Studio; Source: National Library of Ireland Ref.: POOLEWP 3892. **THE UNVEILING**; Photographer: *The Irish Press*; Source: Galway City Museum. **PÁDRAIC Ó CONAIRE**; Photographer: Unknown; Source: Galway City Museum. **IN THE BLUE STACK MOUNTAINS**; Photographer: Unknown; Source: National Folklore Collection Ref.: M004.29.00598. **WAITING FOR MASS**; Photographer: Tomás Ó Muircheartaigh; Source: National Folklore Collection Ref.: D010.01.00009. **DIGGING PEAT**; Photographer: Frank and Frances Carpenter Collection; Source: Library of Congress Ref.: 99471535. **SINGING BY THE FIREPLACE**; Photographer: Ritchie-Pickow Collection; Source: National University of Ireland Galway Library Archives Ref.: p100904. **YOUNG MAN OF ARAN**; Photographer: Leo Corduff; Source: National Folklore Collection Ref.: M003.01.00027. **TEATIME**; Photographer: Elinor Wiltshire; Source: National

Library of Ireland Ref.: WIL k4[54]. **PINT ANYONE?**; Photographer: James P. O'Dea; Source: National Library of Ireland Ref.: ODEA27/19. **SERVING TIME**; Photographer: James P. O'Dea; Source: National Library of Ireland Ref.: ODEA 36/64. **FUN TO BE HAD**; Photographer: Unknown; Source: National Library of Ireland Ref.: WIL 57[9]. **FRANK 'WINGS' CAMPBELL**; Photographer: Michael J. Murphy; Source: National Folklore Collection Ref.: M004.25.00071.

Women and Children

POSING ON THE DOORSTEP; Photographer: Poole Studio; Source: National Library of Ireland Ref.: POOLEWP 4003. **SISTERLY LOVE**; Photographer: Dillon family; Source: National Library of Ireland Ref.: CLON55. **CHRISTMAS DAY**; Photographer: Dillon family; Source: National Library of Ireland Ref.: CLON1945. **IT'S A DOG'S LIFE**; Photographer: Dillon family; Source: National Library of Ireland Ref.: CLON860. **'THE YOUNG FIRBOLGS'**; Photographer: Robert (R.J.) Welch; Source: National University of Ireland Galway Library Archives Ref.: P28/18. **THE WOMEN FUELLING IRELAND**; Photographer: Unknown; Source: Library of Congress Ref.: 2004681998. **ERIN'S SONS AND DAUGHTERS**; Photographer: Underwood & Underwood; Source: Library of Congress Ref.: 2005694753. **THE CLADDAGH CATCH**; Photographer: Unknown; Source: National Library of Ireland Ref.: Eas 4055. **MOTHER AND BABY**; Photographer: A.H. Poole; Source: National Library of Ireland Ref.: POOLEWP 1013. **GIFFORD AND ORPEN**; Photographer: Unknown; Source: National Library of Ireland Ref.: NPA POLF253. **HANNA AND OWEN IN NEW YORK**; Photographer: Bain News Service; Source: Library of Congress Ref.: 2014703392. **'THE SPRING'**; Photographer: Bain News Service; Source: Library of Congress Ref.: 2014695446. **POVERTY IN THE IRISH FREE STATE**; Photographer: Poole Studio, Waterford; Source: National Library of Ireland Ref.: P_WP_3148. **SMILING AND CURIOUS**; Photographer: Carl W. von Sydow; Source: National Folklore Collection Ref.: M001.18.00497. **MIGRATION AND TRAGEDY**; Photographer: Independent Newspapers; Source: National Library of Ireland Ref.: INDH3064. **BAREFOOT AND SMILING**; Photographer: Åke Campbell; Source: National Folklore Collection Ref.: M003.01.00042. **SPINNING**; Photographer: Caoimhín Ó Danachair; Source: National Folklore Collection Ref.: B063.05.00002. **GATHER ROUND**; Photographer: Tomás Ó Muircheartaigh; Source: National Folklore Collection Ref.: E003.01.00001. **PEIG SAYERS**; Photographers (clockwise from top left): Caoimhín Ó Danachair, Séamus Ó Duilearga, Caoimhín Ó Danachair, Thomas Waddicor; Source: National Folklore Collection Refs.: M001.18.00299, M001.18.00316, M001.18.00657, M001.18.00693. **AN TOBAR BEAG**; Photographer: Donncha Ó Cearbhaill; Source: National Folklore Collection Ref.: F023.01.00026. **MAGGIE FROM MAN OF ARAN**; Photographer: Frances Hubbard Flaherty; Source: National Folklore Collection Ref.: D018.01.00015. **EPHEMERAL ISLANDERS**; Photographer: Tomás Ó Muircheartaigh; Source: National Folklore Collection Ref.: D014.01.00003. **BIDDING THE TIME OF DAY**; Photographer: Michael J. Murphy; Source: National Folklore Collection Ref.: M004.24.00023. **SUBLICHS**; Photographer: Elinor Wiltshire; Source: National Library of Ireland Ref.: WIL 13[54]. **SIXTIES STYLE**; Photographer: Colman Doyle; Source: National Library of Ireland Ref.: CDOY83. **POSING IN 'THE GREEN'**; Photographer: Elinor Wiltshire; Source: National Library of Ireland Ref.: WIL 11[11]. **'GOD BLESS THE CORPORATION'**; Photographer: Elinor Wiltshire; Source: National Library of Ireland Ref.: WIL 3[8].

The Irish Abroad

OSCAR WILDE; Photographer: Napoleon Sarony; Source: Library of Congress Ref.: 98519733. **THE LAST OF THE GREAT IRISH HARPERS**; Photographer: David Octavius Hill and Robert Adamson; Source: Open Content Program of the J. Paul Getty Museum, Los Angeles Ref.: 84.XO.734.4.3.17. **1ST DUKE OF WELLINGTON**; Photographer: Antoine Claudet; Source: Open Content Program of the J. Paul Getty Museum, Los Angeles Ref.: 85.XT.449. **ADMIRAL WILLIAM BROWN**; Photographer: Unknown; Source: Wikimedia Commons. **JOHN BOYLE O'REILLY**; Photographer: Unknown, for Thomas A. Larcom; Source: New York Public Library Ref.: NYPW93-A241. **SERGEANT THOMAS DARRAGH**; Photographer: Unknown, for Thomas A. Larcom; Source: New York Public Library Ref.: NYPW93-A241. **ROBERT 'BIG BOB' CRANSTON**; Photographer: Unknown, for Thomas A. Larcom; Source: New York Public Library Ref.: NYPW93-A241. **MICHAEL HARRINGTON**; Photographer: Unknown, for Thomas A. Larcom; Source: New York Public Library Ref.: NYPW93-A241. **JAMES WILSON**; Photographer: Unknown, for Thomas A. Larcom; Source: New York Public Library Ref.: NYPW93-A241. **MARTIN HOGAN**; Photographer: Unknown, for Thomas A. Larcom; Source: New York Public Library Ref.:

NYPW93-A241. **THOMAS HENRY HASSETT**; Photographer: Unknown; Source: Wikimedia Commons. **FOUNDER OF CELTIC FC**; Photographer: Unknown; Source: Wikimedia Commons. **CHARLES STEWART PARNELL**; Photographer: Matthew Brady or Levin Corbin Handy; Source: Library of Congress Ref.: 2017893366. **OSCAR WILDE**; Photographer: Napoleon Sarony; Source: Library of Congress Ref.: 98519702. **ADA REHAN (1857–1916)**; Photographer: Aimé Dupont; Source: Library of Congress Ref.: 2005683746. **MARGARET TERESA DOHERTY PENDER**; Photographer: Unknown; Source: Wikimedia Commons. Ref.: File:Mrs._M.T._Pender.jpg. **DRACULA**; Photographer: Unknown; Source: Wikimedia Commons. **DRUNK AND DISORDERLY**; Photographer: Unknown, North Shields Police Station; Source: Tyne and Wear Archives Ref.: DX1388-1-55-Michael Mulvaney. **TRAMPING**; Photographer: Cardiganshire Constabulary; Source: Llyfrgell Genedlaethol Cymru/National Library of Wales Ref.: NLW MS 23203B. **ALICE RUSSON**; Photographer: Unknown, originally from 'Pantomime Stars in Town and in the Provinces', *The Bystander*; Source: Wikimedia Commons. **IRISH MAJOR LEAGUER**; Photographer: Bain News Service; Source: Library of Congress Ref.: 2014689203. **JAMES CECIL PARKE (1881–1946)**; Photographer: Bain News Service; Source: Library of Congress Ref.: 2014683850. **MENDING THE BAGS**; Photographer: Herbert Poynting; Source: Wikimedia Commons Ref.: File: EvansCrean1911.jpg. **SALLY'S PUPS**; Photographer: Frank Hurley; Source: Wikimedia Commons Ref.: File: Tom_Crean.jpg. **'REVOLUTIONARY' JOYCE**; Photographer: Camille Ruf; Source: Wikimedia Commons. **TORMENT IN FRANCE**; Photographer: Unknown; Source: The Rosenbach, Philadelphia Ref.: EMs 1293/9 Silver gelatin print. **IRELAND'S MOST FAMOUS TENOR**; Photographer: Bain News Service; Source: Library of Congress Ref.: 2014712444. **THE IRISHWOMAN WHO SHOT MUSSOLINI**; Photographer: Italian Ministry of the Interior; Source: Whale Oil Ref.: 6a015436b6d8f4970c01a3fd10340d970b. **IRELAND'S MOST FAMOUS WOBBLIE**; Photographer: National Photo Company; Source: Library of Congress Ref.: 2016843688. **MAGGIE FROM MAYO**; Photographer: Erich Salomon; Source: Wikimedia Commons. **PEGGY CUMMINS (1925–2017)**; Photographer: Unknown at Columbia Pictures; Source: Wikimedia Commons. **GRACE**; Photographer: Unknown at Metro-Goldwyn-Mayer; Source: Wikimedia Commons. **PRESIDENT JOHN F. KENNEDY'S VISIT TO IRELAND**; Photographer: Sean McKeown; Source: With permission of the Irish Defence Forces Military Archives Ref.: PRCN-01-50 Kennedy in Green Park, Limerick.

Scenic Ireland

CLIFFS OF MOHER; Photographer: Albert Eskeröd; Source: National Folklore Collection Ref.: M010.19.00041; **IRISH SHORTHORN CATTLE**; Photographer: Robert French; Source: National Library of Ireland Ref.: L_CAB_05640. **SKELLIG MICHAEL**; Photographer: Thomas Mason; Source: National Library of Ireland Ref.: M18/18/8. **TRAVELLING IN STYLE**; Photographer: Robert French; Source: National Library of Ireland Ref.: L_ROY_00775. **LEENANE**; Photographer: Robert French; Source: National Library of Ireland Ref.: L_CAB_00346. **CORK FROM AN OPEN TOP TRAM**; Photographer: Fergus O'Connor; Source: National Library of Ireland Ref.: OCO 370. **WALT DISNEY AT LADIES' VIEW**; Photographer: Larry Lansburgh; Source: National Folklore Collection Ref.: M010.18.00114. **GIORRAÍONN BEIRT BÓTHAR**; Photographer: Kathleen Price; Source: National Folklore Collection Ref.: A001.01.00222. **THE GUINNESS LAKE**; Photographer: Maurice Curtin; Source: National Folklore Collection Ref.: A001.10.00075. **GATHERING STONES**; Photographer: Heinrich Becker; Source: National Folklore Collection Ref.: A042.01.00001. **HERDING PIGS**; Photographer: Tomás Ó Muircheartaigh; Source: National Folklore Collection Ref.: M003.01.00339. **MÁIRE RUISEAL**; Photographer: Tomás Ó Muircheartaigh; Source: National Folklore Collection Ref.: M001.18.00879. **HARVESTING SEAWEED**; Photographer: Domhnall Ó Cearbhaill; Source: National Folklore Collection Ref.: B039.01.00010. **WANTED ON THE WILD WESTERN WAY**; Photographer: Robert French; Source: National Library of Ireland Ref.: L_CAB_03580. **SLIDING ON THE LEE**; Photographer: Likely Robert French; Source: National Library of Ireland Ref.: L_NS_00017. **JAUNTING**; Photographer: Bloxham Collection; Source: Royal Australian Historical Society. **BRICKEEN BRIDGE**; Photographer: William Lawrence; Source: New York Public Library Ref.: b11878004. **GONE FISHIN'**; Photographer: Maurice Curtin; Source: National Folklore Collection Ref.: B005.26.00018. **HAVERGAL HALL**; Photographer: Robert French; Source: National Library of Ireland Ref.: L_CAB_03984. **BLOWING UP BRIDGES**; Photographer: James O'Dea; Source: National Library of Ireland Ref.: ODEA 3/30.

References

Bartlett, Thomas (ed.), *The Cambridge History of Ireland Volume 4: Ireland, c.1880 to the Present* (Cambridge: Cambridge University Press, 2018).

Breathnach, Ciara (ed.), *Framing the West: Images of Rural Ireland, 1891–1920* (Dublin: Irish Academic Press, 2007).

Carville, Justin, *Photography in Ireland* (London: Reaktion Books, 2011).

Crowley, John, Donal Ó Drisceoil and Mike Murphy (eds), *Atlas of the Irish Revolution* (Cork: Cork University Press, 2016).

Evans, E. Estyn and Brian S. Turner, *Ireland's Eye: The Photographs of Robert John Welch* (Belfast: Blackstaff Press, 1977).

Fitzsimons, Peter, *The Catalpa Rescue* (Australia: Constable 2019).

Hanna, Erika, *Snapshot Stories: Visuality, Photography, and the Social History of Ireland, 1922–2000* (Oxford: Oxford University Press, 2020).

Kelly, James (ed.), *The Cambridge History of Ireland Volume 3: Ireland, c.1730–c.1880* (Cambridge: Cambridge University Press, 2018).

Kinealy, Christine, Jason King and Gerard Moran (eds), *Children and the Great Hunger in Ireland* (Cork: Cork University Press, 2018).

Murphy, Seán J., 'Some Notes on the Patrick Pearse 1916 Surrender Photograph', https://www.academia.edu/12232694/Some_Notes_on_the_Patrick_Pearse_1916_Surrender_Photograph [accessed 28/07/2020].

Sexton, Seán and Christine Kinealy, *The Irish: A Photohistory, 1840–1940* (London: Thomas and Hudson, 2002).

Slattery, Peadar, 'The uses of photography in Ireland 1839–1900', Unpublished PhD thesis, Trinity College Dublin, Department of History, 1992.

Websites and Databases

The National Library of Ireland

Dúchas.ie – The National Folklore Collection

RIA Dictionary of Irish Biography Project

Amhráin Aran, http://aransongs.blogspot.com

Ainm.ie

The Irish Times

The Irish Independent

The Irish Press

The Irish Story

The Limerick Chronicle

The New York Times

The Shields Day Gazette

The Pall Mall Gazette

The Clare Herald

Siobhán Lynam, *RTÉ Documentary at One*, 'The Irishwoman Who Shot Mussolini'

Century Ireland, https://www.rte.ie/centuryireland/

Wikimedia Commons